THE QUEER NUYORICAN

PERFORMANCE AND AMERICAN CULTURES

General Editors: Stephanie Batiste, Robin Bernstein, and Brian Herrera

This book series harnesses American studies and performance studies and directs them toward each other, publishing books that use performance to think historically.

The Art of Confession: The Performance of Self from Robert Lowell to Reality TV
Christopher Grobe

Realist Ecstasy: Religion, Race, and Performance in American Literature
Lindsay V. Reckson

The Queer Nuyorican: Racialized Sexualities and Aesthetics in Loisaida
Karen Jaime

The Queer Nuyorican

Racialized Sexualities and Aesthetics in Loisaida

Karen Jaime

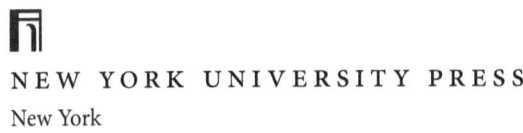
NEW YORK UNIVERSITY PRESS
New York

NEW YORK UNIVERSITY PRESS
New York
www.nyupress.org

© 2021 by New York University
All rights reserved

References to Internet websites (URLs) were accurate at the time of writing. Neither the author nor New York University Press is responsible for URLs that may have expired or changed since the manuscript was prepared.

Cataloging-in-Publication data is available from the publisher.

Library of Congress Cataloging-in-Publication Data
Names: Jaime, Karen, author.
Title: The queer Nuyorican : racialized sexualities and aesthetics in Loisaida / Karen Jaime.
Description: New York : New York University Press, [2021] | Series: Performance and American cultures | Includes bibliographical references and index.
Identifiers: LCCN 2020055483 | ISBN 9781479808281 (hardback) | ISBN 9781479808298 (paperback) | ISBN 9781479808274 (ebook) | ISBN 9781479808304 (ebook)
Subjects: LCSH: Sexual minorities' writings, American—History and criticism. | Performance poetry—Social aspects—New York (State)—New York. | Performance poets—New York (State)—New York. | American poetry—20th century—History and criticism. | American poetry—21st century—History and criticism. | Minorities—New York (State)—New York—Intellectual life. | Lower East Side (New York, N.Y.)—Intellectual life. | Nuyorican Poets Cafe.
Classification: LCC PS153.S39 J35 2021 | DDC 811/.540935266097471—dc23
LC record available at https://lccn.loc.gov/2020055483

New York University Press books are printed on acid-free paper, and their binding materials are chosen for strength and durability. We strive to use environmentally responsible suppliers and materials to the greatest extent possible in publishing our books.

Manufactured in the United States of America

10 9 8 7 6 5 4 3 2 1

Also available as an ebook

Para Mami . . .

CONTENTS

List of Illustrations	ix
Introduction: Welcome to the Nuyorican	1
1. Walking Poetry in Loisaida	27
2. This Is the Remix: Regie Cabico's *Filipino Shuffle*	57
3. Tens across the Board: The Glam Slam at the Nuyorican Poets Cafe	89
4. Black Cracker's "Chasing Rainbows": Hip-Hop Minstrelsy, Queer Futurity, and Trans Multiplicity	123
Conclusion: The Open Room	155
Acknowledgments	171
Notes	177
Bibliography	191
Index	199
About the Author	207

ILLUSTRATIONS

I.1. Nuyorican Poets Cafe bar, 2012. 2

1.1. Cover of Miguel Piñero's chapbook, *Miguelito Piñero's Random Thoughts and Walking Poetry*. 28

1.2–1.3. Murals by Joe "EZO" Wippler and Antonio "Chico" García. 48–49

1.4–1.6. Awnings at the entrance to the Cafe. 50–52

2.1. Regie Cabico performing on HBO's *Def Poetry Jam*, 2002. 81

3.1. Andres "Mother Diva" Xavier hosting the Glam Slam, 1999. 107

3.2–3.3. Andres "Mother Diva" Xavier voguing at the Glam Slam, 1999. 108–109

3.4. The author performing at the Glam Slam, 2003. 115

4.1. Vintage ad for skin lightening cream. 139

4.2. Initial scene from Black Cracker's music video "Chasing Rainbows." 146

4.3. Final scene from "Chasing Rainbows" music video. 153

C.1. Nuyorican Poets Cafe button. 156

C.2–C.3 Luis Guzmán performing at the Nuyorican Poets Cafe, 1974. 160

C.4. Stephanie Chapman performing at the Nuyorican Poets Cafe, 1974. 161

Introduction

Welcome to the Nuyorican

We are all Nuyorican.
—Bob Holman

This is something that belongs to us, we'll share it, but there are limits. Bob stated in *The New York Times*, "Anybody can be a Nuyorican." That's bullshit.
—Pedro Pietri

I can still remember going to dinner with friends in the West Village on a Friday night in 1997, and then spontaneously deciding to go to the Nuyorican Poets Cafe. We opt to walk there, through Washington Square Park, past the New York University buildings surrounding it, toward the East Village/Lower East Side. Although the specific route from West to East mostly escapes me over twenty years later, more than anything I remember our increasing excitement as we moved closer and closer to the Cafe. Upon arrival we are greeted by a tall, gray-haired gentleman with a mustache who gruffly tells us to wait in the line stretching down the block. In spite of my fear that the space will reach capacity and we will be unable to enter, we each pay our five dollars, gain admittance, and walk through the blue door of the Nuyorican Poets Cafe. I had thought that the space would be larger. Instead, what greets me is a venue with a smallish wraparound bar and a Puerto Rican flag hanging on its back wall, with "Nuyorican" written in bubble letters underneath.

On one side of the bar is a nook with a prayer candle and a black-and-white picture of Cafe co-founder Miguel Piñero. The small stage, covered by an Oriental rug, is pushed up against the same brick wall as the bar, with a microphone in the middle; the front of the stage faces out to a series of wobbly tables with rickety chairs. As my friends and I walk

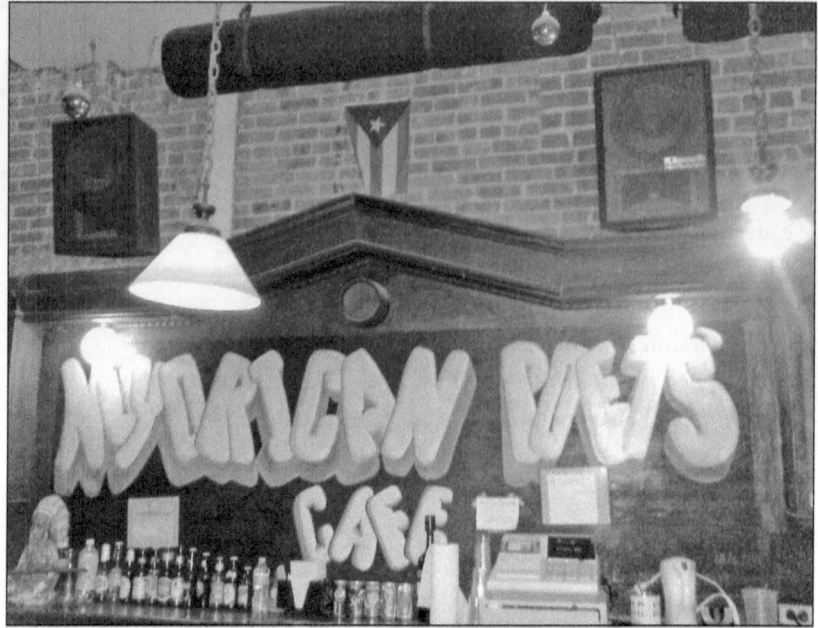

Figure I.1. Spray-painted sign behind the bar at the Nuyorican Poets Cafe with the Puerto Rican flag hanging above it. Photo by author, 2012.

through the diverse crowd, many of whom are also looking for seating, we find ourselves raising our voices in order to hear one another over the hip-hop blasting through the speakers. A few minutes after sitting down, we are asked to serve as judges for that evening's Friday Night Poetry Slam (poetry competition). We agree.[1]

As one of the judges, and someone familiar with the history of the Cafe, I am most compelled by the competing poets whose works are political in content, but troubled by other performers whose writing lacks such substance, evidenced by an overinvestment in buzzwords and catchphrases to elicit applause and finger snaps. I realize now that my experience at the Cafe was influenced by a course I took as a college sophomore at Cornell University, "Poetry and Politics in the Americas," taught by Dr. Ben Olguín. It is in this class that I first hear about a performance space in the Lower East Side of New York City called the Nuyorican Poets Cafe. Through this course, I am also introduced to the politics of the term "Nuyorican," uppercase *N*. "Nuyorican" was an

epithet once used by Puerto Ricans still living in Puerto Rico to refer to people of Puerto Rican descent living in the United States, specifically New York, whom they viewed as less ethnically authentic because of their usage of English mixed with Spanish, or Spanglish. While I more fully unpack and theorize "Nuyorican" later in this introduction and in chapter 1, the use of Spanglish in both the written and spoken word is one that initially compelled me. I recall how I was struck by the fact that such a place existed to showcase work created by poets of color, and that their poetry didn't necessarily rhyme or follow all of the literary conventions I had been taught defined "proper" literature. The Spanglish words I encountered reflected my ethnic, cultural, and linguistic lived experience—in other words, some of the poets were describing what it meant to grow up both Latina/o/x and working-class in the United States. This movement between English and Spanish in literature was something I had never experienced before; the books I read for school were only in English, and those I read at home or in church were only in Spanish. Moreover, although I spoke using both languages when communicating with my Latina/o/x friends, I was taught to speak and write in only one language at a time in order to be taken seriously as a scholar. Yet, as Doris Sommer contends, one need only encounter the writing of Cafe co-founder Miguel Algarín to understand that code-switching is as much about "arriving at an organized respectability" as it is about staying "disruptive aesthetically."[2] Algarín's use of Spanglish in artistic productions challenged a cultural push for coherence and respectability in a way that deeply impacted works created by and about the artists performing at the Cafe. As a student reading about the Nuyorican Poets Cafe in that English class, I was moved by the aesthetic disruption proposed by Sommer and exemplified by many of the Cafe's artists of every generation and artistic imperative.

I was searching for this type of work—political in content and aesthetically disruptive, although not necessarily bilingual—that evening in 1997.[3] After I convince my friends to give a low score to a particularly contrived performance, and subsequently eliciting boos from the audience, the host, Keith Roach, challenges me to perform in the Open Room, the noncompetitive event following the slam. I accept, and while my writing and performance are admittedly raw and quite green, Roach sees something that compels him to extend another invitation to

compete in the following week's poetry competition. I lose, but Roach continues to call me frequently to participate, leaving messages on my answering machine that I accept more often than not until stepping away from competing, preferring instead to organize and curate noncompetitive events. This continues for a number of years before I finally do return as the host of the Friday Night Poetry Slam following the departures of Roach and his successor, Felice Belle.

In addition to hosting the Friday night poetry competition, my other responsibilities include touring with poets and performing at different colleges and universities for various student groups. I can recall one event at the College of New Jersey where the flyer advertising our performance included our pictures and referred to us as "Nuyorican" poets. The promotional material struck me in its usage of "Nuyorican," since none of us were ethnically Puerto Rican, yet "Nuyorican" was collectively naming us as representatives of the Cafe. This flier and its deployment of "Nuyorican" seemed to contest much of what I had studied regarding the emergence of "Nuyorican" as an ethnic marker with a specific cultural and political history. That moment at the College of New Jersey has compelled me to interrogate whether or not "Nuyorican" has become a hollowed-out signifier contemporaneously accessible to anyone who has a relationship with the Nuyorican Poets Cafe. This question ultimately informs the interventions I make throughout this project while framing my engagement with this material and community as both professional and personal. My years of experience as a performer, a host, and an active community member allow me to move between autoethnography, performance analysis, and literary criticism to consult physical documents and texts as well as audiovisual footage as my archive.

Ultimately, the critical artistic genealogy I trace here as both practitioner and scholar also includes my own set of identifications as a queer of color, a first-generation, butch Dominican lesbian born in the United States. My subjectivity, like all subjectivities, includes a constant negotiation of space, place, and time. These temporal, geographic, and spatial dynamics in the United States and the world over mark and are marked by the racial, sexual, and historical dimensions of colony, capital, and empire. As Sara Ahmed asserts, there is both a "spatiality of sexual desire" and "the racialization of space," such that "spaces are like a second skin."[4] Ahmed aids me in reckoning with the ways the works of queer

artists Miguel Piñero, Regie Cabico, the Glam Slam participants, and Ellison Glenn as Black Cracker are impressed on by the Cafe while simultaneously impressing upon the space.[5] The relationship between the artists and their publics, the works created and performed at the Cafe, and the space's geographic location all serve as foundational to this study of the nuyorican aesthetic. Throughout this text, I argue that specific conjunctural deployments of recombination, positionality, gesturality, and orality comprise this nuyorican aesthetic as a queer and trans formation. What initially began as a question prompted by a flyer became a research project, and now a book as I join a debate that began in 1997 between Pedro Pietri and Bob Holman, the very year I first set foot inside the Cafe.

The debate between Pedro Pietri, a foundational figure of the Nuyorican movement and the Nuyorican Poets Cafe, and Bob Holman, a White performer, poetry activist, and former director of the poetry program at the Cafe, underscores the theorizations, the poetic formulations, the call-and-response interactions, and the histories and argumentation encoded in Nuyorican and nuyorican aesthetics. The Spanglish term "Nuyorican," initially a pejorative, is appropriated by Miguel Algarín and Miguel Piñero for their Nuyorican Poets Cafe, founded in 1973. Algarín and Piñero recodify "Nuyorican" as an ethnic and political marker for artists and people of Puerto Rican descent. I, in turn, use "nuyorican," with a lowercase *n*, to refer to an aesthetic practice rooted in broadening the specific ethnic marker "Nuyorican" to include queer, trans, and diasporic performance modalities.

My project intervenes in Pietri's and Holman's debate, but also operates in dialogue with recent texts focusing on the Nuyorican Poets Cafe. For example, Urayoán Noel's attention to conceptions of visibility and invisibility as they pertain to what he defines as an embodied counterpolitics, a mining of "the body as a site of political articulation while simultaneously testing its limits," proves especially useful when unpacking cultural productions created by artists inhabiting multiple identitarian categories.[6] His critical writing serves as a valuable entry point for my analyses of performed poetry and the negotiation between the written and performed verse. Significantly, as the first comprehensive history of Nuyorican poetry, Noel's *In Visible Movement* highlights the masculinist history of the Cafe and how, for example, "[Cafe co-founder] Algarín's

model of 'outlaw' activism privileges an 'agnostic (and invariably male) '*street poet*,'" which I challenge by highlighting the queerness—in terms of sexual desire, practice, and insurgent aesthetic practices—that emerges at the Cafe from its founding.[7] To be clear, Cafe co-founders Algarín and Piñero both had relationships, romantic and sexual, with men and women. Lesbians such as Stephanie Chapman, whose presence I document more fully in the conclusion, were also active participants in the early Cafe days. Although not historically framed as such, the Cafe since its inception functioned as a space for artistic *and* sexual exploration, experimentation, and the challenging of identitarian fixity. Further substantiating my claim about the male-dominated, heterosexist historiography assigned to the Cafe is Patricia Herrera's book on feminist performance at the Cafe. In *Nuyorican Feminist Performance*, Herrera describes an uppercase-N Nuyorican aesthetic that artists practice in creating art evidencing a social and political investment in the betterment of Puerto Rican, Latinx, and other underrepresented communities. Similar to my experience at the College of New Jersey and the contention between Pietri and Holman, Herrera shares an experience wherein Nuyorican founding poet Sandra María Esteves, in 2006, bestows the moniker "Nuyorican" as an honorific to be assumed by a group of women—mainly White women—during a post-performance workshop. Herrera discusses her discomfort with Esteves's use of the term in reference to both her and the White women present, none of whom are of Puerto Rican descent. As a New York native active in theater and performance, Herrera is familiar with the political and cultural history of the term. Yet despite her unease, she comes to understand that Esteves is referencing a performance modality that extends beyond ethnic and cultural belonging. She goes on to describe how, for Esteves, in this situation "Nuyorican" signals a feminist aesthetic practice.[8] In turn, Herrera's experience with Esteves provides the germinative material for her definition of an uppercase-N Nuyorican aesthetic as one that "puts into practice intersectional feminism" and enables her to engage with the omission of women from the dominant narrative of the Cafe's founding.[9] I draw from both Herrera's work and the Cafe's history to propose another nuyorican, lowercase-n aesthetic, one not contingent on ethnic affiliation or belonging, in order to challenge masculinist and heterosexist framings of the Cafe. Analogous to how Herrera "records

how women were erased and rendered silent in the historical narrative of the Nuyorican Poets Cafe," I seek to amplify the Cafe's foundational yet never specifically documented queerness—in terms of both sexualities and performance practices.[10] The nuyorican aesthetic operates as a queer artistic practice that facilitates my tracing of the Cafe's queer history. As a result, I demonstrate how this particular queer history is intertwined with the spatial politics that helped engender efferent racialized sexualities that play out in poetry, hip-hop theater, drag, camp theatrics, and audiovisual cultural productions. Specifically, in *The Queer Nuyorican* as a cultural study, I attend to queerness at the Cafe and textually mark the move from the performers and performances to a broader artistic diaspora vis-à-vis this newly theorized nuyorican aesthetic.

In order to situate my intervention and delineate the stakes of Pietri and Holman's contentious debate, I begin by defining the term "Nuyorican" itself. The ethnic marker "Nuyorican," rather than "New York Rican," can ultimately be attributed to a translocal moment shared by Algarín and Piñero while walking through the San Juan airport in Puerto Rico. In discussing this moment, Algarín describes how he and Piñero, as Puerto Ricans from New York speaking in English rather than Spanish, heard the then pejorative marker "new-yo-rican" as they walked past. This term highlights their complicated relationship to ethnic identity, language, and geography. Seen as not fully Puerto Rican, Algarín and Piñero were not accepted as US citizen subjects either, as evidenced by Algarín's receipt of a contract from William Morrow for an anthology to be entitled *Puerto Ricans in English*. Thus, as a way to contest the abject framing of Puerto Ricans in New York by those on the island, and to reappropriate their ethnic identity and particular migratory experience, Algarín proposes to Piñero that they use "newyorican" in their book title. Piñero rejects the term as "an intellectualism" that identifies them as "new," resulting in him and Algarín agreeing upon the phonetically spelled "nuyorican."[11]

Their shared experience in the airport prompts Piñero and Algarín to codify "Nuyorican" as a resistant political and literary identity that they later use to claim and name their performance space. They challenge the perceived lack of cultural capital and ethnic authenticity as it is used against them. Thus, their use of Spanglish operates as a political gesture signaling a refusal to write or perform in only one proper or official

language due to a lack of fluency and/or as a way to highlight linguistic and identitarian fluidity. This maneuvering between languages and their enmeshment as Spanglish function as "the ultimate space where the in-between of being neither Latin American nor North American is negotiated."[12] Spanglish, then, demonstrates the rich vernacular of Nuyoricans while simultaneously operating as a form of resistance, a strategy to debunk standards of proper language and writing. Code-switching, evidenced by Spanglish, defines the coinage and initial deployment of the ethnic marker "Nuyorican." For writers and performers of the mid-1970s such as Algarín and Piñero, using the term "Nuyorican" in their poems and plays and especially in their performance space signaled their outsider positions and insurgent politics. Significantly, "Nuyorican" also speaks to the vexed and intertwined relationship between a longtime colony, Puerto Rico, and a world superpower, the United States. "Nuyorican" serves as an ethnic marker, a political project, and the signifier for a performance space with a storied countercultural history.[13] The nuyorican aesthetic, in turn, defines an artistic practice originally rooted in resistance—to standards of proper English and Spanish; to what constitutes high art versus low art; and to the politics of authenticity as they pertain to ethnic identity and art works challenging racism, colonialism, and poverty while celebrating sensual embodiment, memory, and diasporic cultures.

In addition, Algarín's and Piñero's use of "Nuyorican" connects the Nuyorican Poets Cafe with Chicano, Black, Asian American, American Indian, and Third Worldist movements' efforts to uplift their peoples and connect to global anti-imperialist struggles via historically denigrated symbols and signifiers of (masculinist) strength, defiance, and resistance. Articulating these coalitional, rather than competitive, relationships, Pietri expounds on the interconnections between the Nuyorican and the Sacramento-based poetry and visual art collective the Royal Chicano Air Force (RCAF). The Nuyorican movement, an artistic movement that began in the late 1960s, focused on the economic, social, and political realities of Nuyoricans living in New York City through artistic and cultural productions. Specifically, Nuyorican movement artists created art that served as tools for "political resistance" and as examples of "physical and existential endurance," performing testimonies enunciating the need for survival amidst the subhuman living condi-

tions that Puerto Ricans withstood in the United States.[14] Similarly, the Royal Chicano Air Force also began in the late 1960s, but on the West rather than East Coast, and focused on Chicano/as rather than Nuyoricans. The RCAF produced "major works of art, poetry, prose, music and performance" based on the merging of "the hegemonic signs, symbols, and texts of two nations with particular but often fragmented knowledge of their indigenous ancestries."[15] In a 2004 interview, Pietri traces these artistic genealogies into their twenty-first-century popularity and significance by describing members of the Nuyorican movement and the RCAF as being in alliance with one another as "honorary members." He grounds their connection in their shared experiences of having their land and culture stolen from them through colonization and genocide, defining the resultant Nuyorican and Chicano art-making practices as each group's "cultural outlet," as the mechanism for challenging their abjection and erasure. Specifically, Pietri highlights the usage of Spanglish "not [as] an indication of an inferior mind," but as "an indication of an imagination that should be completely fertile."[16] Importantly, in using Spanglish, both the Nuyorican movement and the Royal Chicano Air Force challenged institutionalized art-making practices that excluded minoritarian artists who sought to reflect their ethnic and class-based identities while effecting long-lasting change through art.[17]

"Nuyorican," then—as a signifier for a movement, an ethnopolitical identity, and a Spanglish term—emerges in negotiation with empire rather than as an imperial imposition operating as a form of political mobilization that resisted institutionalization.[18] Moreover, "Nuyorican" also references a political and cultural genealogy rooted in the forced migration from Puerto Rico to New York for many Puerto Ricans due to the implementation of Operation Bootstrap, an ambitious project carried out by the United States in 1947 on the island of Puerto Rico. The operation was predicated on a three-step process: a shift from a one-crop sugar culture to a more industrialized society; the implementation of educational campaigns and the construction of birth control clinics for population control; and finally, a push for the emigration of surplus workers.[19] This push in neocolonial/imperial operations by the United States resulted in social and cultural changes on the island, prompting many Puerto Ricans to leave. Pietri, a self-proclaimed Operation Bootstrap casualty, was born in Ponce, Puerto Rico, in 1943 and moved with

his family to El Barrio, the East Harlem neighborhood also known as Spanish Harlem, in 1947.[20] Pietri roots his aesthetic and cultural politics within a lived historical experience of geographic and economic displacement, where "Nuyorican" reflects his experience as a minoritarian subject living away from his homeland in the ethnically marked and segregated neighborhood of East Harlem/El Barrio. Through Pietri, and alongside Cafe co-founders Algarín and Piñero, we also see the relationship between geography, migration, and identitarian markers as it pertains to Puerto Ricans born and/or living in New York City. Pietri's contention with Holman is grounded in his investment in the cultural history and legacy of Nuyorican identitarian politics.

Bob Holman's stance in this historic debate stems from his status as an "influential poet in the post-Beat history of New York City's Lower East Side."[21] Holman is responsible for the founding in 1977 of the NYC Poetry Calendar, which, until 1999, linked different poetry happenings, spotlighting the "poetry in rap music" and showcasing world poetry on US stages.[22] Specifically, as a poet, artist, and innovator, he has constantly looked to move beyond established disciplinary boundaries and definitions in order to create new avenues for self-expression. Grounding his interest in populist art-making practices in his experiences as someone born in Tennessee and raised in Kentucky, and who later attended Columbia University, Holman worked and continues to be affiliated with the St. Mark's Poetry Project and is the founder of the Bowery Poetry Club.[23] Also referred to as St. Mark's or the Poetry Project, this reading series began in 1966 as a successor to the coffeehouse literary gatherings organized in the Lower East Side during the early 1960s. These venues served as the sites for the emergence of different performance practices, such as the Umbra or Black Beat poets, alongside the Beats and the poets of the New York School. The Black Beat poets demonstrate an increasing politicization of art around issues of race and ethnicity, with a key example in LeRoi Jones, who leaves the Beat poets, founds the Black Arts movement, and takes on the name and identity of Amiri Baraka. Holman, as a poetry activist and participant in the downtown arts scene through his work at St. Mark's, ultimately applies for and is granted funding from the National Endowment for the Arts and New York State Council of the Arts. He uses this money to begin diversifying the Poetry Project so that it re-

flects this shift toward more racially and ethnically marked cultural work. He also begins looking for a venue to rent, eventually coming into contact with Miguel Algarín. The version of the Cafe that Holman encounters in the late 1980s is in dire need of repairs after the Cafe's 1982 closure and Miguel Piñero's death in 1988. After a year of devising a plan that would use the entirety of the space, dealing with city bureaucracy, and countless hours of sweat equity, the Nuyorican reopens. These circumstances of reopening the Cafe after being closed for approximately six years in the mid-1980s, alongside Holman's desire to push for poetry and art making for the people, all lead to the introduction of poetry slam to the Cafe.

Poetry as Competition

Started by Marc Kelly Smith at the Get Me High Lounge in Chicago in 1984, slam poetics and practices are first introduced to Cafe audiences by poet/performer Bob Holman in 1989. A poetry slam, or three-round poetry competition with five sets of randomly selected judges, opens the Cafe to a broader audience who travel to Loisaida/Lower East Side every Friday night in order to participate. The Nuyorican, initially the only poetry slam venue in New York City, has a storied literary history, the promise of luminaries who were known to stop by, and a tangible reward for the victorious poet; Paul Beatty, the first winner of the annual championship, had his poetry collection published and has gone on to become an accomplished novelist and Columbia University professor. The Nuyorican has become the "mecca of spoken word," a mecca that combines Holman's desire for a venue showcasing emerging and experimental artists and Algarín's constant push to establish a homespace for racialized oral tradition and expression in New York City. Algarín traces a historical lineage from contemporary poetry slam to griots in the introduction to *Aloud*, the anthology he co-edits with Holman. Algarín presents a mandate to poets at the Cafe by stating that the work created must say and *do* something. It is through the influence of both Algarín and Holman that spoken word and poetry slam at the Cafe transition from local populist performance genres to more stylized, hip-hop–driven global entities that open up a space for pointed political critiques operating as alternative historiographies.

This transition from the local to the global informs Holman's assertion that all poets and artists who perform at the Cafe are Nuyorican. He makes this declaration over twenty years after the term is first used, following the release of Paul Devlin's film *SlamNation: The Sport of Spoken Word*, documenting the 1996 National Poetry Slam competition in Portland, Oregon.[24] Devlin's documentary focuses on the 1996 Nuyorican Grand Slam Team, comprised of Saul Williams, Jessica Care Moore, Craig "muMs" Grant, and Beau Sia, all poets of color whose works engage the politics of their marginalized racial/ethnic, gendered, and class-based subject positions in the United States. Devlin's film begins with footage of the 1996 Grand Slam Finale at the Cafe, and subsequently introduces the Cafe and its audiences to a wider audience. This emphasis on poetry slam at the Cafe, with its inherent competitive aspect, meets with resistance from older Nuyorican poets such as Pietri, who label it a "disgrace."[25] For Pietri, a founding poet of the Nuyorican Poets Cafe, his connection to the space begins in the informal gatherings in Algarín's living room on East 6th Street, where the poems read are described as "first draft poems."[26] The term refers to the initial draft of a poem, often written on a napkin or a sheet of notepaper during a reading, that is performed immediately thereafter without editing. Occurring during the "decline of the Beat Generation," when poetry is shifting back to colleges and universities, this organic creative process becomes a means through which "street poets" can reclaim poetry.[27] The immediacy of their writing and subsequent performance provides these poets and writers with a built-in audience. In turn, Algarín's living room as the meeting place for these writers to come together and share their first draft poems, devoid of competition, serves as the original Nuyorican Poets Cafe. Poetry and self-expression, regardless of spectator response, function as the motivations for this gathering of writers who, as explained by Pietri, often lack an audience. These "street poets" take back poetry as a vernacular cultural production, moving it away from institutionalized spaces in order to express the realities of their lived experiences. The writings and performances Pietri describes are not about heavily workshopped poems to be performed; present-day first draft poems rarely, if ever, prove successful as slam poems. So Holman, as the slammaster or host, and as the person responsible for introducing the genre to the Cafe, symbolizes a shift from the recitation of poetry and the creation of art whose merit is

not up for evaluation through scorecards to the performance of verse as sport and, later, capitalist consumption.

The move from the raw, "first draft poems" to the more rehearsed and commercialized poetry slam competitions facilitates Holman's assertion about claims to Nuyorican identitarian politics. Specifically, his declaration that everyone is Nuyorican seems to assert that Nuyorican politics and poetics are accessible to all who perform at the Cafe. Yet his claim is that "we are all Nuyorican," rather than "we are all Nuyoricans," separating the specificity of the ethnic marker "Nuyorican" from the shorthand "Nuyorican" often deployed in reference to both the Cafe and the artists performing there. Pietri's resistance to Holman's statement demonstrates his investment in contesting the erasure of Nuyorican ethnic identity and the cultural nationalism and localism inherent in the Cafe's founding in the 1970s.

From Nuyorican to Nuyo

Importantly, this debate between Holman and Pietri in the late 1990s marks a transitional moment in the Cafe's history, when slam poetics increasingly defined the space in a rapidly gentrifying neighborhood. Gentrification, "the threat of the disappearance of affordable housing and the displacement of working-class residents," impacts the surrounding neighborhood around the Cafe from the 1970s onward.[28] Specifically, the mid- to late 1970s mark a shift from the industrialized urban center to its relocation outside the city, leaving many of the residents of the Lower East Side unemployed. This move, alongside deliberate strategies by the city and private investors to keep many of the residents below the poverty line, leads to many landlords neglecting to maintain their buildings as the tenants had little money to spend on rent. In turn, the city pulls funding from the area, opting not to invest money in public schools or firehouses. The ultimate goal of this divestment is the city's reclamation of buildings once they become uninhabitable, thereby forcing tenants to vacate in order to bulldoze the neighborhood and rebuild it from scratch. The Lower East Side's location between two recently gentrified neighborhoods of the time, Greenwich Village and SoHo, and its proximity to Wall Street, "the new economic center of New York City," serve as the primary reasons for this push to replace existing tenants

with monied transplants and new high-end businesses.[29] Gentrification becomes imminent as abandoned buildings dominate the neighborhood and two-thirds of its residents, most of them Puerto Rican, begin leaving. This divestment by the city of New York in Lower East Side real estate leads to the Nuyorican Poets Cafe's initial state of disrepair in the early 1980s as described by Holman.

Situated on East 3rd Street between Avenues B and C, the Cafe functions as a vital component of Loisaida, a neighborhood with a storied history of community activism. I use the term "Loisaida" in addition to "Lower East Side" throughout this text to refer to the specific ethnic enclave surrounding the Cafe. Neighborhood resident, artist, and community activist Bittman John "Bimbo" Rivas coined the term "Loisaida" in the mid-1970s. It functions as the Spanglish version of "Lower East Side" by the neighborhood's then predominantly Puerto Rican Spanish-speaking residents. Rivas holds a special significance in Nuyorican history and the Lower East Side for his work with CHARAS/El Bohio Cultural and Community Center, one of the original organizing spaces in the community.[30] Rivas's 1974 love poem "Loisaida" best expresses his relationship with the area. Written in Spanglish, this poem artistically redefines Loisaida as an appealing and desirable place to live, despite the crime and drug trafficking:

> Increíble
> una mezcla, la perfecta
> una gente bien decente
> de to 'as rasas
> que estiman
> que te adoran
> que no saben explicar
> lo que le pasa
> cuando ausente de
> tus calles peligrosas
> si te aman
> A ti, mi hermosa Loisaida
> O what a town.....
> even with your drug-infested
> pocket parks, playgrounds

where our young bloods
hang around
waiting, hoping that
one day when they too
get well and smile again
your love is all
they need to come around.
Loisaida, I love you.
Your buildings are
burning up
that we got to stop.
Loisaida, my love,
Te amo.[31]

In this poem, Rivas configures the community as one comprised of a beloved racial and ethnic mix of people surviving in spite of the economic deprivation experienced throughout the neighborhood. Rivas's love poem can also be read as a call to action for everyone in Loisaida to fight for the preservation of their community. The term "Loisaida" has multiple functions and literary applications, as evidenced by Bimbo's renaming of his play from *Don Quixote of the Lower East Side* to *Don Quixote de Loisaida*, co-written with fellow poet and CHARAS founder Carlos "Chino" Garcia. The story of *Don Quixote*, written by the Spaniard Miguel de Cervantes, represents the Spanish-language touchstone of classic European literature. In situating *Don Quixote* in Loisaida, Rivas infuses this seemingly hopeless neighborhood with the unbridled idealism of the titular character, simultaneously reconfiguring the area as another possible space for the creation of utopic art. Thus, in naming the area Loisaida, Rivas performs a restorative gesture that simultaneously functions as a part of what social space theorist Edward Soja terms complex "mental spaces." Soja explains that "the generative source for a materialist interpretation of spatiality" is the understanding that space is socially produced and, like society itself, space exists on three levels: physical, mental, and cognitive.[32] Loisaida, then, operates as the proper name of a physical space, one with an ethnic neighborhood with community gardens and parks; a mental space, as part of the Nuyorican imaginary; and a cognitive space, one in which people enact daily life

by embodying a bilingual and bicultural existence. Soja's theorization of mental space helps to situate the Nuyorican Poets Cafe within a complex framework of recuperative linguistic and aesthetic practices, alongside its physical relationship to Lower East Side residents and New York City artists.

Thus, much of the Nuyorican's currency is derived from the enclave surrounding it. As Edrik López explains, "Nuyorican writing has been concerned with migration, language, and urban depravity" as "spatial constructions" that "constitute the critical sites of contention in Nuyorican poetry" because they construct their "surrounding space not as the setting of where the events of their poetry occur, but as the reason Nuyorican poetry happens."[33] López's analysis of the dynamic between the Cafe and its geographic position confirms that the changing economic and racial landscape of Loisaida, alongside the introduction of poetry slam, prompts the emergence of the nuyorican aesthetic. Similar to a critical engagement with blackness as diasporic, the nuyorican aesthetic queers fixed definitions of Nuyorican identity by recognizing and including queer poets and performers of color whose writing and performance build upon the politics inherent in the Cafe's founding, extending them within the Loisaida's changing demographics. Subsequently, the neighborhood's shift from a predominantly immigrant/racial minoritarian working-class space to a gentrified White middle-class neighborhood results in a queering of the term "Nuyorican." This shift is made evident through the resultant aesthetic practices that emerge and flourish at the Cafe, and it is this queering of "Nuyorican" that undergirds the nuyorican aesthetic. Because of its international reach, I envision this nuyorican aesthetic as glocal, circulating beyond its initial formation at the Cafe, in Loisaida and in New York City, and traveling with these writer-performers to critique and imagine new political and literary land/soundscapes across the United States and Europe. Throughout *The Queer Nuyorican* my critical engagement is with queerness as emblematized by the queer performers whose work I analyze, the Nuyorican Poets Cafe, and aesthetics and racialized sexualities as they are initially enacted on that stage in Loisaida. My focus is on a specific location and the interplay between a locally rooted community and an aesthetic of poetics and performance—highlighted by spoken word—that became international. Just as there is a distinction between the Lower

East Side and Loisaida, there is a difference between identifying someone as "Nuyorican," someone of any ethnicity affiliated with the Cafe, and calling them "*a* Nuyorican," signaling an emerging global artistic aesthetic and politic.

Further evidence of the aesthetic shifts occurring at the Cafe includes Holman's departure as the director of the poetry slam program in 1997, the same year he articulates his Nuyorican claim. Holman's departure results in Keith Roach replacing him as host. Unlike Holman, Roach relies on Black aesthetic traditions, less predicated on slam culture and showmanship and more rooted in musical idioms such as soul and jazz. Where Holman is theatrical in his delivery, Roach is more subdued, walking around the stage with his head down, his face partially covered by his ever-present baseball cap and round wire-rimmed glasses. He sports a goatee as he introduces poets in his trademark deep gravelly voice, a lit cigarette dangling from his lips. Roach's style is one of jazz riffs, a way of hosting that harkens back to the origins of the Cafe, but through slam rather than the initial noncompetitive readings.[34] Importantly, Roach replaces Holman on the heels of the 1996 slam team's appearance in *SlamNation*, and his tenure cements the shift from Holman's more universalist gesture to a specifically US Black, heteronormative hip-hop aesthetic, initially made visible through 1996 Grand Slam Team member Saul Williams. In analyzing the connection between slam poetry, spoken word, and other current vernacular cultural productions, Williams proves significant as "the crossroads figure who officially hybridizes hip-hop and spoken word, unequivocally representing both with or without a beat."[35] This shift toward a more hip-hop-driven performance style also results in the shorthand for the cafe—Nuyorican—becoming further shortened to "Nuyo." This textual and oral shift removes the "Rican," highlighting the emergence of neo-soul or new soul—a subgenre of hip-hop marketed as a "conscious," often heterosexist version of contemporary R&B that includes spoken word, honing in on "instrumentation and narrative construction."[36] The aesthetics of neo-soul closely mirror the tropes that come to be widely associated with slam poetry and spoken word in general, post-1996.[37]

This is the scene I first encountered in 1997. The shifts in politics and poetics, moving away from the somewhat organic and home-based gatherings of young and old predominantly working-class Puerto

Ricans to more slickly professional, commercialized performance events by and for more middle-class audiences, proved challenging for me. While I enjoyed watching and sometimes participating in poetry slams, I had, and continue to have, issues with the aesthetic tropes and class- and race-based stereotypes that poets perform at the Cafe to wow the crowd. Like Algarín before me, I firmly believe that the performed verse should *do* something, should work to effect change, enunciate hopes and desires, and decry social and economic deprivation. Poetry slam as a globalized performance genre serves as a useful medium to articulate the realities, politics, and existence of minoritarian subjects that are often ignored and rendered invisible by hegemonic culture. However, in establishing its own hegemony and cultural currency, slam poetics often reify notions of authenticity and appropriate the pose and rage of urban, working-class people of color without their presence on stage or within the Cafe's audience. I side with Pietri in that not everyone can be a Nuyorican—there is a political history and a cultural legacy in being a Puerto Rican born and/or raised in New York City. The Nuyorican Poets Cafe and the surrounding Loisaida can be drawn from, but not appropriated, nor fully subsumed into narratives foreign and hostile to the raced inhabitants of the Lower East Side. Holman's claim, however, is not without merit, as there are poets who ethically and respectfully invoke the Cafe's history and initial aesthetic practices to increase the visibility and circulation of queer life narratives and representational strategies. It is this redeployment of the Cafe's history, initial aesthetic, and performance of ever-present queerness that I term the nuyorican aesthetic, not as an appropriated ethnic marker, but as a capacious aesthetic practice.

Thus, the poets and performers whose work I center both acknowledge and deviate from the Nuyorican Poets Cafe's lineage and genealogy. Moving between honoring the history of the Cafe and recognizing the politics evidenced in the recodification of the identitarian marker "Nuyorican," these artists create works that extend beyond the Cafe and its initial focus. They recombine tropes associated with US gay, lesbian, and trans cultures and the insurgent histories of Black, Caribbean, and Asian/Filipino communities with punk, hip-hop, drag, and ball techniques to intentionally highlight their charged differences. They deploy remixing, hip-hop flows and cadences, poetry slam and ball awarding

systems, gay camp, drag, and queer and trans vernaculars to highlight the dialectical relationship between communities and art practices. This deployment results in the displacement of dominant figures and identity formations of the Cafe's poetry scene—Nuyoricans, urban New Yorkers, heterosexuals, and (cis) men—who are read by these trans people, butches, drag artists, non-New Yorkers/Nuyoricans, and femme gay men.

In theorizing the nuyorican aesthetic, I also focus on the connection between gesturality and orality. As Juana María Rodríguez states, "Gestures emphasize the mobile spaces of interpretation between actions and meanings."[38] I focus on the significance of those mobile spaces, interrogating the relationship between corporeal and oral articulation, between what is said and *how* it is said. I take on plays, poems, television appearances, oral interviews, music videos, poster art, social media postings, and publications in an effort to generate a theory of the performative/enunciative acts that serve as central and crucial to the artists comprising this book and the creation of the nuyorican aesthetic. My theorization of these artists' expressions across mediums and geographies offers an initial look at the critical embodiments of trans and queer identities/communities, raced and sexed gestures, and corporeal and oral performances of this aesthetic. The explosive outpouring of spoken word and poetry slams at the Nuyorican Poets Cafe remains a forthright expression of queer of color politics and communities in the urban United States. Specifically, I attend to how the aesthetics formulated in this packed dark space operate as foundational to poetic-political, literary, and performative matrices of the late twentieth and early twenty-first centuries. I posit this shift as both racial *and* sexual, a rekeying of identitarian racial poetic politics with queerness central to the narrative of the Nuyorican, and with the transformative power of spoken word and cultural/community centers serving as a collective ethical base.

Proposing "nuyorican" as a signifier that queers "Nuyorican" in turn centers artists who are not necessarily ethnically Puerto Rican, but whose performance practices are simultaneously influenced by, and are critical of, the countercultural discourse inherent in the founding and continuance of the Nuyorican Poets Cafe. I choose to emphasize aesthetics in the title of my monograph as a way to forthrightly index the work of artists who all began their careers at the Nuyorican Poets Cafe

as performance poets, but whose work now extends beyond poetry to include music, theater, video, and drag, highlighting how the politics of their work parallel those exhibited in the recodification of the term "Nuyorican" from pejorative to empowering. This work—both this book and these artists' multifarious products—challenges the prevailing narrative defining the Nuyorican Poets Cafe and its history as ethnically Puerto Rican, sexually straight, and authoritatively (cis) male. I document the interventions made by queer and trans artists of color, demonstrating the ways the Nuyorican Poets Cafe has operated as a queer space since its founding, both in terms of sex acts and performance practices. While existing histories of the Cafe focus primarily on the writers and the space within a nationalist, heterosexist framework, I highlight the queer work of artists including Miguel Piñero, Regie Cabico, the Glam Slam performers, and Ellison Glenn as Black Cracker. I propose this redeployment of the archive as recuperative of the Cafe's elided histories and negated futurities. I push for a reexamination of the space as discussed in preexisting scholarship that documents the history of the Cafe, and Nuyorican writers/poets specifically, as part of a literary canon.[39] Specifically, my intervention lies in reading the writer-*performers* who formulated a nuyorican aesthetic, a queer/trans of color poetic that, while situated within the Cafe's physical space and countercultural discursive history, exceeds these gendered, geographic, and ethnic boundaries. I document queers and queerness at the Cafe, making visible queer sexuality, sexual identities, and performative strategies present—if occluded—at the Nuyorican Poets Cafe since its inception.[40]

In chapter 1, "Walking Poetry in Loisaida," I juxtapose the relationship between Miguel Piñero's writing, performance, and sexuality with the contemporary changes to Loisaida's demography and culture. Here, I trace the ways Piñero's streetwise and urban rhythmic poetries function as queer critical tools challenging the heterosexist fixity of ethnic, racial, and sexual identities. I suggest that Piñero's 1970s strut was a queer poetic stroll through the neighborhood of Loisaida and the term "Nuyorican." Honing in on the title of Piñero's chapbook, *Miguelito Piñero's Random Thoughts and Walking Poetry*, I investigate the ways Piñero's queer, free swagger functions as a performance that marks and claims racial-sexual space as he takes ownership of his geographic surroundings through thinking, naming, and calling out as he walks. In

particular, Piñero's cruising through Loisaida in his "Lower East Side Poem" becomes a last will and testament in verse, using Michel de Certeau's theoretical framework.[41] Piñero's chapbook highlights the mobility and fluidity of aesthetics, linguistic practices, and identity politics at the Cafe while remaining geographically rooted in this environ. Thus, this chapter historically situates the space and the queer art-making and sex practices that have existed at the Cafe since its founding. Piñero employs a distinct methodology that continues to leave its imprint and fuel contemporary poets and performers at the Cafe. I focus on the 1970s as a time of economic recession and political repression nationwide, highlighting how Piñero helped to create a site within the Nuyorican for collective celebration and rage. As Ramón Rivera-Servera asserts, it is during this time of increasing visibility for Latina/o people within the "mainstream commercial and political venues" and when "Latina/o public space(s)" are being "threatened by the redevelopment of urban centers and a revived anti-immigrant campaign" that queer Latina/os use performance as a way to claim space and articulate "ways of being that allowed their queerness and latinidad to exist."[42] In turn, the lyrical praise and political anger fomented in 1970s Loisaida give way to rapidly increasing gentrification in the 1980s. This gentrification and city divestment significantly impact the Cafe, as it remains closed and in dire need of repairs from the early to late 1980s. When it reopens in 1988, the neighborhood changes result in the sardonic and camp critiques of 1990s slam poetries at the Cafe that hone in on economic redevelopment, increasing rents, and the influx of young monied, mainly White transplants who push out Puerto Ricans and other working-class and immigrant people.

I conclude the first chapter by returning to Piñero's queer walk and poetics. Piñero's queerness, like his street walking and random thinking, has been placed outside the Cafe's storied and now canonical history. Movement between temporalities, through geographies and different forms of writing, serves as my methodology throughout this chapter. I agree with Renato Rosaldo's contention regarding the non-linearity of narrative and also believe that "restrict[ing] narrative to linear chronology" evidences both a misunderstanding of preexisting histories and an underestimation of the potentialities of different ways of relaying information. In other words, all narratives inherently meander as they shift

from one perspective to the next, often providing an overview before returning to share what was occurring elsewhere in the meantime.[43] Thus, my critical approach is to meander, and I both follow in and diverge from Piñero's tracks through the Cafe's move from a space codified as ethnically Puerto Rican, politically nationalist, and presumptively heterosexual to one emphasizing polyracial identities, multivarious gender projects/sex practices, and diasporic art politics.

In chapter 2, "This Is the Remix: Regie Cabico's *Filipino Shuffle*," I focus on Regie Cabico's queer Filipino reimagining of the mini-series *The Thorn Birds* and of the films *Hollywood Shuffle* and *Monster's Ball*. I explore how he utilizes humor, in the form of parody and camp, alongside the hip-hop practices of sampling and remixing to articulate a nuyorican aesthetic. I unpack the politics behind Cabico's usage of hip-hop aesthetic practices through a critical reading of performer and hip-hop theater pioneer Danny Hoch's and theorist Tricia Rose's writings. Hoch's framing of hip-hop theater aesthetics is vital to my exploration of what is at stake in Cabico's sampling and remixing of an Australian romance novel-cum-US television miniseries, as well as an independent American film that focuses on satiric and dramatic renditions of Black stereotypes and pathologies. Throughout *Filipino Shuffle*, Cabico develops a nuyorican aesthetic that can contain his queer Filipino narrative and vitality. Unlike mainstream theatrical productions that are sampled and remixed in order to appeal to middle-class audiences, Cabico's situating of his show within the rubric of hip-hop theater functions as a form of what Rose defines as versioning, a mixture of both the old and the new within a fresh context.[44]

Cabico's creation of hip-hop theater proves significant because, as a Filipino based on the East Coast, he operates outside what US theater has positioned as solely an African American cultural practice. Thus, through my analysis of Cabico's work I also build on playwright and scholar Jorge Ignacio Cortiñas's critique of this racial monologic while also attending to how Cabico's articulation of homosexuality challenges expressed homophobia in mainstream hip-hop productions and audiences. Through *Filipino Shuffle*, Cabico theatrically and comically expresses his queer ethnicity, raced sexuality, and determined resistance to his ethnically marked and objectified sexual fetishization. Cabico articulates his ethnic identity vis-à-vis the colonial relationship shared by

the Philippines and Puerto Rico to the United States since the Spanish-American War of 1898, as presented in the work of sociologist Julian Go. In addition, through Martin F. Manalansan IV's conceptions of quotidian queer Filipino life, I attend to how Cabico expresses his sexuality through his critical engagement with the role of religion (Catholicism) in his life and throughout his performance works by resisting the stereotype of the emasculated, passive Asian male. Similar to Cabico, I cut, mix, and sample Brown artistic and theoretical shade on the Afrocentric rendition of hip-hop history and theater, sociological readings of colonialism, materialist analyses of Roman Catholicism within queer Filipino everyday life, and readings of humor and race in order to arrive at the chapter's end.

Chapter 3, "Tens across the Board: The Glam Slam at the Nuyorican Poets Cafe," focuses on the verbal and oral articulations of the participants in the Glam Slam at the Nuyorican Poets Cafe from 1998 to 2008. As a queer happening, this event brought together the competitive spoken word/slam poetry and ball culture communities, resulting in a new framework for the proclamation of queer poetics at the Cafe. During the Glam Slam—and similar to the competitive balls of New York's Black and caribeño queer, drag, and trans communities documented in Jennie Livingston's *Paris Is Burning*—poets walked the runway and, instead of voguing against one another, performed poetry in categories including "Best Love Poem in Fire Engine Red" and "Best Wig-a-Poem," among others. In bringing together these two communities, competitors queered the Nuyorican in terms of the proclaimed sexualities of the performers and audiences, as well as the types of performances that occurred at the Cafe. I attend to the heightened glamour and fabulous nature of the Glam Slam through Madison Moore's interpretation of Pierre Bourdieu's accumulation of symbolic capital. I then critically examine the interplay between realness in balls and the performance of verbal authenticity in poetry slams through the work of Judith Butler and Susan B. A. Somers-Willett. The title of this chapter refers to the maximum score possible in each category for competitors in both poetry slams and balls—tens across the board. Autoethnographic in scope, the chapter details my own performances in the Glam Slam, as competitor and eventual winner in 2002, within E. Patrick Johnson's framework.[45] Both my personal experiences and critical analysis demonstrate how the

poetic and corporeal expressions during the Glam Slam made visible socially, politically, and economically marginalized communities of color in New York City, populations that have always been at the forefront of the Cafe's aesthetic, if never before in such resolutely queer terms.

In chapter 4, "Black Cracker's 'Chasing Rainbows': Hip-Hop Minstrelsy, Queer Futurity, and Trans Multiplicity," I focus on the work of Ellison Glenn, a contemporary transgender spoken word performance artist and musician. Through his performance persona Black Cracker, Glenn appropriates a historically pejorative term and recodifies it, ultimately forging a critique of the current political, social, and economic conditions of African Americans in the United States through both poetry and music. I parallel Glenn's recodification of the racialized epithet "cracker" with that of Algarín and Piñero's redefinition of "Nuyorican." I situate the work of Glenn as Black Cracker within a historical framework, rooted in a particular African diasporic history and experience. Cracker enables Glenn to place issues of gender and sexuality alongside those of race and class in his performances, articulating his intersectional identity through poems, raps, songs, videos, and live performances. Significantly, Glenn initially uses the persona of Black Cracker as a form of colonial mimicry and biting satire, shockingly combining queer hip-hop and minstrelsy.[46] Although Glenn maintains Black Cracker as his performative persona, the shock and comedy have been reduced as he moves toward building a lyrical and visual trans-Afrofuturism.

Glenn's early articulation of Black Cracker and his deliberate use of toxic imagery and iconography forge a powerful social and political critique vis-à-vis Eric Lott's theory of the racial economy encoded in blackface performance. I chart the development of Glenn's reappropriation of the minstrel, his critique of hip-hop masculinity, and his queer performative intervention by documenting his early days in poetry slam. His success as a competitive poet, despite his (queer and trans) gender identity, challenges Jack Halberstam's assertion that poetry slams "can easily degenerate into a macho contest of speed and fury."[47] Although Glenn enjoyed success as a competitive poet, he creates Black Cracker as a means to move his work beyond spoken word and enter social and political economies of the recording industry as a producer, composer, and musical performer. I read Glenn's move from a localized understanding of US racial constructions, the Black/White binary evidenced

in the name "Black Cracker," through Diana Taylor's theorizations on the cultural specificity of performance. I conclude this chapter by examining critical interventions made by Alondra Nelson and L. H. Stallings to approach Black Cracker's poster/publicity art and music videos, wherein he imagines and performs a multiplicity of trans and queer racial identities.

In my conclusion, "The Open Room," I analyze the gathering that initially served as the Cafe's open mic but now follows the Friday Night Poetry Slam. Unlike the poetry slam competition held earlier in the evening, the Open Room provides a space for the sharing of work. There are no scores given, just applause if the small audience that stays behind at the end of a long Friday night deems the poet and poem worthy. People who feel too nervous, scared, or apprehensive about slamming tend to workshop their writing during the Open Room. This event connects the organic "first draft" poetic gatherings of the 1970s with contemporary audiences. Algarín describes the Open Room as "the basis for the open, generous, embracing attitude that is in fact the aesthetic of the Cafe" and frames "its continuity through all the years" as the Nuyorican Poets Cafe's "root."[48] This "Open Room" provides an opportunity for further discussion of the nuyorican aesthetic and how contemporary modes of performance reflect the history of the Cafe. Ultimately, "The Open Room" acts as a literary and performative undercommons. While slam cultures operate as heatedly (if not always financially) competitive, the practice of scoring and the language of champion, winner, and demarcation of first place within spoken word cultures signal slam's hierarchies and scales of achievement. The Open Room disrupts and dissolves that competitive tension, allowing for a different palaver and performative dimension.

This performative dimension and my desire to make visible queerness at the Cafe fueled both my writing and research for this book. As a queer butch and, thus far, the only lesbian Latina to host the Friday Night Poetry Slam, I found an artistic home at the Nuyorican Poets Cafe. It was at the Cafe where I was able to engage with past and present critical interlocutors through verse and performance. Thus, my work situates the Cafe alongside the critical interventions of Piñero, Cabico, the Glam Slam participants, and Ellison Glenn as Black Cracker in order to signal the aesthetic possibilities of countercultural productions within and

beyond geographic, raced-ethnic specificities. Interestingly, only some of the Glam Slammers remain in New York City, committed to verse and public lyric expression, while the nuyorican aesthetic continues to meander, strut, shuffle, and dance between and across literal and figurative temporalities, geographies, and performance genres. This is a journey I hope you'll take with me. So, as I used to say as the Friday Night Poetry Slam host, "Welcome to the Nuyorican!"[49]

1

Walking Poetry in Loisaida

In 2004, a year after beginning my tenure as host of the Friday Night Poetry Slam at the Nuyorican, Julio Dalmau gifts me with a small chapbook. He is the older man at the Cafe door who collected my five dollars and granted me entrance to the Cafe in 1997. The chapbook, printed in 1985 by the Nuyorican Poets Cafe on shiny paper in a combination of pink and blue ink, is a slender compilation by Cafe co-founder Miguel Piñero highlighting his relationship with the Lower East Side neighborhood of New York City, both in title—*Miguelito Piñero's Random Thoughts and Walking Poetry*—and with the accompanying cover art.

The pole perpendicular to the ground on the cover bears the "Avenue B" sign mounted above a traffic light, geographically marking Piñero's work as occurring within the Lower East Side. This pole and streetlight also frame Piñero's smiling face, while the hanging shoes and shadowed figure with the hat in midair above their head stand in for the urban grit, cultural habits, and racial demography of the area. In this image, the masculine figure shoots a gun with one hand while holding another gun in the opposite hand. The sneakers dangling from the streetlight are totemic, a potential marker of gang claim, a memorialization of a lost community member, or possibly a sign of drug availability.[1] This cover illustration situates Piñero's poetry as both of and on the Lower East Side. Piñero's laughing expression works in contradistinction to the faceless, armed silhouetted figure, capturing joy and laughter within racialized urban masculinity. Published three years prior to his death, when the Nuyorican Poets Cafe was closed and in dire need of repairs, the chapbook includes excerpts from Piñero's journal in the early 1980s, photocopies of newspaper articles describing his arrest for selling drugs in 1982 on the Lower East Side, and writings detailing Piñero's complicated relationship with alcohol and drugs, culture and poverty, desire and imprisonment. The collage of poems and reportage places the chapbook within the lineage of downtown experimentalism begun

Figure 1.1. Front cover of *Miguelito Piñero's Random Thoughts and Walking Poetry* chapbook.

by Beat poets in the West Village in the 1950s. However, the images and content root the work in the Lower East Side during the early to mid-1980s, which is central to my queer analytic of Piñero's writing, performative presence, and sexuality as subjugated knowledge and initiation of the nuyorican aesthetic. Specifically, I explore how the nuyorican aes-

thetic speaks to the dialogic relationship between the performances at the Cafe—from the initial open mics, music "concerts," and dramatic plays to the introduction of poetry slams/competitions—and the changing political and geographic landscape outside it.

In writing about the relationship between geography, art making, queerness, and Nuyorican identity, Lawrence La Fountain-Stokes analyzes the construction of Nuyorico. According to La Fountain-Stokes, Nuyorico functions as "a concept that riffs off the tradition of Nuyorican cultural resistance that has been a hallmark of diasporic Puerto Rican life since the late 1960s but also points toward a more recent cultural development."[2] La Fountain-Stokes defines Nuyorico through the cultural work of dancer Arthur Avilés and comedian/performer Elizabeth "Macha" Marrero, as a space that reimagines the abjection levied at the economically impoverished, ethnically and racially marked South Bronx as a "Northern metropolitan ghetto."[3] Nuyorico redefines this neighborhood as the epicenter of the Puerto Rican diaspora due to the cultural productions created there, the progressive politics practiced, and the heightened queer visibility. Similar to La Fountain-Stokes's critical analysis of Nuyorico, I interrogate the nuyorican aesthetic as a queer practice that emerges in an ethnically marked space, the Nuyorican Poets Cafe in the Lower East Side of New York City, a venue operating as the homespace of a queer artistic—rather than ethnic—diaspora. As an antecedent to Avilés's and Marrero's Nuyorico, Piñero's recodification and "resignifi[cation] of the negative valence" associated with Loisaida and the term "Nuyorican" itself also signal the germinative material for the development of the nuyorican aesthetic.[4]

Cafe co-founder Miguel Algarín's original "Nuyorican Esthetic," characterized by bilingualism as a means of expressing a Nuyorican identity and relaying the lived experience of the street, proves useful for my analysis. Algarín's esthetic is comprised of three essential components. The first element is "the expression of the self orally and the domination of either language or both languages together to a degree that makes it possible for you to be accurate about your present condition."[5] This operates as a direct challenge to critics who seek to disregard the validity of bilingual oral narratives and the literary value of Spanglish and bilingual poetry. Algarín expresses a call to action regarding the establishment of physical spaces "where people can express themselves" and in doing so

find and publicly create transformative art in order to effect change.⁶ I draw from and extend Algarín's Nuyorican Esthetic in terms of my own nuyorican aesthetic to examine through a contemporary lens Piñero's work from the 1970s until his death in 1988. In particular, a more current framing enables me to consider Piñero's migratory history from Puerto Rico to the United States, his artistic trajectory alongside Algarín, his queerness, and how performances of his poetic texts gesture toward the affective style later associated with poetry slam competitions at the Nuyorican Poets Cafe. In his writing, Piñero celebrates an abject—and now erased—version of the Lower East Side: a vibrant neighborhood full of poor and working ethnic people, illicit economies and activities, and local and international liberatory politics. As part and parcel of neoliberal financialization and turbulent demographic displacement in the area, slam poetry becomes the medium of commercialization, repositioning the Cafe in relationship to its now gentrified surrounding neighborhood.⁷

Geographer Neil Smith interrogates the politics of gentrification in the Lower East Side/Loisaida beginning in the 1960s and 1970s as part of the construction of an "urban frontier" defined by the real estate industry and the culture industry.⁸ The "new urban frontier," according to Smith, operates as "a political geographical strategy of economic reconquest," similar to Western expansionism, which positions ethnically marked and economically challenged neighborhoods like Loisaida as primed for gentrification by the "collective owners of capital."⁹ The real estate industry works to rename the neighborhoods to make them more palatable to consumers, so the Lower East Side/Loisaida and Alphabet City are renamed the East Village, while the culture industry works to reconfigure urban decay as attractive, functioning alongside gentrification to convert Loisaida from an abject neighborhood to a "landscape of glamour and chic spiced with just a hint of danger."¹⁰ Smith's intervention influences my designation of the Cafe's increasing visibility, and the performances happening there following the success of poetry slam, as part of this culture industry.¹¹ Poetry slam makes visible the tension between the initial impetus for founding the Cafe—providing a space for marginalized voices to articulate their sociopolitical realities and affirm their ethno-racial identities—and the realization of a venue that includes artists and performers who embody the relationship between gentrifica-

tion and the culture industry.[12] In her memoir on the AIDS years, Sarah Schulman writes alongside Smith to track the changing demography of Manhattan and index the relationship between the AIDS crisis and gentrification from 1981 to 1996. In focusing on the East Village, she describes the cultural shift from Latina/o and Eastern European immigrants, "noninstitutionalized artists, gay men, and other sexually adventurous and socially marginalized refugees from uncomprehending backgrounds living on economic margins (in an economy where that was possible)," to new tenants who "were much more identified with the social structures necessary to afford newly inflated mortgages and rent."[13] Piñero, as a long-standing Lower East Side resident and artist, uses his work to call out and resist the commodification and gentrification affecting the neighborhood.

Although Piñero claimed Loisaida as his home, he was in fact born in Gurabo, Puerto Rico, on December 19, 1946, and only moved to New York City's Lower East Side in 1950. Because of his family's poverty, he starts stealing food for his expectant mother at age eleven, whereupon he is arrested, convicted, and sent to the Juvenile Detention Center in the Bronx, and then to Otisville State Training School for Boys. Upon his return, he joins the Dragons street gang at the age of thirteen and starts hustling at fourteen.[14] Convicted of armed robbery at eighteen, Piñero spends the next several years in and out of prison, beginning with Rikers Island and eventually entering Ossining Correctional Facility (colloquially referred to as Sing Sing) in 1971 at the age of twenty-five. Sing Sing proves particularly formative and crucial for Piñero's poetics, as it is here that he joins a writing workshop for inmates run by Marvin Felix Camillo, former actor-in residence at Sing Sing.[15] Camillo is instrumental in helping Piñero find his poetic voice, initially submitting Piñero's first poem, "Black Woman with a Blonde Wig On," to a contest Piñero ultimately wins.[16] Along with supporting Piñero's poetry, Camillo helps him develop as a playwright and performer, most notably through their collaboration on the play *Short Eyes*. Camillo also introduces Piñero, upon his release from Sing Sing in 1973, to the Family, a theater/workshop group Camillo organized whose members are former inmates of Bedford Hills Correctional Facility. Within the structure of the Family, Piñero develops *Short Eyes* in 1974. Significantly, a majority of the cast members of this award-winning production (both on stage and in the

film version) are members of this performance collective.[17] Piñero goes on to mentor his own artistic collective, the Young Family, a group comprised of at-risk youths. Similar to the gatherings at Miguel Algarín's apartment that are the precursor to the Nuyorican Poets Cafe, Piñero's gatherings convert "his shabby apartment on the Lower East Side into a theatrical commune for young Puerto Ricans," aiming "to create an alternative for youngsters about to repeat the self-destructive pattern of his own early years."[18] Piñero's work with the Young Family and their constant presence in both his and Algarín's respective apartments reflect his ideology regarding art making, community formation, intergenerational support, and activism.[19]

Loisaida in the 1970s

The culture of the Lower East Side during the 1970s is visually and sonically captured in the 1978 documentary *Viva Loisaida*.[20] One of the scenes in Marlis Momber's film includes community activist Carlos "Chino" Garcia discussing the housing crisis plaguing Loisaida and the lack of resources available to the community. Yet in spite of the governmental neglect impacting the area, in *Viva Loisaida* Momber juxtaposes these images of dilapidated buildings and abandoned lots with full-scale murals and artistic productions, including music and poetry. In particular, she focuses on neighborhood resident and community activist Bittman John "Bimbo" Rivas reciting his love letter to Loisaida alongside other performers in a community garden on East 9th Street.[21] As I discuss in the introduction, it is Rivas who first uses the term "Loisaida," proclaiming it shorter and easier to pronounce than "Lower East Side" for the predominantly Spanish-speaking community. Loisaida, through artistic productions and community activism such as those acts represented in the documentary, functions as the space where orality as Nuyorican cultural expression is used to resist the dominant, profit-driven economic control and power of landlords and real estate developers. Poetry and performance created by the marginalized people in this neighborhood, like Piñero, function as the verbal tools challenging their erasure, their way of saying no to eviction, displacement, and gentrification.

Moreover, the usage of the term "Loisaida" to refer to this area enables members of the community to verbally lay claim to it. As Liz Sevcenko

argues, "the making of Loisaida—officially the area between Houston and 14th Streets and between Avenue A and the East River—stamped a new Puerto Rican territory on the map of Manhattan and marked a significant step in the latinization of New York City."[22] Loisaida, then, symbolizes raced urban motion, describing the demography and burgeoning arts and politics of a particular ethnic neighborhood and populace. Activating Loisaida as a name and a counter-ideological geography and community operates akin to the reclamation projects in other New York ethnic enclaves such as Harlem's El Barrio. Officially recognized as East Harlem, El Barrio refers to the area located between East 96th Street/Fifth Avenue and East 125th Street/Fifth Avenue, bordering the Upper East Side. In discussing the name El Barrio, Arlene Dávila cites activist and church leader Carmen Villegas, who shares that El Barrio means "*la lucha*, that everyday struggle of living, of our culture and roots." Specifically, she marks a Puerto Rican identity that was configured as "the worst of the worst."[23] El Barrio, like Loisaida, imbues this neighborhood with a name describing a specific populace, highlighting their culture and legacy, and redefining a historically economically impoverished area as one that also includes an artistic, political, and counter-ideological richness with "cultural reassertion emerging alongside current developments."[24]

Analogous to El Barrio, Loisaida, and by extension the Loisaida movement of the 1970s and 1980s, addresses the need to counter the economic strategies of real estate developers who seek to strip the neighborhood of its ethnic mercantilism and its association with gangs and illicit economies such as drug sales. Hence, "the ideology of Loisaida—a spirit of working-class activism and ethnic pride expressed in a defined geographic area—did not represent a simple symbolic appropriation of a neighborhood; it was designed as a tool to mobilize residents to roll up their sleeves and physically take over their environment."[25] In 1972, for example, CHARAS, a community organization based in the Lower East Side, rehabbed a building on East 11th Street. This occurred during the mayorship of John Lindsay, who granted ownership of buildings to people willing to use their own labor, termed "sweat equity," for refurbishing and making repairs as a way to ameliorate the housing crisis. Shortly thereafter, under Mayor Ed Koch, CHARAS was then able to fix and lease PS 64 from New York City under the Adopt-a-Building Program for a dollar a year from 1978 to 2001.[26] During its tenure, PS 64

served as a meeting space for groups that dealt with housing issues, drug rehabilitation, police brutality, and environmental concerns.[27]

It is during this time period and in this economic context of rundown buildings and citywide economic divestment that Piñero's friend and artistic collaborator Miguel Algarín purchases the building in 1981 that becomes the permanent location of the Nuyorican Poets Cafe. Algarín buys the building, located at 236 East 3rd Street,[28] from the City of New York at a very low price because the building is "in rem."[29] In rem foreclosure "refers to a lawsuit or other legal action directed toward a property rather than toward a particular person."[30] The owner of the building prior to Algarín was Ellen Stewart, founder of the Lower East Side experimental theater La MaMa, who "had to let it go for taxes."[31] According to Nuyorican founding poet Lois Elaine Griffith, Stewart essentially utilized 236 East 3rd Street as lodging for musicians who traveled to New York and needed a place to stay.[32] Griffith's recollection aligns with that of Stewart, who recalls introducing Black musicians at 236 East 3rd Street and providing them with a place to rehearse and play. In addition, Stewart would host theater and jazz workshops there, with an "end goal of the space and programming" funding the establishment of a Hispanic theater center.[33] Rachel Leah provides a more complete history of the relationship between the physical space of the Nuyorican Poets Cafe, La MaMa, and Ellen Stewart. Specifically, Leah attends to how Stewart "acquired 236 East 3rd Street and other abandoned buildings on the Lower East Side" and converted them into art spaces, using 236 "primarily for community workshops, in an effort to engage and produce art that was reflective and representative of the surrounding neighborhood."[34]

The Nuyorican Poets Cafe that Piñero helps to establish is exemplary of the community art-making possibilities available to artists and communities during the 1970s. Algarín, as faculty at Rutgers University, and Stewart, as the first Black woman to "run a fashion design department at Saks Fifth Avenue," use their earnings to purchase rundown buildings at low cost to be used for artistic creation and performance.[35] The geographic location of the buildings in the Lower East Side/Loisaida and East Village during the 1970s and early 1980s speaks to the types of opportunities available to artists during this particular time period, as well as the ethnic and racial composition of these neighborhoods during the

earlier stages of gentrification and prior to the hyper-commercialization of the arts through capital and mass media.[36]

Since its inception, the Nuyorican Poets Cafe has emphasized poetry and various performance styles that reflect a coming together of people who use self-expression to challenge racism, affirm their identities, and meditate on their personal and collective realities. As previously explicated, the Nuyorican Poets Cafe is initially about the articulation of subaltern identities and the emergence of a counterpublic sphere through performance. Michael Warner defines counterpublics as operating in "tension with a larger public" while maintaining "an awareness of its subordinate status."[37] Urayoán Noel echoes Warner in contending that "Nuyorican poetry had a significant counterpublic dimension from the beginning," and goes on to question whether the oppositional logics of Nuyorican identity and performance can be sustained due to their "dependence on mass media."[38] While mass media do inform the circulation of Nuyorican poetics after 1996—particularly through the visibility afforded the Cafe and its surge in cultural capital—there is a need to acknowledge that the space's initial focus was not on creating a venue where performances held a promise of commercial, mass-mediated success. The nuyorican aesthetic, then, identifies the mobilization of "Nuyorican" as a rekeyed identifier, one that marks a queer counterpolitics. Thus, although I agree with Noel that counterpolitics prove a useful starting ground, they fail to capture the logics of mobility and subsequent globalization enacted through the queer poetics that venture into the space and draw from its history and aesthetics to enact different art-making practices in the 1990s.

Providing a space for self-expression operates as a significant component of the mobilization associated with the aforementioned Loisaida movement, as it represents a celebration of the people and the resources within the neighborhood itself. In turn, the Nuyorican Poets Cafe as a space for the creation of community art serves as a tool for the artistic practices necessary to reclaim the Lower East Side as Loisaida. This is because, "as an ethnic neighborhood, . . . Loisaida celebrated an identity of multiculturalism contained in the symbol of Puerto Rican ethnicity. It creates a puertorriqueñidad that promotes racial tolerance and can be used to mobilize a diverse group of Latin American, European, and other residents."[39] Ultimately, this artistic community, in the form of

musicians and poets, helps to shape this concept of a Nuyorican culture in the mid-1970s as emblematized by the Cafe's founding. This move from the privacy of Algarín's home to the Cafe's physical location, first at East 6th Street and finally at East 3rd Street, cements the Nuyorican Poets Cafe as more than just a concept. The Cafe's founding during the mid-1970s "climaxe[s] Loisaida's 'golden age'" and signals its "pregentrification flowering."[40] Significantly, it highlights how the Loisaida community "reached rootedness in the neighborhood," thus allowing it to "nurture its own poets."[41] The Cafe is understood as a community space and as an institution becoming a part of the larger neighborhood community that experiences isolation because "people didn't want to come below First Avenue."[42] Yet this very isolation creates an insularity that yields a close-knit bond between the people, the Cafe, and its mission. Much of this has to do with how the Cafe acts as a gathering place for the neighborhood residents who do not possess a great deal of disposable income to spend on expensive entertainment in New York City. As a result, the Cafe holds the occasional weekend dances that include children from the surrounding projects, who can gain entrance for only two to three dollars.[43] While limited funds hinder the community's ability to access art outside Loisaida, Algarín and Piñero bring the art to them. The Nuyorican, then, as a performance venue represents not just a place where poets recite their poetry; the act of performing alongside the work being presented inevitably *does* something—it effects change. Algarín expresses this sentiment when he states, "Poetry is the full act of naming. Naming states of the mind. . . . To stay free is not theoretical. It is to take over your immediate environment."[44] Here Algarín defines poetry as a vital tool in the struggle for self-determination at the individual as well as the community level.

Piñero's Queer Poetic Strut Lays Claim to Loisaida

Alongside the process of naming and articulating linguistic ownership over space is the way one claims possession through the physical act of walking and, in so doing, engaging with space and the people within it. As Michel de Certeau argues, the city operates as a text to be read, and "the act of walking is to the urban system what the speech act is to language and to the statements uttered."[45] For de Certeau, walking has a triple "enunciative function," wherein "it is a process of *appropriation*

of the topographical system on the part of the pedestrian (just as the speaker appropriates and takes on the language); a spatial acting-out of the place (just as the speech act is an acoustic acting-out of language); and it implies *relations* among differentiated positions."[46] Thus, Piñero's walks around his beloved Lower East Side, wherein he is creating and performing poetry at the Cafe, buying and/or selling drugs, and cruising and hooking up with men, contest the sanitizing impulse of topographical appropriation through gentrification. While Piñero's poetry works to (re)claim the Lower East Side, the aesthetics of his performances forecast the emergence of poetry slam, the genre that results in the Cafe operating as part of the culture industry. To be clear, poetry slam at the Cafe has historically reflected the culture and communities outside the space, providing much-needed opportunities for marginalized voices and people to articulate their too often ignored realities and experiences, such as those of Regie Cabico, the Glam Slam participants, and Ellison Glenn. Yet the continuing neighborhood transformations, alongside the growing commercialization of the space, have resulted in performances reflecting the commodification of the venue. Unfortunately, these performances co-opt the affectation most closely associated with the Cafe but are often devoid of the politics inherent in the Cafe's founding impetus and of the historic demography surrounding the space.

Piñero's poem "Seekin' the Cause" predates and thus helps establish the aesthetics associated with poetry slam, illustrating a queer lineage to the Cafe even as the temporal and political shifts within the neighborhood mark the reception of Piñero and the slam poets distinctly. In this piece Piñero provides an alternate history of the atrocities endured by soldiers in the Vietnam War. For this performance, he steps up to a small wooden podium as people are seated in rows in front of him, similar to the layout of a classroom during a lecture or a presentation. His delivery is an early precursor to the affect associated with Nuyorican slam—the gesticulating limbs, the measured cadence, and the increased speed of delivery denoting the poet's investment and the poem's urgency. We see Piñero with his skintight rolled up jeans, tight striped tank top, and handlebar mustache dressed and styled for queer effect as he begins with the following lines: "downtown . . . uptown . . . midtown . . . crosstown."[47] Piñero articulates the lines denoting the different directions, pointing with his right hand in the opposite direction. For downtown he points up,

and for uptown he points down, continuously playing with constructed notions of spatial organization, of geographic and cultural fixity. The speaker of the poem traverses New York City before revealing that his body exists everywhere rather than in one place. Piñero confirms, "his body was found all over town."[48] He continues, "seekin' a cause / seekin' the cause," and thus lays the groundwork for the particular theatricality currently associated with poetry slam. The "a" prior to "cause" is uttered at a higher volume than the rest of the stanza, while the "the" of the second part is spoken at a lower volume, with the cadence slowed and a minor pause inserted between "the" and the final "cause." This linguistic acting out of the written word activates the piece—Piñero is not just reading the poem, he is inserting himself into it, taking that which is on the page and opening up a larger dialogue on the politics of war. His voice continues to rise, becoming angrier in tone while he punctuates the words with a closed hand that rises and falls with his delivery:

> found
> in the potter fields of an o. d.
> found
> in the bowery with the d. d. t.'s
> his legs were left in viet-nam
> his arms were found in sing-sing
> his scalp was on Nixon's belt
> his blood painted the streets of the ghetto
> his eyes were still lookin' for jesus to come down
> on some cloud & make everything ok
> when jesus died in attica[49]

Following his utterance of the final line, Piñero starts snapping his fingers and singing, "do-do-do-do-do / Goodnight my love / Well, it's time to go / do-do-do-do-do" as his own riff on the classic 1950s doo-wop song "Goodnite, Sweetheart, Goodnite," originally sung by the Spaniels.[50] This song closes out the performance. In this context, the singing is an interruption that relocates the audience within their own sonic memories. As Piñero's movements switch from a closed fist and angry, punctuated words to snapping fingers and rhythmic swaying, the mood, too, transitions from the violence found in Vietnam and the political unrest of the

Nixon era to a calmer, quieter place as he sings at a much lower volume. Piñero's poetry textually and affectively moves between different geographies, drawing attention to how violence occurs on both a foreign and domestic scale. His affective performance—with the poetic phrasing of his expressed discontent, the corresponding physical movement, and the disruptive singing—becomes a template for political performances later included in poetry slam competitions at the Cafe.

Piñero also documents his particular relationship with the streets, gesturing toward his deployment of the nuyorican aesthetic as comprised of recombination, gesturality, and orality. In "The Book of Genesis according to Saint Miguelito," he writes,

> In the beginning
> God created the ghettos & slums
> and God saw this was good

A few lines later, God continues his activities:

> God commanded the rivers of garbage & filth
> to flow gracefully through the ghettos.
> On the third day
> because on the second day God was out of town
> On the third day
> God's nose was running
> & his jones was coming down and God
> in his all-knowing wisdom
> he knew he was sick
> he needed a fix
> so God
> created the backyards of the ghettos
> & the alleys of the slums
> in heroin & cocaine

In the poem's conclusion,

> He noticed his main man satan
> planting the learning trees of consciousness

> around his ghetto edens
> so God called a news conference
> in a state of the heavens address
> on a coast to coast national t.v. hook up
> and God told the people
> to be
> COOL
> And the people were cool
> And the people kept cool
> And the people are cool
> And the people stay cool
> And God said
> "Vaya..."⁵¹

Piñero's retelling of the biblical creation story gestures to the "urban depravity" theorized by Edrik López as a central tenet of Nuyorican poetry. Piñero attributes this "decadence" to acts of God. In Piñero's creation mythology, he himself is "Saint Miguelito," while God is a junkie who builds the ghettos and slums as the origins of humankind, with Spanglish operating as the first language. While drug addicts are generally relegated to outsider status within mainstream society, throughout this poem Piñero moves these figures from the periphery to the center, elevating the junkie from a non-person to a deity. Similar to Rivas's laying claim to the term "Loisaida" by giving it a raced cultural history, Piñero's messianic dope fiend in the Spanglish-speaking Loisaida is emblematic as God among, not above, his chosen people.

Piñero extends the vexed relationship between space and belonging, and home and homelessness in one of his final works, "Lower East Side Poem," demonstrating how his poetry is always active and in motion. As his poetic last will and testament, "Lower East Side Poem" spells out Piñero's visceral connection with his adopted homeland of Loisaida:

> Just once before I die
> I want to climb up on a
> tenement sky
> to scream my lungs out till

> I cry
> then scatter my ashes thru
> the Lower East Side.

In this initial verse, he speaks to how, in spite of his many accomplishments, he remains part of a community defined and constricted by poverty, where the roof of a tenement represents the pinnacle of success.

> So let me sing my song tonight
> let me feel out of sight
> and let all eyes be dry
> when they scatter my ashes thru
> the Lower East Side.
>
> From Houston to 14th Street
> from Second Avenue to the mighty D
> here the hustlers & suckers meet
> the faggots & freaks will all get
> high
> on the ashes that have been scattered
> thru the Lower East Side.
>
> There's no other place for me to be

In the final stanza Piñero writes,

> I don't wanna be buried in Puerto Rico
> I don't wanna rest in long island cemetery
> I wanna be near the stabbing shooting
> gambling fighting & unnatural dying
> & new birth crying
> so please when I die . . .
> don't take me far away
> keep me nearby
> take my ashes and scatter them thru out
> the Lower East Side[52]

In this piece, Piñero delineates the boundaries of Loisaida, extending his dialogue further than the neighborhood's geography when he writes, "here the hustlers and suckers meet / the faggots and freaks will all get / high." This moment in the poem speaks to the people who comprise this area prior to the onslaught of gentrification. Outcasts all, they, like Piñero's ashes, have been scattered there, not at home but still belonging. Piñero self-identifies as a member of this community—he is both a faggot and a freak. Although he has relationships with men, most notably with visual artist Martin Wong, this queer history is too often ignored in books documenting the evolution of the Cafe and the Nuyorican movement as a whole. After meeting at an art show during the early 1980s in the Lower East Side, Piñero moves into Wong's apartment a few weeks later. While often referred to as roommates or "friends," they are lovers and live as such for a year and a half. They also collaborate artistically, with Piñero inspiring Wong's *Portrait of Mikey Piñero* and *The Annunciation According to Mikey Piñero: Cupcake and Paco*, among others. Wong's paintings in the 1980s depict "the African and Latino communities of New York's Lower East Side"; more importantly, some are "spiritually and erotically charged narratives, loosely based on the writings of Miguel Piñero, with whom Wong had an intense, stormy relationship."[53]

In *The Annunciation According to Mikey Piñero: Cupcake and Paco*, viewers are presented with Wong's version of a scene from Piñero's award-winning play (and subsequent film) *Short Eyes*.[54] The painting features a dark-skinned Black man standing shirtless, his head held down and to the right where another dark-skinned man kneels, his right leg at a ninety-degree angle while his left leg is bent and extended backwards. The position assumed by the kneeling man is reminiscent of the pose associated with marriage proposals. A sign on the wall to the left of the standing man identifies him as "Cupcake," while a sign with the name "Paco" is positioned to the right of the kneeling figure, thus identifying him. Their interaction takes place behind the bars of a jail cell and we see a guard in gray tones, identified as "Mr. Nett" by a sign next to his head, peering through to bear witness. The dialogue between Cupcake and Paco is written on another set of signs next to their bodies. Wong includes the Spanish text of the conversation between the two prisoners: Cupcake: "Que me deje quieto que yo no soy maricon," which

I translate as, "I said to leave me alone, I'm not a faggot!" This is followed by Paco's response of "¿Y que? Oyeme negrito, dejame decirte algo. Tú me tiene loco, me desespera nene. Estoy enchulao contigo. Yo quiero ser tuyo y quiero que tú sea mio. ¿Y que tú quiere que yo haga por ti?" which, translated, states, "So what? Listen to me *negrito*. Let me tell you something. You are driving me crazy, I am a desperate man. I am smitten with you. I want to be yours and I want you to be mine. What do you want me to do for you?"[55]

This collaboration between lovers, between a poet/playwright and a painter, between a Nuyorican and a Chinese American, between image and language is a textual-visual representation of homoerotic enunciation. Textually, this scene, as relayed through Wong's painting, employs an ethnically marked Puerto Rican argot such as "enchulao" rather than the grammatically correct "enchulado." This verbal exchange between Cupcake and Paco signals Piñero's ethnic background and class position. Additionally, the usage of "negrito" to identify Cupcake by Paco references a racialized position. While "negrito," as the diminutive term for "Black," is often used as an affectionate linguistic gesture regardless of race or skin color, in this instance I argue that Piñero, through Wong, also uses the term as a way to highlight Puerto Rico's Afro-diasporic heritage. Through his collaboration with Piñero, Wong's painting indexes their same-sex desire and sexual relationship and, in doing so, underscores how queerness is intertwined with space, specifically the East Village/Lower East Side/Loisaida. As described by Arnaldo Cruz-Malavé, the East Village underground art movement and the ethnic or racial Otherness represented by the neighborhood itself are also reflected in the sexual and gendered Otherness of the artists themselves. In addition to his collaboration with Wong, Piñero takes ownership of the Lower East Side neighborhood he calls home by queerly strutting and commenting on Lower East Side culture in the mid-1980s.

Throughout his artistic practice, and specifically his "Lower East Side Poem," Piñero rejects nostalgia for a Puerto Rican homeland, instead assuming the identity of the Nuyorican. He chooses to make "home" within the context of homelessness and migration in New York, in the Lower East Side. Piñero highlights how the multiplicity and multidirectionality of Nuyorican cultural identity are based on a very particular migratory experience, one where constructed notions of authenticity

challenge concepts of belonging and citizenship. New York City is home for Piñero because of his lived experience; the fact that he was born on the island of Puerto Rico and lived there until age four does not confer symbolic or cultural citizenship. New York City is the only place he belongs because of its mixture of different classes, races, ethnicities, and sexualities and the freedom this mixture affords him. His social position and queerness go unquestioned in Loisaida. Piñero's mandate to scatter his ashes throughout the Lower East Side operates as a physical remembrance of his cultural and ethnic identity; it is his way of marking the space with his absent presence *in* death. His ashes are not placed in one specific location because there is no one place for him; they are scattered within the boundaries of his neighborhood. How then does this poem unwittingly foreshadow the whitewashed, consumerist Loisaida that is to come? How does Piñero represent the queerness at the Cafe present since its beginnings? His poem reflects Loisaida's ceaseless motion, the swirling ashes of those gone too soon on the streets being ground underfoot, first by hustlers and then by yuppies.

Following Piñero's death on June 17, 1988, from cirrhosis, Algarín, with the help of the Loisaida and Nuyorican Poets Cafe communities, carries out Piñero's wishes. In a 1998 on-air interview, Algarín describes the funeral procession. As the first stanza of "Lower East Side Poem" is read, drumming fades in and Algarín recites the following lines: "so let me sing my song tonight / let me feel out of sight."[56] The walking begins, people spread Piñero's ashes, and onlookers join in this march that journeys from Houston to 14th Street on Avenue D, from 14th Street to Houston on Avenue C and then on to 2nd Street. Throughout this walking poetic performance, the women of the surrounding projects begin taking the ashes and marking the symbol of the cross while the junkies bow their heads. This performance of poetry in motion is purposefully temporal as Piñero's physical remains are subsequently erased by the pedestrians/spectators/participants who walk over and around them. Contesting this erasure is the strung-out Puerto Rican that Algarín mentions, who lies atop Piñero's ashes as people pass him. This act reveals how Piñero's ashes, his absent presence, are nonetheless carried as part of the physical bodies of those who encounter Loisaida. In locating his final request within the boundaries of the Lower East Side, Piñero transforms the neighborhood, celebrating its associated characteristics—the

drug use, the gang presence, the poverty, and the queerness—that are deemed abject. He reaffirms his troubled relationship with his land of origin in writing, "I don't wanna be buried in Puerto Rico," and makes his wishes further known by stating, "I don't wanna rest in long island cemetery."[57] Piñero rejects the concept of Puerto Rico as home although his family wants him buried there. He simultaneously rejects the upward social and economic mobility represented by suburban Long Island. Even in death, Piñero performs his identity as "walking poetry."

This concept of "walking poetry" is an enactment of Piñero's conceit of poetry as an active force, poetry that *does* something. Through this queer poetic strut, he helps to redefine and empower a neighborhood seeking to maintain its cultural identity. In turn, the Nuyorican Poets Cafe becomes a cultural institution reflective of Loisaida and its changing demographics. It is a place historically connected to the neighborhood and its residents. This connection is evidenced in the preparations for Piñero's funeral procession/ceremony; Algarín describes it as a "scattering of ashes [that] forged an unbreakable bond between the artists and the working people of the Lower East Side."[58] Piñero's "walking poetry" demonstrates a move from an ethnically fixed Nuyorican identity toward the more fluid nuyorican aesthetic. When the abject is redefined not only as useful, but necessary—both in terms of the ethnic marker "Nuyorican" and the adoption of "Loisaida"—the move from identitarian marker to aesthetic occurs. A defining characteristic of the nuyorican aesthetic is Piñero's model of recodifying identities as empowering through the writing of poetry that expresses minoritarian subjectivities. It is a practice rooted in the physical space of the Cafe and in the culture produced through communitarian art making within its walls. He constitutes the history of that area, one still visible in spite of its transformed profile. One of those transformations, of course, is the movement from the local to the global in terms of the Cafe's intensifying focus on poetry slam.

Inspired by Piñero's queer movement through the Lower East Side, I chart my own walk from the Second Avenue train station in lower Manhattan to the Cafe in the mid-2000s during my time as host of the Friday Night Poetry Slam. My walk is my own attempt at invoking Piñero's queer strut, and is also a way to analyze the neighborhood changes.[59] Upon exiting the F train station on Second Avenue one night, I begin walking toward the Cafe through the Lower East Side/East Village and

into Loisaida on East 3rd Street and Avenue A. I continue down East 3rd Street, witnessing the continuing battle between the encroaching development and the long-standing immigrant and working-class communities that already live in the neighborhood. I witness the contrast between the "First Houses" housing projects still remaining from the 1970s. These apartments for low-income families, many surviving on public assistance, with faded Puerto Rican flags hanging from their gated windows, are disrupted by new eateries like Poco Restaurant and Cafe Cortadito, a high-end Cuban place on the corner of Avenue B. These restaurants exemplify how "gentrification br[ings] the 'fusion' phenomena—toned down flavors, made with higher quality ingredients and at significantly higher prices, usually owned by Whites, usually serving Whites," as Sarah Schulman discusses.[60] Upscale venues offering bottomless brunches, these restaurants contrast with historic establishments such as Casa Adela on East 5th Street, a no-frills Puerto Rican eatery. Further down the block, I pass the trendy organic cleaners and the high-rise building with glass doors and a twenty-four-hour security guard constructed in the early 2000s. This is definitely not the same area pathologized as crime-ridden and dilapidated during the 1970s, where building a private residence would have been both unrealistic and undesirable for wealthy Whites.

Living across the street from the Cafe in public housing, with Los Amigos Garden as his backyard, is Julio Dalmau, who is the ideal house manager for the Nuyorican. Like Piñero, he was born in Puerto Rico but has strong ties to Loisaida. A tall man with broad shoulders who initially worked as a numbers runner in uptown Manhattan, Dalmau rarely finds his authority at the door questioned. He stands in for the community struggling to survive. The newer businesses and residential buildings defy the Latina/o/x community by continuing to push prices up and the ethnic community out to make room for the gentry. This convergence of peoples marks the Cafe as a space populated by long-standing residents, young monied transplants, and the visiting consumers who all provide the space with a distinctive identity. In essence, the Cafe functions as a community space for global art, where the Nuyorican local extends to the nuyorican global.

As I walk up to the Cafe that evening, I encounter a mural of men wearing zoot suits that greets queuing patrons. With their long coats

tied at the waist and fedoras cocked to the side, they represent urbanity, masculinity, fashion, resistance, and nightlife.[61] While these men's clothing is spray-painted in white, their faces fade into the royal blue background. They appear to be in motion, entering the Cafe with the word "Nuyorican" hung above their heads (figure 1.2).

Depicting nearly all men, the mural reflects women's lack of visibility within the Nuyorican movement. The one woman in the painting hunched at the end of the line stands in for Nuyorican/Dominican poet, performer, and visual artist Sandra María Esteves, a lone female voice documenting the Nuyorican experience. The mural itself also reflects the male-dominated, masculinist history that continues to inform our understanding of the Cafe. Where are the women and queer people who have frequented the Cafe since its inception? If space is produced through practice, how does this mural seek to establish and affirm a particular Nuyorican mythos? The mural reaffirms the heterosexist, patriarchal, and masculinist history of the Cafe, omitting the foundational contributions of the women and queer people who have performed there from the beginning.

In continuing my walk into the Cafe, I turn to the other side of the doorway and see a mural depicting Pedro Pietri (otherwise known as El Reverendo) painted shortly after his death in 2004. Local graffiti artist Antonio "Chico" García paints his murals in order to recuperate neighborhoods addled by drugs and violence.[62] Horizontal and vertical lines giving the illusion of a brick exterior frame both murals. The heavy, creaky metal/iron front door is surrounded by a white frame and bears the building number, 236, while a multicolored acrylic sign created by Diana Gitesha Hernandez reading "The Nuyorican Poets Cafe" hangs above it.

Until 2008, the door and the sign are the only locators of the Cafe. With the front door closed on a dark New York City night, one could easily walk past the building without noticing it. I remember heading down East 3rd street in 1997 and walking by the Cafe only to have to turn around and locate the building by referencing that 236. Currently, an enclosed black wind guard with the Cafe's website address and phone number on top faces the street (figure 1.4). Included on the side is the logo designed by graphic artist Clare Ultimo, a spiky-haired person in mid-run/walk and mid-yell, holding a book next to the words "Nuyorican Poets Cafe" (figures 1.5 and 1.6). The wind guard with the hanging

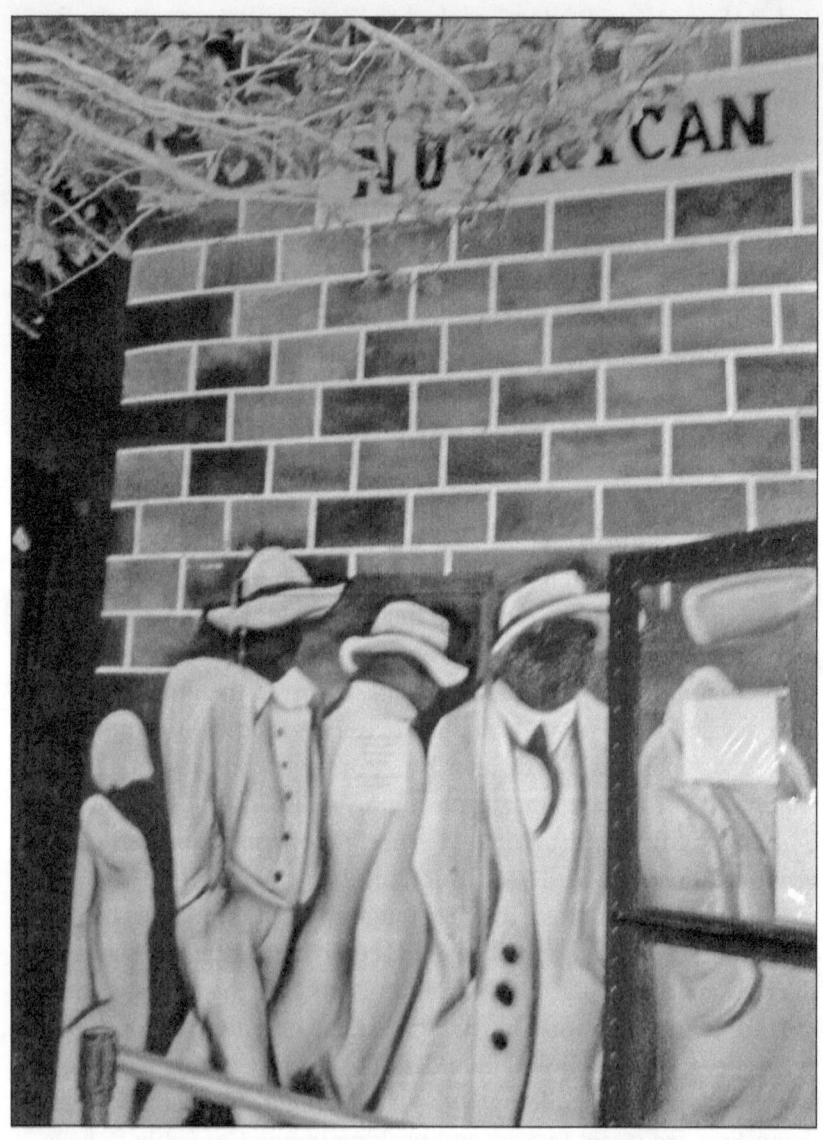

Figure 1.2. Mural painted by Joe "EZO" Wippler outside the Nuyorican Poets Cafe. Photo by author, 2012.

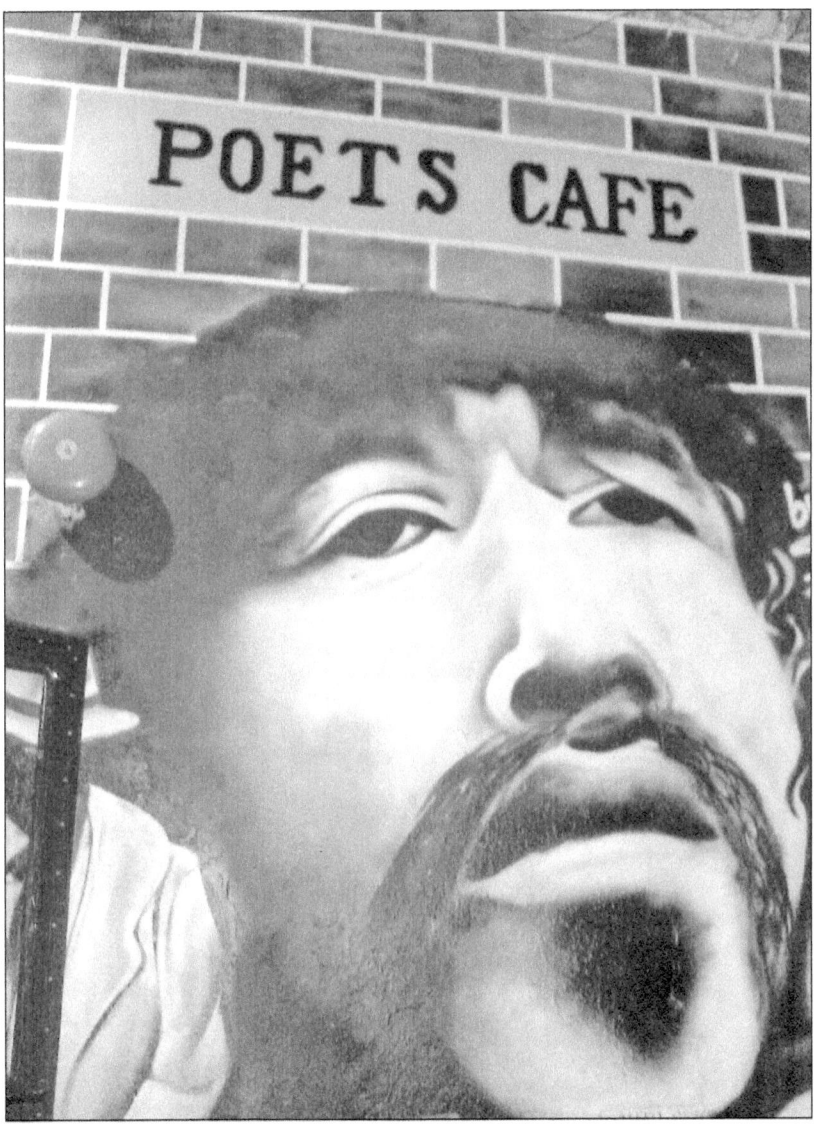

Figure 1.3. Antonio "Chico" García's mural of Pedro Pietri painted outside the Nuyorican Poets Cafe in 2004. Photo by author, 2012.

Figure 1.4. Front of Cafe. Photo by author, 2012.

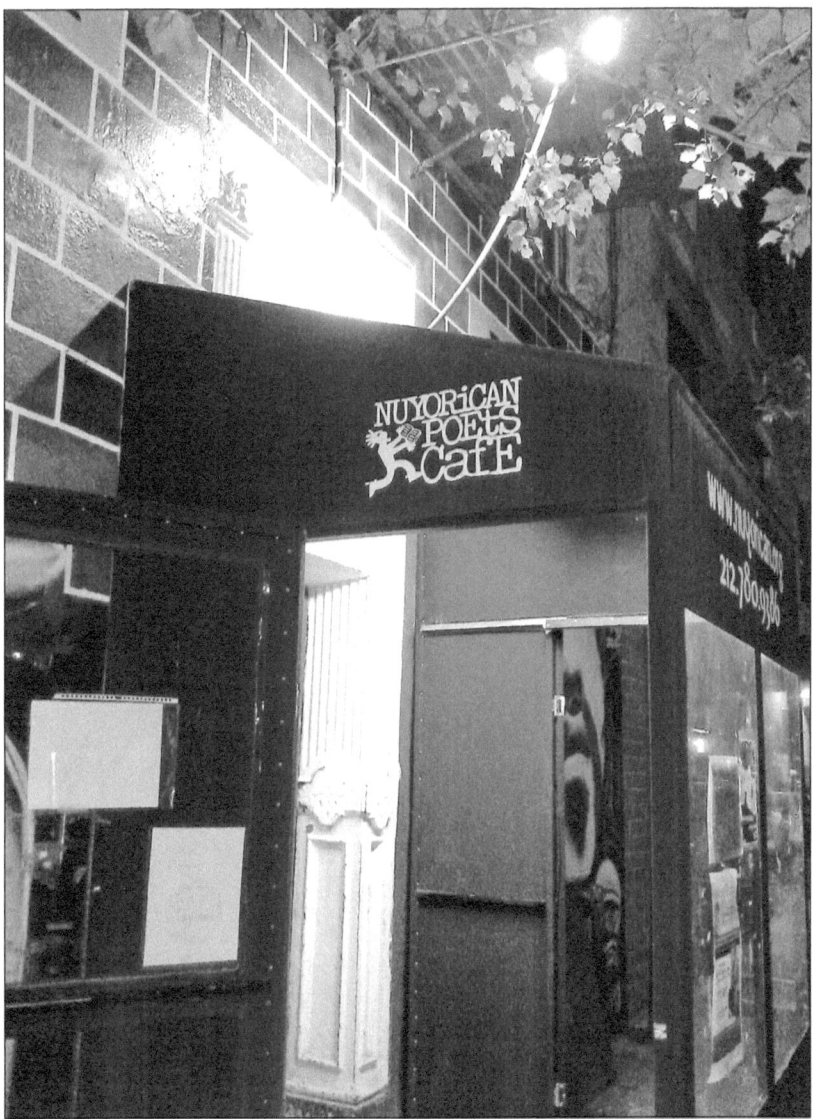

Figure 1.5. Left side of Cafe entrance. Photo by author, 2012.

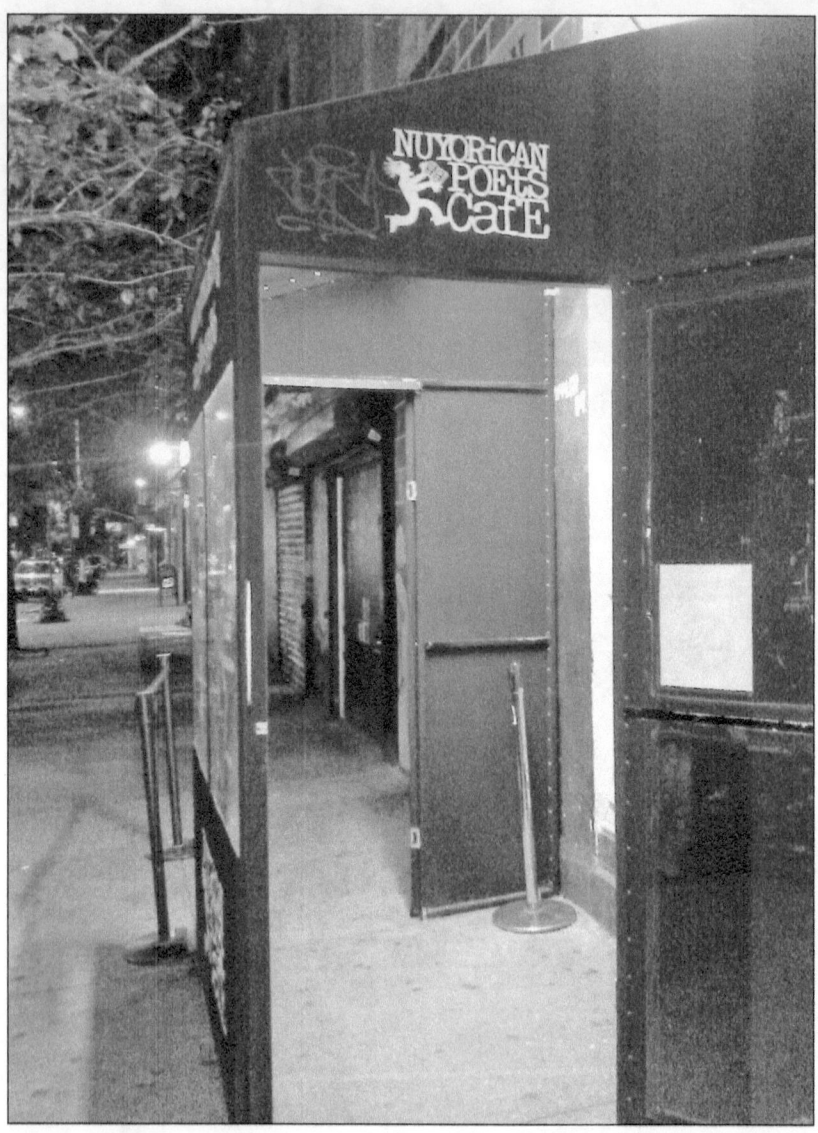

Figure 1.6. Right side of Cafe entrance. Photo by author, 2012.

light bulb inside is lit when an event is happening, increasing the space's visual accessibility. Newcomers and regulars alike are now able to easily locate the Cafe. Additionally, the wind guard helps to muffle some of the noise made by patrons seeking entrance or by those standing outside during an intermission, while the clear plastic around the middle doubles as additional promotional space for fliers and handbills. As a response to the noise complaints occurring on the westward side of the wall from the residential building adjacent to the Pietri mural, the Cafe installs a red rope to demarcate the border between the two buildings, 236 and 238. A sign on the outside wall is another reminder for people to keep their voices down. The addition of the rope and sign signals the adjustments made by the Cafe as it continues to transition from an artistic space in a previously working-class and poor neighborhood to one populated by the gentry.

The wind guard in front of the building is the most significant external and physical representation of the Cafe's deliberate move to adapt to the changing demographic in Loisaida. This is not the Nuyorican Poets Cafe of the 1970s, where its location was in the heart of a tight-knit immigrant (Eastern European, Latina/o, and Asian) community. The Cafe is approximately two blocks and two and a half avenues from the nearest train, located in the middle of a rapidly gentrifying area. Thus, the wind guard distinguishes the Cafe from the newly constructed residential buildings surrounding it. The Cafe now functions as an institution attempting to remain relevant amidst a changing cultural landscape, where its history and significance as a space for performances by, for, and about marginalized people are not always known or readily apparent to the neighborhood's new denizens.

Entrance into the Cafe on a packed Friday night pre-2012 is granted on a first-come, first-served basis, where people are granted access until the place fills to well over capacity.[63] As I walk up to the Cafe this evening, I see the poets who will compete in the poetry slam standing across from the people waiting in line. I greet the competing poets or slammers before pulling open the door, check in with Dalmau, and am met by the German Slam Poetry Champion requesting an opportunity to perform. I tell him I'll include him in the latter half of the program and continue walking by the crowded bar as Pepe, the resident

bartender, serves beer and wine. Making my way to the small area behind the bar where I will stand for the rest of the evening proves difficult as the place overflows with people—some are sitting on the mismatched wooden chairs around the rickety round tables spread throughout the Cafe while others, mainly New York University students, sit cross-legged on the floor directly in front of the stage. Even the stairs leading up to the second floor are crowded, as are the rows of chairs in front of the overhead balcony. I give DJ Rocky the signal to stop playing the hip-hop blasting through the Cafe and to turn off the lights. The crowd goes silent as they wait for the downbeat of another song and the spotlight follows me as I walk to the stage. The lights will remain dim for the rest of the evening, save the spotlight on the performer. Standing center stage, I welcome the crowd to the Friday Night Slam at the Nuyorican Poets Cafe. The evening's poetry competition has begun. Between the second and third rounds there is a break where a poet from the audience has the opportunity to perform. This particular evening, as promised, I call upon the German Slam Poetry Champion.

He steps on to the stage and begins to perform. I immediately recognize his cadence and physical gestures as those usually employed by slam poets during a competition. While he recites his poem, his arms form a ninety-degree angle—his forearms moving back and forth as if on a lever and pulley, physically punctuating the rise in volume and increased speed of delivery as he marks every word uttered by aiming his hands at the crowd. His body sways from side to side, seemingly propelled by the strength of his words. His actions mirror those of earlier poets but read as overly rehearsed. His performance-as-rendition lacks the political content of the earlier work presented that evening, failing to demonstrate an investment in performing poetry that *does* something other than reproduce a commodified style. Instead, his performance exemplifies the culture industry described by Neil Smith. Specifically, his poetry reads as mimicry, a copying of Piñero's affect devoid of its political and historical context. The German poet is more intent on obtaining my autograph and those of other poets from the Nuyorican Friday Night "scene."

This "scene," symptomatic of the gentrification boom outside the Cafe and the commodification within it, articulates these changes through performance. The linkages conveyed through Piñero's performances

pre-slam are appropriated for a post-gentrification aesthetic erasing race and sexuality, the fulcrum of what I am terming the nuyorican aesthetic. These nuyorican artistic practices are situated within a broader network as it is no longer just about Nuyoricans and the fight for ownership over Loisaida. Although leading artists from the Beat movement, Allen Ginsberg and William Burroughs, and Black Arts luminaries Amiri Baraka and Ntozake Shangé perform at the Cafe, it is primarily because of their literary connections with Algarín. Ethnic Nuyoricans are the first majority and their performances, mainly in Spanglish, informed the space's earliest identity. The poetry slam encourages interactions between people of different races, ethnicities, and sexualities that, in turn, defines a developing aesthetic movement. For example, there have been only three ethnic Nuyoricans to win the Grand Slam Championship from 1988 to the present—Willie Perdomo, Xavier Cavazos, and Chicagoan Mayda del Valle. This shift makes visible the relationship between the political history of the Nuyorican and its influence on contemporary emerging artists of all backgrounds. These performers and their artistic productions signal a move away from a specifically Nuyorican struggle to a broader, diasporic, globalized one.

This process, this movement from Nuyorican specific to nuyorican aesthetic, is first hinted at in the 1970s with the gatherings of both ethnic Nuyoricans and non-Nuyoricans and fully emerges with the introduction of poetry slam at the Cafe. Piñero's model of recodifying identities as empowering through poetry that expresses minoritarian subjectivities functions as a defining characteristic of this queer artistic formation. It is a practice first rooted in the physical space of the Cafe and in the culture that produces it, drawing from the Cafe's history while not being limited by it. The walking, the scattered ashes, the mixing, and the movement all perform an aesthetic born of the Cafe that also exceeds it. The contexts vary perhaps, the ashes disperse, but it is from the place of these scattered diasporic belongings that the practices from the Cafe continue to "scream their lungs out," and make home.

2

This Is the Remix

Regie Cabico's Filipino Shuffle

He steps onto the stage at the Nuyorican Poets Cafe wearing an orange long-sleeved shirt with khaki pants. The shirt bears a series of black cursive designs on the sleeve; he wears it buttoned up and untucked, and his mid-length, curly black hair is combed back. His appearance fails to serve as an overt signifier of musical taste, sexual orientation, or socioeconomic status. He begins singing a cappella, employing a musical theater show tune affect, "MMMMMEEEEEEMOORRRRYY, like the corner of my eyes."[1] As he campily sings out this reference to Barbra Streisand, he leans to one side with one shoulder raised while the other remains lowered, his arms following the trajectory of his voice. His palms face upward as if opening up his entire body to the sound that emanates from within, the effort of the singing further evidenced by the crossing of his eyes throughout; from the onset this gesture situates his theatrical intervention as parodic: comic and overwrought. Alongside parody and camp, queer Filipino poet and activist Regie Cabico forms his particular nuyorican aesthetic via simultaneity and recombination, alongside a gesturality and orality influenced by slam poetics and hip-hop technologies. Cabico proposes and performs a nuyorican aesthetic by working through remixing, looping, and sampling strategies that refer to "recognizable" (i.e., by White mainstream audiences) tropes and shakes them up, unmoored from stable referents, in order to express composite and recombinant identities and situatedness in flux. Specifically, in *Filipino Shuffle*, Cabico evidences simultaneity through poetic, comedic, and theatrical interventions that both acknowledge and subsequently deviate from the Nuyorican lineage and genealogy that I discuss further in both the introduction and chapter 1. He recombines queer aesthetic practices such as camp through his queer redeployment of the sampling and remixing practices of recordings, both affirming

and critically embodying his position as a queer Filipino who brings racial melodrama into the aesthetic strategies of New York's burgeoning, and largely heterocentric, early 2000s hip-hop theater era.

Hip-Hop Theater Festival founder and performer Danny Hoch interrogates the principles of hip-hop artistic production as challenging the Western theater model, resulting in a performance genre "*by, about and for* the hip-hop generation, participants in hip-hop culture, or both."[2] Specifically, Hoch critically analyzes the performative potential of hip-hop theater beyond just people of color on stage creating and performing in productions that include any of the four elements of hip-hop: graffiti, DJing, b-boying/b-girling, and rapping.[3] According to Hoch, hip-hop theater provides the best paradigm or theoretical framework for defining the new hip-hop aesthetics and investigating their potential. The new hip-hop aesthetics draw from the previously articulated four elements of hip-hop but are not limited by them. Examples include beatboxing, language, and fashion alongside innovations in dance, music, writing, visual art, and theater. For Hoch, the emergence of hip-hop theater opens up new ways of creating and experiencing both theater *and* hip-hop, pushing for an examination of what these genres do separately as well as interdependently.

Hoch attends to a production of *Bomb-itty of Errors* as an example of the types of shows that hinder, rather than help, our understanding of the critical potential of hip-hop theater.[4] Hoch's analysis centers on how the production "sends the message that the hip-hop generation has no important stories of its own, and that in order for hip-hop to qualify as theatre, it must attach itself to such certified texts as those of Shakespeare."[5] In addition, Hoch argues that *Bomb-itty of Errors* "devalues hip-hop as art by relegating rap to humorous accompaniment"; the result is that the audience feels that they are "watching a hip-hop minstrel show," or a show in which hip-hop culture is appropriated, repackaged, and stereotypically presented in texts and productions devoid of context and historicity.[6]

Unlike *Bomb-itty of Errors*, Cabico's *Filipino Shuffle* challenges the very definition of hip-hop theater by pushing it as an artistic medium to include works, subjectivities, and communities that do not overtly fall under the parameters of what constitutes hip-hop. As historicized by Raquel Z. Rivera, hip-hop's cultural formation draws on the shared

histories, geographies, and lived experiences of African Americans and Caribbean peoples in the United States. Specifically, these cultural expressions emerge from a common African source rooted in "creolization processes dating to the early days of slavery in the Americas as well as to heavy migration within the Caribbean and between the Caribbean and the United States."[7] Cabico, as the child of Filipino immigrants who grows up in Washington, DC, alongside African Americans, and who later moves to New York City and begins performing at the Nuyorican Poets Cafe, situates his performance persona within hip-hop and its aesthetic practices. As a Filipino artist, he has a relationship to the Nuyorican and Puerto Rican history and communities that parallels the entwined histories of African Americans and Puerto Ricans detailed by Rivera.

Both the Philippines and Puerto Rico have long-standing colonial relationships to the United States, serve as military outposts for US imperial interests, and were Spanish territories, alongside Guam, until the end of the Spanish-American War in 1898 when the Treaty of Paris resulted in the transfer of territorial control from Spain to the United States. Initially designated as unincorporated territories, they were later granted commonwealth (arguably, colonial) status. The Philippines and Puerto Rico also share a history of being "foreign in a domestic sense," evidenced by the Insular Cases regarding trade and revenue beginning in 1901 that brought to light the relationship between the peoples of these territories and their protection, or lack of protection, under the Constitution.[8] Specifically, "the Insular Cases held that the islands belonged to but were not part of the United States," resulting in the formation of two types of US subjects—"the imperial citizen and its uncanny 'unincorporated' double, the colonized national."[9] This means that both Puerto Ricans and Filipinos have historically functioned as colonial subjects under US sovereignty while not being fully incorporated into the US body politic. In turn, although the Philippines has since become a democratic republic, Puerto Rico and Guam remain commonwealths/colonies; and all three remain military outposts for the US army alongside Guantánamo in Cuba. The relationship between the Philippines and Puerto Rico helps me to frame Cabico's inclusion/participation in specific histories and art worlds of New York City. In addition, although officially positioned distinctly as a democratic republic (Philippines)

and a commonwealth (Puerto Rico), both are initially subjected to what cultural sociologist Julian Go defines as tutelary colonialism. Tutelary colonialism is an American colonialist project intent on transforming the Philippines and Puerto Rico into clones of the United States in terms of both national identity and governmental practices.

Premised on the ideology that these colonies were unfit to govern themselves and needed the United States, tutelary colonialism served as the mechanism through which the United States sought to maintain total control over Puerto Rico and the Philippines. Both territories were only allowed to vote in elections for local government officials but not in national elections, a practice still currently in effect with respect to Puerto Rico.[10] Go's analysis of the relationship between the Philippines and Puerto Rico proves useful because of his focus on culture and how the United States utilized its control over these two territories as a means of cultural transformation. The United States aimed to dismantle any and all "local practices, forms of authority, and meaning structures" that American officials deemed "retrograde, backward, and uncivilized."[11] Go, drawing on the work of Bernard Cohn and Edward Said, "consider(s) culture as a *semiotic system-in-practice*, a matter of signs, cultural schemas, and meaning making."[12] Thus, *Filipino Shuffle* as a theatrical production, based on the vernacular cultural productions of spoken word and slam poetry, and grounded in the hip-hop aesthetics of sampling and remixing, helps to create a system of meaning that provides a vehicle for making visible the queer, Filipino subjectivity that Cabico represents. This interconnectivity between formerly colonized peoples living within the metropole—in this instance, Manhattan—is historically consistent for cultures and communities of resistance in the postcolonial era and functions as a hallmark of what I am calling the nuyorican aesthetic, formed by queer and trans artists of color at the Nuyorican Poets Cafe in the 1990s.

An award-winning slam poet and spoken word artist, Cabico earns the title of 1993 Nuyorican Grand Slam Champion and wins top honors at both the 1994 and 1997 National Poetry Slam competitions. In *Filipino Shuffle* he does not demonstrate the performance affect associated with hip-hop–influenced spoken word, such as using rap or referencing hip-hop culture in his delivery, which challenges existing scholarship analyzing poetry competitions. For example, fellow poet and theorist Susan

B. A. Somers-Willett attributes the success of many slam poets to their usage of "rhymed, metered verse" that uses "the hip-hop idiom" and attributes this to the popularity and influence of contemporary programs such as *Russell Simmons Presents Def Poetry Jam*.[13] In contrast, Cabico, a graduate of New York University's Tisch School of the Arts, employs a performance style that reads as more musical theater and stand-up comedy than rap. Instead of simply including one of the four elements of hip-hop or adapting a traditional text, as in the case of *Bomb-itty of Errors*, Cabico develops a nuyorican aesthetic by recombining queer aesthetic tropes with the hip-hop practices of sampling and remixing in order to work with and through hip-hop as a mode of racial-sexual performance.

From Nuyorican Politics to nuyorican Poetics

As stated earlier, my decapitalization of the term "Nuyorican" as "nuyorican" is meant to emphasize the political resignifications of works performed by queer and trans artists of color at the Nuyorican Poets Cafe in the 1990s and early 2000s. Cabico, for example, criticizes the exclusion and misrepresentation of Asians on stage and screen through sampling and remixing, while strategically utilizing queer parody and camp as critical modes of melodramatic performance. I agree with Somers-Willett that poets performing recognizable versions of themselves on stage and in slam competitions are rewarded by audiences who prize performers for what they perceive as "authentic" performances of self. "Authenticity" references a legibility based on constructed ethnic and racial stereotypes, signaling a particular racial, ethnic, sociocultural position and politics within a performance genre defined by an assumed auto-referentiality. Poets in slams are then judged on their adherence to the veracity of the text as signaled by their physical gestures and appearance.[14] Thus, the performance is not only about what is written on the page, but about how the poet performs their text and how their message is reflected in their presentation of self. Because hip-hop and spoken word emerge from marginalized communities—be they class-based and/or racially and ethnically marked—there exists an emphasis on "keeping it real." This is because both genres stress orality as a way to give voice to marginalized communities, as demonstrated in how

rap lyrics initially articulate "the political, social and economic disenfranchisement of New York's Black and Caribbean populaces."[15] With increased visibility through mediated circulation in the mid- to late 1990s, an increase in commercial and monetary success occurs for both rappers and slam poets. Thus, the pressure to articulate "real" or "true" stories through verse begins to operate in dialectical tension with the promise of monetary success for artists who adhere to stereotypes and tropes, even if they deviate from their own life experiences.[16] Important to note is that, in spite of their similarities, I am not arguing that spoken word and rap are one and the same, but that there is a historical and aesthetic overlap, especially in terms of the poetic performances at the Nuyorican Poets Cafe and rap in its infancy.[17]

The relationship between hip-hop, as a cultural formation created by African diasporic peoples that begins in the Bronx, and the Lower East Side is evidenced in films such as *Downtown 81*, first shot in 1980–1981 and later released in 2001, and *Wild Style* in 1982. I focus on *Downtown 81*, starring celebrated Haitian-Puerto Rican artist Jean-Michel Basquiat, rather than *Wild Style* because *Downtown 81* focuses on a visual and textual articulation of the Lower East Side as the grounds for the nascent vanguard of hip-hop artistry: graffiti artists, musicians, dancers, and painters.[18] Indicated throughout is the cultural interplay of Caribbean and African American communities, whose artistic flourish on the Lower East Side operates in contradistinction to the Lower East Side's physical and economic deterioration, visually articulated in scenes of abandoned lots and rundown buildings. Basquiat's character, a version of himself, tags elliptical, koan-like phrases on rundown downtown buildings and walls, and in other scenes attends private parties and underground clubs that prominently feature DJs and b-boys among the artists, art collectors, and nightlife crowds. It is made pointedly clear that the visual, textual, and sonic worlds of downtown Manhattan are enmeshed and form a collage of communities and artistic technologies. The Lower East Side/Loisaida neighborhood, sited as the downtown of *Downtown 81*, is simultaneously economically impoverished and culturally thriving, a place where Black, Brown, and queer artists live, love, do drugs, and make art.

Located in the Lower East Side, the Nuyorican Poets Cafe, for example, shares much in common with Darinka: A Performance Studio on East 1st Street and P.S. 122, a venue that has since been renamed Perfor-

mance Space: New York. Both Darinka, named after owner Gary Ray's Croatian-born mother, Darinka, and P.S. 122/Performance Space: New York, like the Nuyorican, included artists working within different mediums and genres. At Darinka the emphasis was on people working within "performance, theatre, music, dance, film, video, fine art, and poetry and prose,"[19] while at P.S. 122 the focus was on dance, movement, and experimental art forms beginning in the late 1970s. Open for only a year and a half (circa 1984–1985) during the time that the Cafe was closed for repairs, Darinka includes performers such as Hal Sirowitz and Bob Holman, who both later find a poetry home at the Nuyorican after it reopens. Other performance clubs in the area, such as the music venue Limbo and the still-open Pyramid Club—a space that helps to define "the East Village gay and drag scene in the 1980s"—share less in common in terms of performance genres with the Cafe.[20] All, however, are bound together by a desire to create work that pushes the traditional disciplinary boundaries of what constitutes high art, and form a part of the neighborhood documented in *Downtown 81*. This neighborhood serves as the geographic homespace of the Nuyorican Poets Cafe and the queer lifeworld inhabited by Cafe co-founder Miguel Piñero that I analyze in chapter 1. Unfortunately, by the end of the 1980s, Darinka and the Limbo Lounge close, and Basquiat and Piñero are both dead. But the end of the 1980s is also marked by poet, performer, and poetry activist Bob Holman bringing poetry slam to the Cafe.

Poetry Slam in Loisaida

In discussing the Lower East Side, and Loisaida specifically, Cabico articulates his experiences with its changing geography:

> In 1993, you'd have to be desperate, looking for crack, dodging bullets, or a homeless mole person hobbling up the sewers just to read your poetry on 3rd street between Avenues B and C. With craggily poets hunched over wine, the tall ceilings and balcony seemed to be this church-like Alphabet City home for poets. There was something sacred and ornery about the Nuyorican Poets Cafe; it was like you'd expect a ball of tumbleweed to roll through. The poets of all ages and styles were downtown characters mingling in another universe.[21]

This scene of urban decay, economic divestment by the city and real estate developers, as well as drug use cinematically captured in *Downtown 81* serves as Cabico's introduction to the Nuyorican Poets Cafe's spoken word scene. In particular, Cabico's work signals how the Friday Night Poetry Slam, first introduced by Holman in the late 1980s, shares more in common with the experimental downtown arts scene than the current hip-hop–driven, commercialized entity it has since become.[22] Significantly, the Slam during the late 1980s to mid-1990s reflects the geography surrounding the Cafe as cinematized in *Downtown 81*; the Lower East Side was not the increasingly sanitized and more economically affluent place frequented by New York University students that it is today.[23]

Cabico's career as a performance poet at the Nuyorican begins in the early 1990s, after he graduates from New York University, with his participation in the Wednesday Night Poetry Slam Open, the precursor to the Friday Night Poetry Slam. For the Wednesday Night Poetry Slam Open, the first twenty poets who sign up compete against one another in order to determine the winner, who, at that time, wins a total of ten dollars and is tapped to participate in the Friday Night Poetry Slam scheduled for that week. During Wednesday's event, poets face off for three rounds, with the poets receiving the lowest scores eliminated as the rounds progress. Thus, while the first round includes twenty poets, the second round includes ten, and the final round includes five.[24] Competing in the Friday Night Poetry Slam holds the promise of potentially winning the Nuyorican Grand Slam Championship. The multitiered nature of the Wednesday Night Poetry Slam Open offers poets competing in Friday night's competition the opportunity to hone their writing and performance within the rubric of slam poetry, a genre that ideally rewards textual dexterity and performance acumen.

The Nuyorican Grand Slam Championship as a title offers a small tangible economic reward, yet the opportunities presented to the winning poet extend beyond monetary compensation due to the highly competitive nature of the event.[25] For example, the winning poet must win a quarterfinal and semifinal bout in concurrent poetry slams—one loss and the poet must once again win an initial slam before proceeding to the quarterfinal. The winners of all five semifinal slams compete against one another in the Grand Slam Finale, arguably the most popu-

lar and well-attended poetry slam of the year at the Cafe. A poet who loses in the Grand Slam Championship can choose to participate in one of the runoff slams in order to earn a coveted spot on the Nuyorican National Slam Team, or wait to compete the following year in the hopes of earning the highly sought-after title of Grand Slam Champion.[26] While runoff slams determine four out of the five members of the National Slam Team, the Grand Slam Champion automatically earns a spot on the team. Competing in the National Poetry Slam competition affords poets the opportunity to showcase their work to fellow poets and audiences from around the world. Until recently, the Cafe allowed poets to participate as members of the Nuyorican National Slam Team only once, guaranteeing the opportunity for a new crop of poets to share their work every year.

As a slammer, Cabico always closed out his third round with "Check One," a poem where he engaged with issues of race, class, ethnicity, sexuality, and shared histories with other marginalized peoples of enslavement and colonization.[27] There is no archival footage of Cabico performing this poem in a slam at the Nuyorican Poets Cafe in the early 1990s, yet his delivery as part of a TEDx talk in 2018 best replicates his performance.[28] For his TEDx performance, Cabico stands in the middle of a dimly lit stage with a spotlight on. He's wearing a white t-shirt, khaki pants, a blue silk robe tied at the waist, and dark blue/black shoes; his black curly hair is combed back. He keeps his arms at his sides as he begins reciting his poem:

> The government asks me to "check one" if I want money.
> I just laugh in their face and say
> "How can you ask me to be one race?"

He delivers these lines with minimal corporeal movement, slowly raising his arms, punctuating his delivery of the line asking him to "check one" by raising his right index figure. He then lowers his arms again, never raising them higher than his midsection, and states,

> I stand proudly before you a fierce Filipino
> who knows how to belt hard-gospel songs
> played to African drums at a Catholic mass—

> and loving the music to suffering beats,
> and lashes from men's eyes on the capitol streets—[29]

He performs these subsequent lines with his palms open and parallel to the floor, his gestures functioning in physical dialogue with the air separating him and the floor. He raises and lowers his hands as if pumping the air at a slow and steady pace. Whenever he raises the volume of his voice, his arms function as a lever seeming to propel his palms downward as they press down harder, visually and sonically operating in a synchronous verbal and bodily flow. Textually, Cabico mocks and refuses the state's interpellative push for him to identify with one category or subject position. He proudly articulates his Filipino identity as one formed and informed by interactions and historical links to the cultures of other marginalized peoples. In positioning the "African drums" within a Catholic mass, he references the syncretic religious practices of Santería that emerge in Cuba and Puerto Rico after European colonization. In addition, as Tricia Rose writes, "slaves were prohibited from playing African drums, because, as a vehicle for coded communication, they inspired fear in slaveholders."[30] Cabico initiates a dialogue on religion and histories of resistance against enslavement through cultural practices. Alongside syncretic religiosity, Cabico expresses a queer desire and cites his natal geography when he references "lashes from men's eyes on the capitol streets." He continues:

> South-East D.C., with its sleepy crime
> My mother nursed patients from seven to nine,
> Patients gray from the railroad
> riding past civil rights[31]

These lines are performed with his arms rising above his midsection, his open hands gesturing upward, while he holds up seven fingers and then nine when discussing his mother's workday, his appendages mirroring the words he articulates. Cabico's delivery is one where there is minimal bodily movement aside from his arms and his hands, his gaze remaining fixed on the audience throughout as he comments on how South East DC, a majority-Black, economically depressed and criminalized area of DC, is the site of his mother's employment. Significantly,

Cabico aligns his poetic performance persona here within the history of civil rights protests and racial injustice.[32] Cabico's description of the patients his mother nurses as "gray from the railroad" operates on two levels. On one level, gray highlights DC as part of the southern United States—gray was the color of the Confederate uniforms. On another, gray operates as the metaphor for the illness and neglect that Cabico's mother confronts in her nursing patients.[33] "The railroad" mentioned in the poem references the underground railroad of slaves seeking freedom. Cabico deftly moves between broader issues impacting communities of color and the specificities of his colonized experience further in these lines:

> my comedy out-loud, laughing about, our shared,
> stolen experiences of the South.[34]

Here Cabico shifts his weight from his heels to his toes, leaning forward with his upper body, again raising his open palms and arms upwards slightly from his elbows, forming a ninety-degree angle with the ground as he smiles slightly. His facial expression is not one of laughter or happiness but of mirroring the word "comedy": it is a performative rather than affective gesture. Although Cabico smiles, his face remains serious, refusing to engage the audience in a humorous exchange. Instead, he moves between his reference to comedy and the colonized history of Filipinos:

> Would it surprise you if I told you my blood
> was delivered from the North off Portuguese vessels
> who gave me spiritual stones and the turn in my eyes—
> my father's name when they conquered the Pacific Isles.[35]

Cabico continues to stand still, punctuating his delivery with hand movements—the open and closing of his palms, the coming together of his index finger and thumb, while remaining rooted to the center of the stage. His arms never extend toward the audience, nor do they move rapidly; rather, they operate in conjunction with his performance. Cabico's is not the speedy delivery and singsong cadence currently associated with poetry slam; his version of poetry slam is rooted in storytelling and

theatrical monologue rather than a catchy phrase, call-and-response, or the repetition of phrases.[36] He continues:

> My hair is black and thick as "negrito," growing abundant
> as "sampaguita"-flowers defying civilization
> like pilipino pygmies that dance in the mountain.[37]

Cabico's description of his hair and his usage of the Spanish diminutive term for black, "negrito," when positioned alongside sampaguita, the national flower of the Philippines, and the term "Pilipino" rather than "Filipino," map the post/neocolonial construction of his ethnic and racial identity as well as his poetic counter-articulation toward a coalitional racial politics for the formerly colonized.[38] After historicizing his subject position, Cabico then engages with the particularities of his lyric performance identity by positioning global cultural productions within a US framework:

> and you want me to sing one song?
> I have danced jigs with Jim Crow and shuffled my hips
> to a sonic guitar of Clapton and Hendrix,
> waltzed with dead lovers, skipped to bamboo sticks,
> belted kabuki and mimed cathacali
> arrivedercied-a-rhumba and tapped Tin Pan Alley—
> and you want me to dance the Bhagavad Gita
> on a box too small for a thumbelina-thin diva?[39]

Cabico sways a bit during this culminating moment in the poem, feet planted firmly on the floor while his upper body moves from side to side just a bit, punching his arms through the words as he lists the complexities of his identity, resulting in a series of finger snaps and an audible intake of breath from the audience. Due to the consistent rhythm of his delivery, Cabico's cathartic release at this moment functions as a crescendo based on a measured dance between textuality and physicality—not on the raising and lowering of his voice, but on the mastery of his written words and his ability to engage in a dialogue with the audience. Moreover, as he provides examples of different global practices, his wordplay serves as poetic resistance to the reduction of his

multifaceted identity to a single component, one that initiates the poem, as discussed earlier. His question "and you want me to sing one song?" urges audience members to also interrogate the irreducibility of their own multifaceted identities when confronting the state's monological acts of interpellation.[40] Further, Cabico's poem urgently challenges static constructed notions of authenticity predicated on state recognition, proposing instead that identity is about blood, proximity, and practice.

Cabico's poetic intervention of "Check One" and his symbolic and coalitional alignment with different ethnic and racial groups resonate with the work of theorist Kandice Chuh. Chuh examines the ways Filipinos operate both within and outside the "Asian" and "American" imaginary. She argues that "histories of multiple colonizations make it impossible to fix definitive origins, as does the diversity of the social and cultural formations among people residing in the Philippine islands."[41] In "Check One," Cabico navigates the instability of a fixed identitarian category such as "Filipino" through his usage of a nuyorican aesthetic grounded in his own personal and plural ethnic and racial history. Through this poetic intervention Cabico parallels Chuh's discourse on whether it is still "clear—if it ever was—that the subject ('American') is a discreetly bonded, discreetly knowable entity merely modified by a subjective ('Asian')."[42]

Cabico engages this lack of fixity with respect to identity demarcation by utilizing the nuyorican aesthetic alongside the hip-hop aesthetic practices of sampling and remixing in *Filipino Shuffle*. The nuyorican aesthetic Cabico performs draws from previous countercultural productions created at the Cafe. *Filipino Shuffle* follows the trajectory initiated by the Nuyorican Poets Cafe Theatre Festival, a festival that began in the 1970s in order to enable "all actors of color to drop their bandanas wrapped around their heads, pull the razors out of their pockets and the knives from their jackets, and just act."[43] Ntozake Shangé's *for colored girls who have considered suicide / when the rainbow is enuf* is one of the most widely recognized shows presented as part of the Cafe's Theatre Festival. A set of twenty separate poems choreographed to music and engaging with issues of love, loss, empowerment, and struggle in relationship to sisterhood, Shangé's theater piece introduces "the word 'choreopoem' into the then, as it is now, predominantly male, White, and often stale landscape of American theater," breaking ground and

developing "an entirely new format for expression."[44] In describing the significance of Shangé's choreopoem, Nuyorican Poets Cafe co-founder Miguel Algarín shares that her production demonstrated how poems, "when read aloud, had the potential of becoming theatre in the hands of the right director."[45] Specifically, the choreopoem operates as a tangible aesthetic contribution bringing together poems as monologues in the service of creating a poetic narrative drama. Cabico's *Filipino Shuffle*, similar to Shangé's *for colored girls*, utilizes poetry in order to create his dramatic production; yet Cabico moves away from the choreopoem genre through his usage of prose, parody, and camp alongside the hip-hop aesthetic practices of sampling and remixing. Specifically, Cabico uses his poetry to create his own theatrical piece, initiating a dialogue on the dearth of roles offered to actors of color. Through *Filipino Shuffle*, then, Cabico actively works to debunk stereotypes and redefine the boundaries around artistic genres while pushing for a positioning of ethnic (re)presentation as fluid rather than fixed.

The first part of the show's title, "Filipino," directly references Cabico's Filipino ancestry. In analyzing Cabico's usage of the nuyorican aesthetic, an artistic practice that draws from the recuperative history of the ethnic marker "Nuyorican," we should recall the shared colonial history of the Philippines and Puerto Rico explicated earlier in this chapter. The second part of the show's title, "Shuffle," references the 1987 Robert Townsend satirical film *Hollywood Shuffle*. This major motion picture—focused on a Black actor named Bobby Taylor, played by Townsend, who grows tired of being offered stereotypical bit parts and seeks recognition as a potential leading man in blockbuster films—serves as the backdrop for Cabico's theatrical production.[46] In *Hollywood Shuffle*, Taylor must learn how to "act Black" according to the definition put forth by Hollywood casting agents. Taylor exaggerates the stereotypes historically assigned to Black peoples on stage and screen. For example, Taylor stands in front of a mirror and begins to bug out his eyes and stick out his rear end while speaking in exaggerated ebonics or stereotypical urban Black vernacular speech.[47] Townsend situates the construction of Hollywood's limited conception of "Black" identity as performance by having Taylor constantly practice his lines in front of his bathroom mirror. As he rehearses his dialogue, he contorts his face into contrived facial expressions in an attempt to appropriate the affective qualities that will

result in his being cast in a leading role. Drawing on Townsend's satirical critique of Hollywood casting practices, Cabico's *Filipino Shuffle* uses the audience in much the same way that Townsend's character uses the mirror—to rehearse, enact, and satirize Hollywood's racist and sexist tropes. Cabico's performance begins with him moving between direct addresses to the audience and his portrayal of a campy version of his mother. Through his mother, Cabico provides the audience with some insight into his personal history and performance trajectory. Beginning with the title and moving through the first parts of *Filipino Shuffle*, Cabico fashions alternate versions of *Hollywood Shuffle* and another full-length mainstream film, *Monster's Ball*, where he inserts himself as the main character. In positioning himself as the protagonist, Cabico forces the audience to move beyond the tropes associated with his ethnicity and sexuality, rejecting his framing as a fetishized object, subject to orientalization.

The title *Filipino Shuffle* hints at the recombination of various topics and artistic forms that Cabico employs. For example, Cabico uses sampling the moment he steps onto the stage singing the Barbra Streisand classic "The Way We Were" (from the eponymous film). While the show's title operates as a type of performative sampling by Cabico, this particular moment is the first instance of sonic sampling. Danny Hoch defines sampling as the process through which a portion of a song is "borrowed" in the creation of another song—it can be used as the intro to a new song or as the portion of a song that is looped (repeated throughout, similar to a chorus that is sung).[48] Sampling enables the creation of a new artistic production while utilizing a snippet or sample of an already existing composition. Sampling usually involves the borrowing of a drumbeat or a verse from a previously recorded song, resulting in a new version, termed the "remix." I frame "remixes" as analogous to "versionings," which are "mixes of the old and the new."[49] As Tricia Rose argues, samples allow for a narrative reformulation enabling the "*referenced version*" to take on "*alternative lives and alternative meanings* in a fresh context."[50] For Cabico, sampling becomes a way to redefine how particular sounds can be used—and, in the case of *Filipino Shuffle*, what that particular sound ultimately does.

For example, through his sampling of "The Way We Were," Cabico simultaneously addresses his identity as both Filipino and queer through

a melodramatic performance of his mother. As he sings in character, Cabico makes Pancit noodles, a traditional Filipino dish. His re-versioning of the song's second line from "light the corners of my mind" to "like the corners of my eyes" transfers ownership from Streisand to Cabico's mother and recodifies the new version as an ethnic immigrant narrative, evidenced by his singing in a heavily accented English. Cabico's remix also makes clear his desire to upend stereotypes projected onto Filipinos and highlight the historical effects of colonialism on the Philippines, in particular, how the ability to mimic US cultural productions reflects President William McKinley's "benevolent assimilation," with Filipinos expected to "imitate American modes of public and private life."[51] To be sure, "mimicry of American ways of doing, knowing, listening, buying, believing, and being was thus rendered equivalent with their personal and collective success" throughout "the duration of American colonial rule."[52] In turn, as entertainers who are faithful to original music scores and texts, even more so than their US counterparts, Filipinos are able to participate in what Abigail De Kosnik, citing Arjun Appadurai, describes as the "hyper-competent reproduction" of songs and dances that serve as a "valuable export commodity for the Philippines."[53] Through his re-versioning and resulting remix of the Streisand classic ballad, Cabico contests histories of Filipino colonial subjects whose labor as cultural (re)producers is exported as a signpost of their "Americanness." Importantly, Cabico's remix of Streisand's "The Way We Were" points to the ways Filipinos navigate their experiences in the United States—adept in their own cultural practices, as well as fluent in other cultural forms. Significantly, through his version of "The Way We Were," Cabico camps up his racialized ethnicity and his Filipinoness while queering identities through an aesthetic refashioning of pop culture and cross-gender performance.

Following his remix of "The Way We Were," Cabico performs another character, his father. Cabico enacts a three-way dialogue in which he tries to convince his parents to allow him to attend the Duke Ellington School of the Arts in Washington, DC, as opposed to the all-boys Catholic school that they, his mother in particular, want him to attend. In this scene, camp humor and racial melodrama relay Cabico's relationship with his devoutly Catholic mother. Camp, as "the strategic response to the breakdown of representation that occurs when a queer, ethnically

marked, or other subject encounters his or her inability to fit within the majoritarian representational regime," allows for the queer and ethnically marked Cabico to insert himself within the majoritarian sphere of hip-hop theater.[54] Further, camp enables Cabico to create this particular type of theater by utilizing the aesthetic practices associated with hip-hop and queering them. Cabico's sampling and resulting remix, in conversation with camp, help him to enter into a dialogue between queer artistic productions and hip-hop *via* theater.

Cabico continues to employ camp as a queer performance methodology, inserting its aesthetic protocols into the nascent nuyorican aesthetic. This intervention is at its most evident and comically effective when he relays his mother's reaction to his expressed desire to attend a performing arts school, evidenced by his mimicking of her raising her hand in prayer to the Virgin Mother. Here, his mother stands center stage, staring upward while pretending to hold a telephone up to her ear, and says, "the Blessed Mother is talking to me," followed by this dialogue:

BLESSED MOTHER: Tell Regie—
REGIE'S MOTHER: Uh-huh.
BM: He has to go to the all-boys Catholic school.
RM: Uh-huh.
BM: Forget Duke Ellington and tell him also—
RM: Uh-huh.
BM: He has to have girlfriend when he is thirty years old, because if he has girlfriend now he will go into mortal sins.[55]

After this exchange between the Blessed Mother and his own mother, Cabico speaks directly to the audience, articulating his same-sex desire beginning with his crush on his childhood priest. The campy rendition of "The Way We Were" alongside the mimicry of his mother and her heavily accented and grammatically incorrect English are all precursors to this particular moment in the show, as it offers Cabico the opportunity to directly address his sexuality alongside his ethnicity. Cabico starts by once again standing center stage, only this time he breaks the fourth wall and speaks to the audience as himself. In keeping his arms down at his sides, with his palms facing downward, Cabico's performance differs

aesthetically from the hyper-exaggerated performance of his mother. He lowers his voice and slows down his cadence as he says, "I knew about sins, I went to confession every week." He proceeds to describe his priest, Father MacGregor, who wore a maroon Izod pullover sweater with tight black Levi corduroys, smelled like Old Spice, and had big bushy eyebrows like Brooke Shields. Cabico's detailed description of his priest foregrounds his erotic desire for Father MacGregor, a same-sex longing declared in the following line: "I was in love with him, the way that Rachel Ward was in love with Richard Chamberlain in *The Thorn Birds*." *The Thorn Birds*, a mini-series that aired in 1983 starring Ward as Meggie Cleary and Chamberlain as Father Ralph de Bricassart, her family priest, engages with the theme of forbidden love and the conflict between their love for one another and de Bricassart's commitment to his faith.[56] Cabico appropriates the character played by Ward and enunciates his erotic attachments and libidinal wants, while MacGregor assumes the role of Chamberlain, standing in for the unattainable religious figure.

I return to the process of looping, as the repetition of a particular beat or element of a sample, that herein allows for the narrative recontextualization posited by Tricia Rose. Yet Cabico's sampling also uses camp as a way to combine the sonic and the visual, enabling his appropriation of the television character played by Ward. In this scene, Cabico sits on a chair in the middle of the stage and says, "nasty hooky thorns, nasty hooky thorns, nasty hooky thorns" thrice before generating a guttural sound that seems to combine the hissing of a cat with the growling of a tiger.[57] While making this sound, Cabico positions his hands in the shape of claws, opening and closing them, simultaneously jutting his torso out toward the audience. The guttural sound he makes throughout operates as sonically similar to the scratching sounds DJs make when rotating records back and forth on turntables. This scratching alongside the looping operates as an important component of what Hoch defines as an expected and important component of hip-hop theater, DJ aesthetics. Scratching and looping enable "DJs to ultimately become composers in their right."[58] Cabico, by sampling and subsequently remixing *The Thorn Birds* through scratching and looping, composes a queer version of this melodramatic romance novel and television series.

The Catholic Church for Cabico, as opposed to his mother, becomes the space of desire; of public address, not cloistered confession; and of homosexual fantasy and its romantic enactment. It becomes the site of dramatic resolution of the familial conflict performed earlier in the night. Although he auditions and is subsequently denied entry into the Duke Ellington School of the Arts, Cabico still wishes to pursue a career as a performer and tells his mother about his auditioning for a role on the crime show *America's Most Wanted*. As a crime reality show hosted by John Walsh, this television program seeks to track down and apprehend fugitives with the help of the audience, who can call in with clues and tips, including possible criminal sightings.[59] The weekly telecast involves reenactments of crimes, and Cabico auditions for the role of a murderer in one of the upcoming episodes. Once Cabico tells his mother, he mimics her response for the audience by standing center stage and rapidly making the sign of the cross as she repeatedly says, "Oh Regie, that is so good for you! I know that you could be the killer."[60] Cabico's mother then goes on to tell everyone at their church parish, who then proceed to walk around in a circle, similar to a Greek chorus in classical drama, while making the sign of the cross and chanting, "Let him be the killer, let him be the killer, let him be the killer."

In this particular moment, Cabico remixes the significations of the Catholic Church from a site of homophobic repression to a social space for both recognition and misrecognition. This multifaceted approach to one ideological state apparatus is a signal aspect of the nuyorican aesthetic I theorize with the trans and queer artists of color under investigation throughout this book. In turn, the critical writing of Martin F. Manalansan IV helps me to understand how the church enables Cabico's navigation of his Filipino queerness. Manalansan frames his investigation of Filipino social drama within the rubric of two terms: "biyuti" and "drama." "Biyuti" signifies beauty, loosely translated, and also refers to the flow of the everyday, to feelings and to the self.[61] "Drama" indicates theater or theatrical productions in addition to "occupation, sexuality, personality and personhood."[62] Manalansan argues that these concepts, while functioning as a specific aspect of gay Filipino men's argot, provide a useful lens for analyzing the everyday lives of "mainstream" Filipinos. Manalansan proposes that "family life, praying, and 'having fun' are significant and signifying sites of negotiation and contestation."[63] These

quotidian acts, particular scriptings or improvisations, circulate within a transnational framework and result in the rewriting of the Filipino body during these moments of "karaoke sing-along, a block rosary group, and a family dinner."[64] In other words, these everyday spaces—the home, the church, and the restaurants where families congregate—are sites for the negotiation and the vernacular articulation of queer identity.

Through his critical analysis, Manalansan takes into account "emic notions, historical conditions, and structural positions," drawing on the work of Erving Goffman and Victor Turner.[65] Manalansan extends his examination by turning to gender theorists such as Judith Butler and her discourse on the performativity of gender. In bringing these two theoretical frameworks into conversation with one another, he constructs his own theory on a type of performance that he defines as "positioned performance." "Positioned performance" is the way performance, situated within divergent hierarchies, is not only grounded in theory but also read from the "'actors' point of view and cultural knowledge."[66] This type of theory positions the informant as social agent and takes into consideration the informant's definition of performance. Manalansan focuses specifically on gay Filipino men and their strategies of survival, with survival referring to "quotidian struggles that may or may not 'make sense,' or routines or habits that become part of a daily living that is neither a celebration of resistance and contestation nor assimilation."[67]

Cabico shifts from the church as a site of sardonic negotiation to the social space of a bar in order to describe his experiences picking up men and how he is exoticized and othered due to being Filipino. He performs a White suitor who tells him, "You Orientals have the best skin. What do you use?" This is followed by Cabico's response, "Well, we use the pearrrrrrrlllllllll creeeeaaaammmmm," and "I got a pint on the side, it's chicken fried rice." After this interaction, Cabico shares another instance where a White guy approaches him and says, "Oh, you speak such beautiful English," prompting Cabico to answer, "Ohhhhhhhh, you most beautiful man in the worrrrld."[68] Cabico delivers his verbal retorts while scrunching up his face, squinting his eyes into little slits, and smiling broadly, his countenance, alongside his final gesture of pressing his hands together as if in prayer and bowing, referencing racist tropes of Asian deference. Cabico takes on stereotypically constructed renderings of Asianness—the speech patterns and accent of someone who learned

English as a second language, for example—in order to work toward dismantling them. Somers-Willett cites the poetry of Chinese American slam poet Beau Sia, who, like Cabico, critiques the roles offered Asians in mainstream entertainment. Sia exaggerates his embodiment of stereotypes of racial identity in order to transcend them, "asking his audience to question their assumptions about and consumption of performances of racial identity."[69] Here we see the racial shuffling that the piece's title plays off of in relation to Black minstrelsy and stereotyping as seen in *Hollywood Shuffle*. This critique further evidences how Cabico challenges stereotypes surrounding Asians and rejects his role as a fetish object.[70]

In addition to Cabico's statement on racialized fetishism, this scene also pushes toward a redefinition of hip-hop theater by elaborating a critical sexual discourse not evident in Hoch's essay nor regularly performed up until that point at the Nuyorican Poets Cafe.[71] The Cafe, as a space located within "a neighborhood that is an intersection point for Latino, African American, Asian, Italian, and Eastern European peoples," continues to advocate for the creation of art that is relevant to "these diverse communities" in spite of increasing gentrification.[72] Moreover, as demonstrated by the work of Shangé, the Cafe has historically showcased the work of artists attending to the politics of identity whose productions do not fall within the traditional parameters of what constitutes theater or performance, thus serving as the ideal place for Cabico's brand of theater. His version of theater explores what it means to be both queer *and* Asian through performance, subject positions not often critically interrogated in hip-hop but part of the coalitional politics that I name as constitutive of the nuyorican aesthetic.

Cabico's poem "What Kinds of Guys Are Attracted to Me" is a part of the script of *Filipino Shuffle* as well as a stand-alone piece of writing he performs at the Cafe and on HBO. I problematize the limited definition of hip-hop theater and the construction of productions that fall within this genre by examining Cabico's performance of "What Kinds of Guys Are Attracted to Me" as a singular spoken word piece and not as part of the script of *Filipino Shuffle*. Differences in presentation, relationship with the audience, gestures, and overall affect emerge when Cabico performs this piece as part of *Filipino Shuffle* at the Nuyorican Poets Cafe versus on the soundstage for *Russell Simmons Presents Def Poetry Jam*

in 2002. *Def Poetry Jam*, a show on Home Box Office (HBO), produced by Russell Simmons as a spin-off of his successful comedy show, *Russell Simmons Presents Def Comedy Jam*, showcased the work of spoken word artists, slam poets, and well-known performers across genres. Participants included hip-hop artists such as Kanye West, singer Smokey Robinson, and legendary actress Ruby Dee. In bringing together a diverse group of artists at different stages in their careers while creating art in different sectors of the entertainment industries, the show cast a wide net in terms of attracting viewers and audience appeal, operating as a commercial venture where the artists and their cultural productions ultimately devolved into commodities. With Simmons, widely recognized as the "Godfather of Hip-Hop," at the helm and rapper/actor Mos Def (Yasiin Bey) serving as the host, the artists understood that the work presented had to be palatable to an audience rooted in a hip-hop/urban aesthetic. Simmons originally managed the career of foundational rap group Run-DMC in the early 1980s, co-founded the Def Jam recording label in 1984 (a label once run by rapper/hip-hop impresario Jay-Z), and founded the Phat Farm hip-hop clothing line in 1992.[73] Invested in representing and promoting the urban underclass as a niche market and brand, Simmons provided the show with automatic credibility and recognition within hip-hop circles.[74] Cabico, as a former Nuyorican Grand Slam Champion, is also granted a certain credibility due to the Cafe's position within spoken word and slam poetry communities. The Nuyorican Poets Cafe, while not the place where poetry slam began, is the place where disenfranchised poets, and urban poets of color specifically, feel that they can relay their life stories through verse. Cabico's winning of this title demonstrates his ability to communicate with different audiences and communities by speaking within recognizable vernaculars of race politics while simultaneously introducing new aesthetic modes to articulate ethnic, sexual, and (neo/post)colonial difference. The value of his work lies in his ability to bring together the text with the performance, his poetry alongside his musical theater and comedy.

For his performance on HBO, Cabico wears a light gray suit jacket and matching slacks, a pastel printed shirt with an open collar, and underneath that a teal blue t-shirt; his black curly hair is combed back. He begins his delivery by speaking directly to the audience. This performance, similar to that of *Filipino Shuffle*, bears little trace of what Jorge

Ignacio Cortiñas describes as "the dreaded cliché of the spoken-word scene."[75] Cabico walks to the middle of the short catwalk stage, presses his hands together and raises them in appreciation of the DJ playing his introductory music, turns to face the audience, slightly moves his shoulders back and forth while lifting his arms at a ninety-degree angle with the ground, then positions his palms facing up as he declares, "I finally figured out what kinds of guys are attracted to me."[76] The audience erupts with laughter, cheers, and applause. Cabico then shifts his shoulders and arms, and here we see how, in the context of the HBO soundstage and televisual dissemination, Cabico changes his physical gestures. After he delivers the lines "You Orientals have the best skin. What do you use?,"[77] Cabico's response of "We use the pearl cream" is performed with a different affect. He recites these lines in conversation with the audience, pausing as they laugh, leaning to one side, moving his arms and upper body more, then smirking as a wink to an audience that responds in agreement. Cabico does not include the exaggerated corporeal movements or the elongated *l*'s and rolled *r*'s as part of his delivery; he physically articulates the difference between his version of hip-hop theater for an audience at the Cafe and his televised spoken word performance of the same poem.

Writing on hip-hop theater, Cortiñas argues that "hip-hop as an African-American cultural phenomenon" influences the cadence and gesticulations used in the creation of hip-hop theater pieces.[78] For Cortiñas, this cadence and corporeal expression operate as part of a cliché that fails to take into account the plurality of raced histories and identities present in globalized hip-hop culture and products. Similarly, Somers-Willett writes about the ways the hip-hop idiom informs identity in both content and delivery in slams, focusing on the relationship between hip-hop cultural practices and the rewarding in poetry competitions of African American poets resisting their marginal positions through verse. While Cortiñas and Somers-Willett serve as useful entry points for an analysis of Cabico's work as a form of hip-hop theater, the nuyorican aesthetic with its history of divergent voices alongside countercultural productions offers up another lens through which to frame Cabico's writing and performance. Refusing to pander to ethnic stereotypes or to attempt appealing to an audience seeking an authentic "urban" (meaning heterosexual and masculine) performance aesthetic, Cabico challenges these

stereotypes surrounding race, ethnicity, sexuality, and gender on slam and spoken word stages while occupying the much sought-after HBO set. In choosing not to employ the now-standard and often mocked staccato cadence or the singsong voice of spoken word poets, replete with familiarized and rehearsed gestural vocabulary, Cabico advances a performative critique of spoken word strategies and hip-hop poetry's aesthetics—a nuyorican, not Nuyorican—aesthetic and queer politic. Cabico boldly declares his politics of refusal via a positioned performance, asserting,

> you wanna play with me?
> you can just stop orientalizing me!
> 'cuz I ain't gonna fry you
> an Emperor's meal
> or throw you Eurasia
> or fly you an opera[79]

As Cabico delivers the final line, he moves his arms, imitating the wings of a bird in flight. This physical gesture, a direct reference to *M. Butterfly*, alongside his request to stop orientalizing him, marks this piece as one of resistance to racialized erotic objectification.

Cabico further articulates his refusal to be objectified and reduced to constructed ethnic stereotypes and tropes in the scene in *Filipino Shuffle* where he describes the dearth of roles available to him as an actor following his graduation from New York University, just prior to beginning his spoken word career. Cabico reiterates his lifelong desire to perform, reminiscent of an earlier moment in the show when the audience witnesses him preparing for his audition to gain admission into the Duke Ellington School of the Arts. During that initial scene, Cabico stands center stage, raising and lowering his arms while running in a circle around the periphery of the stage and singing the lyrics to the theme song for the movie *Fame*. Cabico imitates the actress Irene Cara, who starred in the movie as Coco Hernandez and sang the film's titular hit song. During this moment, Cabico emphatically sings, "remember, remember, remember my name ... FAME!" while pointing to the audience and ending with a double-footed jump, arms outstretched over his head, both feet raised back off the ground as if ready to take flight.[80]

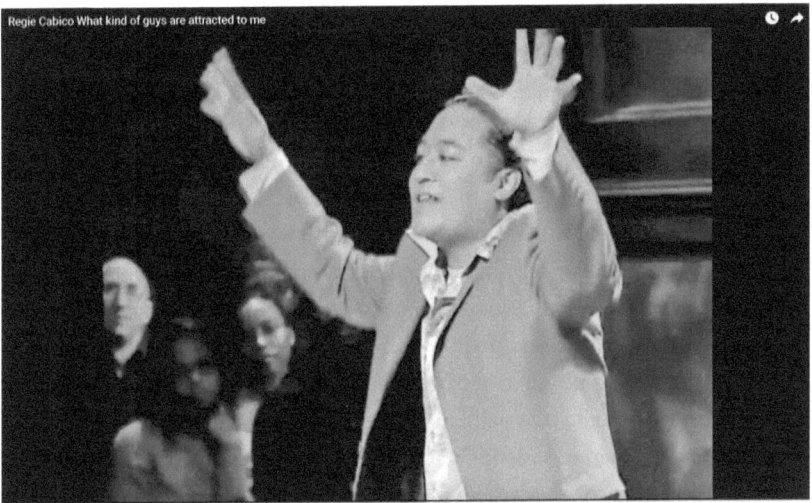

Figure 2.1. Regie Cabico performing "What Kinds of Guys Are Attracted to Me" on *Russell Simmons Presents Def Poetry Jam*, episode 2.3, aired July 5, 2002, HBO. Screenshot by author from YouTube, youtube.com/watch?v=3FY6FYTOEh0.

The movie *Fame* (1980) showcases the lives of a diverse group of students attempting to not only gain entrance to but also succeed at a school modeled on the High School of Performing Arts in New York City.[81] Coco Hernandez, one of the main characters in the film, is a Puerto Rican "triple threat"—a singer, dancer, and actress. *Fame* and the character played by Cara serve as the backdrop for Cabico and his search for Filipino celebrities who can serve as role models for him. Following his enumeration of several Filipino artists, including singer Prince and film actor Rob Schneider, Cabico reads (faux) letters he has written to other Filipino performers. The letter he writes to model, film and television actress, and singer Tia Carrere merits attention as it foreshadows a later scene.

For his reading of "Letter to Filipino Celebrity Number 2: Tia Carrere," Cabico holds up a piece of paper and reads aloud,

> I am so sorry that your action-adventure series *Relic Hunter* got cancelled. You were truly wonderful as an archeologist detective, crawling through mazes and Scooby-Doo like castles. I also like how you ran with a white towel through European forests while fighting off grenades and armed spies. You made the world *schwing* in *Wayne's World*. Tia,

Filipina beauty who displayed so much candor on every talk show. We could sell candy bars for every church group in America. You embodied the hospitality that Filipinos are known for. I am sure you could even play a nurse on *E.R.* too. I almost went to the E.R. when I saw you nude in *Playboy*. Why Tia? Was the cancellation of *Relic Hunter* so traumatic that you decided to hide naked in the grass huts? Your breasts were as full as thirty-two ounce San Miguel beer bottles but your skin was so brown it looked basted. Lying on your side you looked like dinner for thirty stranded boys in *Lord of the Flies*. I wanted to place an apple in your mouth. Why did you do it? Posing in *Playboy* did not help Dana Plato—she was Kimberly from *Diff'rent Strokes*.[82] If you wanted a career boost, do what Halle Berry did and have sex on screen with an older White guy. Instead of showing us your monster boobs and shaved nipa hut, posing next to wooden bowls and bamboo sticks, you looked like you were having an orgasm in Pier 1.

> With Much Love,
> Regie[83]

Through his faux letter to Carrere, Cabico performs for the audience a pointed critique of the objectification and commodification of women of color and their bodies in mainstream US culture. His seriousness as he melodramatically bemoans Carrere's artistic choices provides the humorous context to his critique of the media industry's sexed racism. In addition, the pop cultural references throughout place Carrere's "fame" within a particular time frame and geographic location—the United States, late 1980s and early 1990s. Cabico reclaims Carrere as a Filipina when he describes her as a "Filipina beauty," discussing her possession of a Filipino hospitality, comparing her breasts to San Miguel beer bottles (a Filipino beer) and, finally, referencing her shaved nipa hut.[84] This letter demonstrates Cabico's utilization of sarcasm in relaying politicized critiques of colonial residue and contemporary racism alongside systems of representation and their effect on Filipina/o viewers.

Furthermore, this letter utilizes the spoken word technique of making culturally specific, in-group references to reclaim an artist and subsequently publicly "shame" them for "selling out." "Selling out" refers to the moment a performer, in this instance a minoritarian one, opts for

commercial success by performing degrading racial, ethnic, and sexual/gendered stereotypes. Thus, inhabiting subject positions that affirm erroneous tropes for profit distinguishes "selling out" and merely creating or performing "bad art." Cabico accuses Carrere of inhabiting the role of the exotic, sexualized female Other who makes herself available for consumption by White mainstream audiences. Cabico's letter frames the ingestion of Carrere as both figurative and literal, referring to her overly tanned body as a meal for the boys in *Lord of the Flies*. The public shaming used in spoken word pieces, or in extended vignettes that form parts of shows like *Filipino Shuffle*, place the poet-performer in direct communication with the object under consideration, the subject of criticism and derision.

Even as he satirizes a TV actress for her mainstream achievement and for playing characters steeped in racial-sexual stereotype and cultural objectification, Cabico does not eschew his own commercial success, but rather problematizes the structures surrounding the attainment of mainstream media visibility. His work inserts Filipinos into the larger discourse on race relations, as evidenced by the moment in "Letter to Filipino Celebrity Number 2" when he tells Carrere, "If you wanted a career boost, do what Halle Berry did and have sex on screen with an older White guy."[85] This reference both foreshadows his critique of Berry later in the show and speaks to the trope of women of color as sexualized media objects. Cabico's admonishment of Berry occurs in the second part of *Filipino Shuffle*, where he remixes her film *Monster's Ball*. In Cabico's version, he takes on the lead role of Hank Grotowski, a White southern racist played by Billy Bob Thornton in the film. Grotowski works as a corrections officer on death row in a small southern town. Cabico satirically plays Grotowski in order to comment on race and its construction in the United States, elucidating, as he did in his HBO performance, a queer critique of hip-hop stereotypes.

The scene begins with Cabico facing the audience wearing a blue shirt unbuttoned with a white t-shirt underneath. He holds up a stick figure drawing with his left arm extended, his right arm firmly pinned to his right side as he begins to speak with a southern twang. He lowers the bass in his voice and speaks slowly and deliberately, the somberness of the moment contradicted by the raising of his right eyebrow coyly as he smirks while delivering his lines. The audience laughs as they recognize this as Cabico's own unique version of Hank Grotowski. The stick

figure drawing of a White man with tufts of blonde hair framing his face directly references the scene in the film where inmate Lawrence Musgrove, a role played by hip-hop impresario Sean Combs, presents Grotowski with a portrait Musgrove sketched of him. Cabico as Grotowski, holding up the childlike (White) stick figure as opposed to the carefully drawn image created in the film, employs comedy as a subversive tool in developing his critique of pop cultural representations of race relations. Parody proves useful within the framework of Cabico's hip-hop–inflected aesthetic because it enables him to expose racial representations and binaristic Black/White racial dichotomies.

While Cabico plays the role of Grotowski, spoken word artist and actress Yolanda Kay Wilkinson takes on Halle Berry's Oscar-winning role of Leticia Musgrove. In the Cabico parody, the character's last name changes from Musgrove to Squishaballs. This shift alerts the audience to the cause for Squishaballs's husband's death sentence—he flung his genitalia at a group of police officers. Here we see Cabico include the stereotype of the hypermasculine and genetically endowed Black male, whose penis is large enough to be flung at a group of police officers. While Cabico explains Squishaballs's "crime," Lawrence Musgrove's crime in *Monster's Ball* is never fully disclosed. The only reference to Musgrove's crime occurs in the scene with his son, where he self-identifies as a "bad man" and warns his son not to make the same mistakes he made.[86] Cabico, through his articulation of the reason for Squishaballs's sentencing, levies a sharp and hilarious critique of portrayals of Black men in film, where their execution serves as necessary for maintenance of the status quo. Squishaballs as a version of Musgrove represents the criminalization of Black men and their positioning as hypersexual fetish objects who challenge White male power and authority. Cabico also contests the portrayal of Black women by having Leticia Squishaballs, played by Wilkinson, work in an opium den run by a female Asian boss portrayed by poet/performer Aileen Cho, as opposed to the diner where the character Musgrove works in the movie.[87] Through these characters and revisions, Cabico appropriates ethnic stereotypes and, through parody, initiates a dialogue on interethnic relationships and sexuality.

Arguably the most problematic, reified, celebrated, and criticized scene in *Monster's Ball* is the sex scene between Leticia Musgrove and Hank Grotowski. The moment begins with Musgrove and Grotowski

sitting on her couch discussing the death of Musgrove's young son. As Musgrove cries, Grotowski leans over and says, "I'm sorry. What do you want me to do?"[88] Musgrove replies, "I want you to make me feel better. I want you to make me feel good."[89] She then proceeds to take out her breasts and lean into him as he begins to have sex with her. Throughout the scene, a topless Musgrove constantly repeats the refrain "make me feel good" while writhing on the ground on top of Grotowski. When viewed through a historical lens, this scene demonstrates the undeniable power dynamic and historical objectification of Black female bodies by White male authority figures, if providing the Berry character with a modicum of sexual and verbal agency and desire. For example, in an analysis of this scene, Jane Flax describes this moment as emblematic of "the often violent and predatory history of sexual power relations between White men and Black women."[90] Throughout the scene, Musgrove's body becomes more and more exposed while Grotowski's remains covered, if not by his clothing than by furniture or different props that obscure him from the spectator's view.

In Cabico's staging of the *Monster's Ball* sex scene within *Filipino Shuffle*, the overdetermined dialogue and mise-en-scène of Black and White raced (hetero) sexual relations are subverted toward laughter and queer critical ends. In particular, when Squishaballs aggressively pursues Grotowski, he looks around the stage uncomfortably, right eyebrow still raised while his lips remain pursed. Cabico's version positions Squishaballs as the agent of desire and catalyst for the pursuant sex scene. The blocking of the scene clearly marks Squishaballs as the aggressor—she advances while Grotowski turns away. He crawls away from her, she pursues him. Ultimately, he ends up bent over the couch, prostrated with his palms down on the seat cushions, facing the audience as she simulates anal penetration of him, grabbing his shirt as if it were a horse's reins. Squishaballs's face denotes the force and labor of this simulated sexual act, her exaggerated expression and gestures serving as a wink to the audience. The audience responds to this moment with knowing laughter, understanding the inversion of gender expectations and racial tropes within the remixed sex scene. I find this moment particularly valuable when discussing the nuyorican aesthetic because of how Cabico triangulates "American race relations beyond the conventional Manichean relationship of black and white."[91] He is a Brown man who plays a White

one who gets sexually dominated by a Black woman, sampling from queer sex in order to remix staid and binary race relations and bring gay camp to hip-hop theater's repertoire of aesthetic strategies.

Similar to Piñero, who in chapter 1 gestures toward the emergence of slam poetics to come at the Cafe and includes in his writing and performance political references and a queer affect and aesthetic through movement that claims geographic space in Loisaida, Cabico's work moves to include a queer theatricality, a wry sense of humor, and a Filipino identity as his resistant politic. For his part in *Filipino Shuffle*, Cabico draws from hip-hop aesthetic practices, including sampling and remixing, while refusing to be restricted by them. Rather than rapping, b-boying, or DJing on stage, Cabico samples popular culture and remixes it, and through this bricolage a nuyorican aesthetic emerges. This performative strategy offers up a more complex version of hip-hop theater in its incorporation of a melodramatic queer theatricality that positions immigrant Filipinos in relation to US Black and Latina/o racial-cultural formations.

Cabico is an important figure in the first wave of poetry slammers at the Cafe because, both formally and politically, he deviates from its established norms. These first wave poets, defined by Cristin O'Keefe Aptowicz as those who "enjoyed the spotlight that poetry slam provided but were also able to make the transition from faddish slam poets to established writers," are examples of the possibilities generated by cultural producers seeking to create work that addresses the lived realities of marginalized communities.[92] Cabico, for example, employs a nuyorican aesthetic to intervene in stereotypical constructions of ethnic and racial identity through his work. Through his skillful poetic delivery and his taking on of tropes, he works to dismantle them, not just with humor, but through anger and rage with a smile. He participates in a dialogue with those who experience his work, pushing them to confront their own notions surrounding identity formation, and the resulting misrepresentations on stage and screen. His performances make visible his understanding of who his interlocutors are: in "Check One" it is the US government, and in "What Kinds of Guys Are Attracted to Me" he confronts the White men seeking to exoticize and objectify him. In turn, his further development of a nuyorican aesthetic in *Filipino Shuffle* broad-

ens the scope of hip-hop theater as a performance genre, and helps to foster other critical interventions that serve as necessary tools for queer survival, similar to the work of Piñero, the performers in the Glam Slam, and the cultural productions of Ellison Glenn as Black Cracker that I interrogate throughout this text.

3

Tens across the Board

The Glam Slam at the Nuyorican Poets Cafe

It is January 2, 2018, and I am in New York City over the holiday break, having just hung up the phone after speaking with poet, novelist, and performer Emanuel Xavier regarding his work with the Glam Slam. Xavier began the Glam Slam in 1998 (I first attended in 1999 and later won in 2002) to bring together the competitive spoken word/slam poetry scenes and Harlem drag ball communities in New York City. The change from "Grand" to "Glam" highlighted the queer and camp glamour associated with ball culture and trans/drag/gay of color communities overall, signaling the "over-the-top" nature of the competition. Lasting until 2008, the Glam Slam was first held at Henry Miller's Theater in midtown Manhattan, later moving to the Nuyorican, the Chelsea nightclub Cheetah, and then the Bowery Poetry Club.[1] The Glam Slam, modeled on the competitive balls of New York's Black and caribeño gay, drag, and trans communities, included poets walking the runway and, instead of voguing against one another, performing poetry in categories that included "Best Love Poem in Fire Engine Red" and "Best Wig-a-Poem," among others. The naming of the event "Glam Slam" operated as a linguistic pun and deliberate queering of the spoken word event the Grand Slam, the final poetry slam of the year at the Nuyorican Poets Cafe.[2]

The Glam Slam as an event at the Cafe reconfigured the space's participants and audiences, and especially the type of poetry performed. While I argue throughout this book that the Nuyorican Poets Cafe has always been a queer space in terms of performers' sexualities and performance practices, the Glam Slam centered queerness, not as a part of the happening but as *the reason* for the happening. This poetry/drag ball brought together two ostensibly distinct communities and markedly different aesthetic strategies and techniques, specifically the combination of the slam poetry community and the ball scene through voice and

movement, effectively developing a new poetic aesthetic and rubric for queer poets at the Nuyorican Poets Cafe. Slam poems, alongside walking in categories and voguing, were linked and judged via two systems of evaluation and performance codes, each with its own particular legacy and competitive framework. Thus, in both detail and overarching structure, this spectacle of poetry, wigs, and shade is definitively a nuyorican aesthetic practice—as defined by simultaneity, recombination, positionality, gesturality, and orality.

With respect to simultaneity, the Glam Slam both acknowledged and moved away from the Nuyorican lineage and genealogy. The politics involved in the reimagining of poetry slams as poetry drag balls parallels those exhibited in the recodification of the term "Nuyorican" from pejorative to empowering. As discussed earlier in the book, "nuyorican" operates as a signifier for the creation of art that reflects marginalized sociocultural subject positions. The Nuyorican Poets Cafe, in turn, functions as a physical representation of cultural works and activist practices that challenge dominant culture, with the term "Nuyorican" referencing a politics and an aesthetic, serving as an ethnic identitarian marker for peoples of Puerto Rican descent in the United States, and as a signifier for the Cafe itself. The Glam Slam—as a version of the Nuyorican Poets Cafe's signature poetry slam event, the annual Grand Slam competition—queers poetry slam in terms of both performance practices and the highlighting of embodied queer sexualities.

Although identitarian politics inform the founding of the Cafe and the historical documentation of the space frames it as a male-centered, heteromasculinist venue, as I illustrate in the introduction and chapter 1, the Cafe has always included performers from different ethnic and racial backgrounds, as well as those identifying as gay, lesbian, and bisexual. By the 1990s, those expressing queer politics and sensibilities found in the Cafe a useful forum for their poems and performances of their sexual selves. Since the turn of the twenty-first century, trans performers have graced the stage and artists like Ellison Glenn as Black Cracker, whose work I investigate in chapter 4, transitioned. In the Glam Slam, poetic ball walkers/participants recombine racialized queer and trans aesthetic techniques in order to intentionally and oppositionally draw attention to their differences, especially in terms of ball awarding systems, gay camp, and queer/trans vernaculars, highlighting the dialogic relation-

ship between different communities and their respective art practices. Evidenced in the annual Glam Slam was the contradiction between those generally featured at the Cafe in terms of genders and sexualities (heterosexual, masculine, and cis male) and those not—queers of all genders, feminine (femme) men, and masculine (or butch) women. Moreover, these artists walking the runway at the Cafe and making their way onto the stage speak, write, and perform the queer politics of their day and the Nuyorican stage by corporeally and textually articulating their respective subject positions. In turn, these performers introduced audiences to gay argot and queer/trans vernaculars deployed within ball cultures, including the practices of "reading" and "throwing shade."

While poetry slams originate in 1984 in Chicago and are introduced to Cafe audiences in 1989 by poet Bob Holman, as I discuss at length in the introduction, contemporary queer balls and the ballroom scene originate in the 1920s and 1930s. Originally masquerade balls, this iteration of the ballroom scene serves as a performance space for queer men and women to cross-dress in the Lower East Side, the West Village, and Harlem. Arnaldo Cruz-Malavé writes that "the contemporary African American and Latino queer ballroom scene" as it has been presented in film and television "is heir to the Jazz Age Harlem Masquerade Balls" that continued to occur, although on a lesser scale and paid for by the participating drag queens, "throughout the 1950s and 1960s."[3] Yet the more contemporary scene, organized around alternative kinship networks and queers of color collective survival, deploys the monikers of European fashion houses and the runway modeling of couture shows globally to cultivate and spotlight the skills of New York's Black and Caribbean House members. The balls center competition and trophy winning and are judged by legendary members of the ball community. The late Willi Ninja, founder and Mother of the House of Ninja, describes the aspirational influences and multivalent functions of a House to scholar Tricia Rose:

> Vogue houses are based on the high fashion houses, like House of Chanel, House of St. Laurent and so on. Each vogue house develops a style and an image. They raise money to throw balls. . . . But it's also a family unit. House members stick together like family because some of these kids can't face their parents, can't live with them once they tell them they

are gay. . . . So the fashion house is also just like a real home—a family unit—it's not just a dance group. Also, you could say it's a social clique, or posse.[4]

In addition to providing an alternative homespace, these Houses often compete with one another for prizes/trophies in balls that sometimes serve as fundraisers for nonprofit queer, youth, and AIDS organizations. Unlike balls, the judging in poetry slams occurs through the random selection of five groups of judges from the audience, and the final score for each poet in every round is tabulated by dropping the highest and lowest score, resulting in a maximum score of thirty. For ball walkers, all scores are kept and anything less than "tens across the board" means that the competitor is chopped, or loses their respective category. Additionally, while in poetry slams the same poets participate in every round, with the performer receiving the highest total score crowned the winner, balls are organized around specific categories, and the competitors do not necessarily compete in every category. The ball categories themselves, as articulated by Judith Butler, "include a variety of social norms," a majority of them rooted in White culture as markers of class—the business executive and the Ivy League student, for example. Others are coded as feminine, "ranging from high drag to butch queen," and include identities informed by "straight Black masculine street culture," such as the "bangie."[5]

In interrogating the formation of queer performers and audiences at the Glam Slam, I draw upon the work of Toni Cade Bambara and attend to how the participants in the Glam Slam constitute what Bambara referred to as the "authenticating audience." According to Bambara, the authenticating audience is a necessary component for art and artists that seek "to liberate, empower, and navigate communities that have been historically oppressed or disenfranchised,"[6] and is a term and concept that serves as foundational to the creative process as it "describes the dynamic connection between artists, art work, and audience."[7] Identifying the authenticating audience allows for the artists to measure their artistic success or failure—are they reaching their targeted communities? More importantly, Bambara argues, is that locating this audience results in the artists themselves becoming further empowered. Bambara's concept proves useful for my analysis of the Glam Slam because while pre-

vious modes of poetics and politics at the Cafe figure the audience as Nuyorican within the rhetoric of ethno-nationalism, heterosexism, masculinity, and collective insurgency, the audience for and participants in the Glam Slam were figured as (gender) queer, multiracial, femme/feminine, butch, camp, and sexually insurgent. Thus, the performances in the Glam Slam made visible socially, politically, and economically marginalized queer communities of color in New York City to themselves. Further, as an intracommunal celebration of queerness, the Glam Slam offered textual and corporeal tools for another "embattled community" of New York City—queers of color.[8]

In unpacking the cultural work I analyze in "Tens across the Board," I realize that my personal relationship as an audience member and later as a competitor in the Glam Slam structures my critical analysis. The work of E. Patrick Johnson helps me frame how my performance of multiple identities—a first-generation Latina, butch, presently middle-class, from an immigrant neighborhood on Long Island, New York, who is employed as a professor—influences "my ethnographic experience as/of the Other."[9] Similar to Johnson, "rather than fix my informants as static objects naively claim[ing] ideological innocence or engage[ing] in the false positivist 'me/them' binary," I interact with them as knowledge-producing interlocutors and essential co-authors in my construction of this (auto) poetical-ethnographic account.[10]

I remember waiting in line for the Glam Slam that first time on October 23, 1999, anticipating what might greet me once I entered the Nuyorican Poets Cafe. For me, the Glam Slam brought together two communities I desperately desired to be a part of—spoken word/slam poetry and queer nightlife in New York City. Raised born-again Christian in a small immigrant community on Long Island, New York, I had only recently come out after moving to New York City and was searching for queer kinship. Having just watched *Paris Is Burning*, I recall being struck by the alternative family networks the balls provided, the ways queerness, as sexual practice, political identity, and way of being in the world, was enacted through a performance of self that contested the heteronormativity I had always found myself surrounded and smothered by. As I discuss further in the introduction, I had been attending and competing in poetry slams at the Cafe since 1997, even serving as a judge during my initial visit, but was not a part

of the "scene," and my poetry, in line with my gender presentation, was devoid of queerness.

My first time attending the Glam Slam, I wore a flowy white women's collared top with three-quarter-length sleeves, blue bejeweled bell-bottom jeans, an orange knit poncho, a mini brown leather backpack, and matching platform-heeled brown leather sandals with straps. I was gender conforming, passing as heterosexual, although I was then identifying as bisexual, and walked through the doors of the Cafe as a makeup-wearing femme with long curly hair cascading down to the middle of my back. In entering the Nuyorican Poets Cafe that evening, I felt at home in my queerness in a way that was absent during my other visits—members of the different drag Houses were present, disco and house music was playing, and there was a predominance of same-sex couples holding hands.

Similar to my original pilgrimage to the Nuyorican in 1997, when I was trying to find my artistic home as a writer and performer of color, my journey that evening in 1999 for my initial Glam Slam reflects my search for a *queer* of color artistic home. That night I catch the A train on 181st Street and head down to West 4th Street to transfer to the F train stopping at Second Avenue. From the time boarding the A train to exiting the Second Avenue station, my train ride is close to an hour long. Once I climb the subway stairs, my walk from the station to the Cafe takes me about fifteen minutes. Upon entering the Cafe that Saturday night, I look for my friend Travis Montez Johnson. I met Johnson, a poet, lawyer, and professor, when he was an undergraduate and I was working in student services at New York University. This evening he is competing and invites me to attend. After I find him and secure a rare empty seat—the Cafe is entirely packed, including the entire downstairs and the upper balcony level—the specifics of the rest of the evening, aside from Johnson's performance, remain a blur. Yet, unlike the predominantly heterosexual and gender conforming crowd on Friday night, I am surrounded by queer Brown and Black bodies expressing verbal and corporeal realities in ways completely new and thrilling to me. It is not the ethnographic gaze of the outsider that I am experiencing; I do not feel distant or removed from the people in the audience or on the stage. I am not studying or analyzing them; they authenticate me, and I, them.

When Johnson steps on to that stage competing in the final category of the competition, "Best Verbal Vogue," there is the murmur and chatter that precede the other performances, a reflection of the Afro-diasporic practice of call-and-response present in both poetry slam and ball competitions. As with poetry slams at the Cafe, the music is lowered and, amid the cheers, finger snaps, and general chatter, Johnson, wearing a white t-shirt and blue jeans, begins performing his poem, "Over Me."

> he wrote
> number one gay nigger
> across his son's skull
> because he thought
> that was my name

As Johnson recites this first stanza, the murmuring is replaced by the shushing sound of people in the audience as they lean forward and strain to hear Johnson's poetry. Throughout, Johnson stands almost entirely still, center stage, speaking at mid-range volume into the microphone positioned in front of his face. Directly facing the audience, he describes how he is seen by his lover's racist and homophobic father:

> number one gay nigger
> and I loved the son
> when the father
> couldn't stand
> Black Americans or faggots
> couldn't stand Black Americans
> with their loud music
> their tacky gold chains
> their disrespectful baggy pants
> and he wasn't about to let his son
> be no faggot
> over no
> number one gay nigger
> like me

The Cafe becomes increasingly silent, with only the occasional clinking of glasses interrupting Johnson's voice. Johnson continues within the silence:

 see
 he had traded
 one star for fifty
 just so his son
 could be a man
 and
 a number one gay nigger
 would ruin that dream,
 would make that move
 from one island with palm trees
 to another island with skyscrapers
 useless

 and he couldn't stand
 Black Americans or faggots
 couldn't stand Black Americans
 or their music
 that crying-wailing-dying Black people music
 that sounded like sin

 he couldn't stand their music

 except for that one song
 that:
 over time
 I've been building my castle of love
 just for two
 although you
 never knew
 you were my reason

 he liked that one song
 about love and trying

about losing and finding
because he thought
it was about him
but at the end of the day
he still wrote
number one gay nigger
across his son's skull
just to keep him
from saying my name

and the ironic thing
is just like that song,
over heart
I had painfully turned every stone
just to find
that sometimes
fathers love Leviticus
more than they love their own sons
like Isaac on the altar
like Jesus on the cross
sons stand forsaken
bleeding for sins
they can't name

Two stanzas later he says,

over dreams
I thought things
would be easy
believing Stevie
when he said
true love just needs a chance
but we never had a chance
because one Sunday morning
while the son was sleeping
the father was thinking
about all the nasty things

> we must've been doing
> the night before

Johnson's delivery of these lines and their biblical references strike a chord with me and other members of the audience who shake their heads and hold each other just a bit closer as memories of childhoods surrounded by homophobic propaganda permeate the air. Johnson sways a bit, with his left hand in his back pocket, his right hand slightly curled in alignment at chin level, rising and falling as if on a pendulum with his expression of every line. Johnson deliberately and slowly articulates every word, never raising his voice, as the audience remains transfixed on the poetry he is sharing. Johnson, in this section of the poem, engages with legacies of migration, of homelands left behind that fuel the aspirational politics of first-generation peoples arriving in the United States:

> he had cashed in
> one star for fifty
> just so his son could be a man,
> he traded islands
> he traded Puerto Rico for Manhattan
> he traded islands and sand castles
> for el barrio and manhood
> but his son
> wouldn't be a man
> if I could touch him
> like that
> in the dark
> if I could touch him
> with my music
> if I could touch him
> with my heart
>
> so, one Sunday morning
> while the son was sleeping
> the father took his breath away
> he took that life away from me

and blood climbed the walls
that Sunday morning
over love[11]

Johnson, a gay Black man from Tennessee, references here the close contact between Blacks and Latinos, specifically Puerto Ricans ("traded one star for fifty") that theorist Juan Flores attends to when he historicizes the evolution of hip-hop. Flores indexes the relationship between African Americans and Puerto Ricans in hip-hop cultures, specifically, how rap as an artistic genre emerges as an experiential mode of expression. Flores emphasizes how the participation of Puerto Ricans in hip-hop reflects their relationship with African American "neighbors, coworkers, and 'homies' in inner-city communities."[12] Moreover, these shared geographies inform resulting vernacular cultural productions that form "part of a more extensive and intricate field of social practice, a significant dimension of which comprised the long-standing and ongoing interaction between Puerto Rican and Black youth in the shared New York settings."[13] Flores's examination of this coming together of Brown and Black peoples proves useful in unpacking Johnson's work within the Glam Slam setting. The audience for that evening boasted members of various long-standing Houses, including the House of Ninja and the House of Xtravaganza, that further reflected this coming together of racialized subaltern communities. Further, Johnson's poem resonated with this audience of Brown and Black queers who could identify with a particular first-generation experience, and his engagement with the politics of interracial dating often occurring in these marked lifeworlds.

Through his poem, Johnson verbally conveys the violence directed at bodies of color that do not conform to heteropatriarchal iterations of masculinity because of their expression of homosexual love and proclamation of gay desire. Johnson's explicit highlighting of both queer love *and* desire includes the absent presence of Stevie Wonder's ballad "Overjoyed," which adds an additional layer to his poetic performance. Johnson directly cites Wonder, calling him by his name in the line where he mentions "believing Stevie," and invoking Wonder's song lyrics from "Overjoyed": "over time / I've been building my castle of love / just for two / although you / never knew / you were my reason."[14] Unlike Wonder's song, which engages with love lost, Johnson's poem addresses

issues of racism and homophobia in the context of reciprocal queer love and sex. Johnson's delivery of the last three stanzas positions the epithet directed at Black peoples after the word "gay" to evidence the ways he and his lover were similarly and differently framed as abject by a homophobic and racist father:

> he killed his son
> over sex with a man
> over sex with a
> number one gay nigger
>
> he killed his son
> over islands traded
> over sand castles given away
> over what people might say
> over machismo bullshit
>
> he killed his son
> over time
> over love
> over a number one gay nigger
> over me[15]

Johnson's performance of this final section results in everyone standing, applauding, cheering, and snapping their fingers in appreciation. In this moment the Cafe becomes a site of collective and enfolding queer desire, knowing, love, and kinship.

I position Johnson's poem within the Glam Slam as a critical example of how this event works to resituate the Cafe and the practices within it as queer. In making visible queer sexualities through both textual and corporeal movement and performance, the Glam Slam disrupts the ways the Cafe has always been historicized as a racialized heterosexual space. In having the Nuyorican serve as the site of a ball, one that heeds Cafe co-founder Miguel Algarín's call for performances within the oral tradition "to do something" by articulating the realities of marginalized communities, resisting abjection, and challenging existing power structures through both the poetic word and subsequent action, the Glam Slam

creates a counterpublic sphere.[16] This counterpublic sphere enables poetry slam to reflect the realities, desires, and life forces of Latina/o/x and Black queers, both on stage and in the audience of the Cafe. The Nuyorican in its queer reconfiguration moves past its previous nationalist and masculinist articulations of racial-cultural pride, political rage and analysis, and heterosexual romance and practice.

"Coming to the Stage": Realness, Keeping It Real, and Walking the Runway

At the first Glam Slam held at the Nuyorican Poets Cafe on October 23, 1999, the categories were Best Slam Poet with High Fashion Eyewear and Hat, Best Verbal Vogue in Glamorous Evening Wear, Best Slam Poet in Full Glamorous Drag, Best Glamorous Diva Jeweled Slam Performance, Best Slam Performance with Major Production, Best Slam Poet in High-Heeled Stilettos, Best Supermodel Slam Performance with Runway Effect, and Best Erotic Slam Poetry in Sexy Underwear or Lingerie. Including the word "slam" in a majority of the category titles, alongside words such as "glamorous," "high fashion," "vogue," "diva," "production," and "runway," combines the argot of the poetry slam and drag ball scenes. Analogous to how the usage of bilingualism and code-switching marked the writing of early Nuyorican writers in the late 1960s and 1970s, the usage of these particular terms gestures toward what this event aims to do—bring together these two communities and open up a space for the verbal and corporeal articulation of marginalized queer of color subjectivities.

In analyzing the 1999 Glam Slam, I turn to footage of the event from the television program *HomoVisiones*, which began airing in 1994 on public access in four out of five New York boroughs (Staten Island was the only holdout). The show focused on New York's gay and lesbian Latina/o populace, and functioned "as a way to reach a mass audience about sexuality, AIDS, and issues that affect the Latino gay community in New York."[17] In this episode, in addition to interviewing Glam Slam and House of Xavier founder Emanuel Xavier, they also documented the second annual Glam Slam, which was the first one held at the Nuyorican Poets Cafe. The video recording of the event includes Xavier standing center stage, wearing a long suit jacket with a vest underneath

and a white collared shirt; his spiky black hair and red-tinted sunglasses perched atop his head complete his look. That evening, he begins by introducing the five celebrity judges, the same number as in poetry slams. Yet, unlike slam judges, who are selected in random groups, these individuals possess a certain status within the literary, ballroom, and/or nightlife scenes. For example, Xavier begins by introducing *Village Voice* columnist Michael Musto, famous for his column "La Dolce Musto"; Willi Ninja, ball legend and Mother of the House of Ninja; poet Eileen Myles; Hector Xtravaganza, dancer and grandfather of the House of Xtravaganza; and film director Sini Anderson.[18]

The judges for the Glam Slam are not introduced in the usual spoken word or Cafe way, however. As a former host of the Friday Night Slam at the Nuyorican, I would introduce poets by announcing their names and read a short bio containing an interesting fact written by the poet on a small slip of paper before their initial poem in the first round. During the remaining subsequent rounds, I would simply introduce them by their first names. While I would often ad lib if I was familiar with the poet, I generally just read the information they provided on their information sheets. The poets would then walk from wherever they were located in the crowd, seated at a table, or on the side of the bar, while doing their best not to step on anyone sitting on the floor as they attempted to reach the small stage off to the side of the Cafe. There was no runway for them to traverse and the procession to the stage was more utilitarian than anything else. In terms of the judges, I introduced them by their chosen "group names," alongside their individual names, and shared with the audience an interesting group fact that they relayed to me. The judges remained seated, did not walk to the stage, and were selected because they were not active participants in slam poetry competitions, and were thus deemed impartial. In contrast, at the Glam Slam, the judges emerge from behind a black curtain set up on the large stage positioned at the front of the runway in a queer performative mode.

The way the Glam Slam competitors and judges are introduced makes visible the fabulousness associated with the ball scene as a site of resistance and queer world making. In his critical writing, Madison Moore frames fabulousness as "a queer aesthetic, an essence that allows for marginalized people and social outcasts to regain their humanity and creativity."[19] Balls enable queer people of color specifically to resist

and recodify their abjection, reappropriate and redeploy cultural norms regarding gender presentation, intracultural relations, and sexuality as forms of empowerment. Poetry slam allows for the performance of socially marginalized voices, especially at the Nuyorican Poets Cafe with its politicized history. Yet not all slam poets are outcasts, and some occupy privileged gendered, social, racial, and economic positions. Still, House/drag balls as spaces for queer folk, specifically queer youth of color, to "perform gender, create kinship, and forge community" serve a slightly different function.[20] Balls are about queer world making as a form of survival where success, as evidenced in films such as *Paris Is Burning*, results in what Pierre Bourdieu defined as "symbolic capital," not necessarily monetary gain. Symbolic capital functions as an alternate nonmonetary currency that acquires value within a social group or groups.[21] One acquires symbolic capital in poetry slam competitions by winning poetry slams and, in House/drag balls, by winning categories and ultimately the grand prize. Judges for the Glam Slam were chosen because of their symbolic capital. As discussed by Moore, drawing on the work of Bourdieu, "the sex appeal of symbolic capital lies in its world-making power and its ability to create alternate universes and systems of value."[22] Thus the judges for the Glam Slam were chosen due to their heightened symbolic capital within their respective lifeworlds, and they walked across the stage with fabulousness, iconicity, and panache. Musto, for example, steps out and pretends to be writing on a notepad, only to subsequently discard his notes, his movements a coy and campy nod to the audience and his noted role as a columnist for New York's downtown, club, and queer demimonde. In contrast, we see Ninja step out center stage and begin voguing, immediately claiming the stage and situating himself and his positionality as both judge and icon, a legend within the ballroom scene. Hector Xtravaganza enters likewise—he walks out, hair coiffed, multicolored jacket covering his slim frame as he strikes a pose, pivots, and then sits down.

The importance of Ninja and Xtravaganza to the history of voguing cannot be overstated. They are considered the progenitors of the dance practice and in many ways are responsible for its worldwide dissemination via their work in dance, fashion, music, and film/video. Ninja relays this history to Tricia Rose in the aforementioned interview: "When I finally met Hector I pounced on him so badly to show me his moves,

and when he showed me I was floored. He was incredible. So, then Hector started showing me the basic moves and I just went on and created my own style from there."[23] That Hector Xtravaganza and Willi Ninja serve as judges for the inaugural Glam Slam at the Cafe situates this hybrid slam/voguing competition within the genealogy of ball culture and Black and Latino New York's ephemeral expressive culture. The inclusion of non-club, White literary arts figures such as Eileen Myles and Sini Anderson expresses Xavier's presence in, and relationship to, worlds outside ball culture. The emergence of Myles and Anderson, White butch dykes, to use the parlance of the time period, is marked by a performance of queer shyness and hesitation in the case of Myles, who awkwardly walks across the stage. In addition, while Myles—wearing a black suit, with a gray vest underneath—signals a particular bohemian, artsy, 1990s lesbian chic, Anderson in a t-shirt, jeans, and work boots points to a working-class butch aesthetic turned queer and clubby. However, as my presence onstage as a butch Latina poet from the spoken word/slam worlds and winner of a Glam Slam in 2002 indicates, queer women of color are afforded expressive space and an honored place within the Glam Slam. Although, as I show in my fourth chapter on Ellison Glenn as Black Cracker, lesbians/queer women, butches, and transmen of color were somewhat rare in the slam world, we/they have been included in ball culture since its inception. For example, the designer and frequent Glam Slam judge Patricia Field, Mother of the House of Field and out lesbian of color (Cypriot/Armenian), is perhaps the best-known queer woman of color from the 1980s and 1990s heyday of balls. Moreover, as Ninja explains, lesbians—particularly masculine/butch ones—have always walked in balls: "Then there were the lesbian categories for women: Looking Like a Man, Looking Like a Boy, Best Dressed Butch in Executive Wear."[24] The Glam Slam's incorporation of a greater variety of gender projects and expressions on the Nuyorican's stage, based in its reliance on ball/vogue culture and competitions, intervenes in the Cafe's heterocentric history and is one of the most salient characteristics of what I am terming the nuyorican aesthetic throughout this book. Significant as well is the fact that, although organized by one person, the Glam Slam articulates its interventionist aesthetic from the collective force of its multiracial judges, performers, and audiences.

Following the introduction of the judges, Xavier introduces the Mother of the House of Xavier, and onto the stage steps Mother Diva (né Andres Chulisi Rodriguez). Xavier describes how Mother Diva "turned it the fuck out" at a slam mini-ball held in April of that same year and was then chosen to serve as Mother of the House of Xavier.[25] As Mother Diva's name is called, the classic house track "Doctor Love" plays in the background, and Mother Diva steps to the stage holding a cigarette in one hand and a cup in the other. He wears a beige turtleneck with dark slacks and reading glasses, and his hair is blown out, with the curled ends resting on his shoulders as he moves about, checking the microphones.[26] Mother Diva locates the one microphone that is turned on, thanks the DJ for playing "Doctor Love," and addresses the audience with, "Welcome to the second annual Glam Slam," lingering on the "m" in "glam" and "slam" a bit, snapping his head from his left shoulder and back for emphasis. He then says, "Now, before we start, before I envelop you with my beauty, and my love, and my wisdom of words, like fuck it, who cares, and what of it." These lines are delivered with his left hand holding the microphone on the stand, his right arm at a ninety-degree angle, pinned to his side, his wrist also turned at a ninety-degree angle while between his fingers remains his cigarette, the posture reminiscent of the angular bodily stylings of vogue dancers before they begin performing. Mother Diva's hand seems to hold an imaginary tray, which makes sense as he was ready to serve—to use the argot of this queer of color subculture. To serve means to be operating at maximum level or impact, whether that be in terms of makeup/beauty (serving face), dress/fashion, or wit/verbal quickness. He follows this interaction with the offhanded comment, "Oh, we forgot the legendary, whatever." He then says, "I'm gagging, there are so many people here, and all y'all people are not participating with the poetry part, which is OK," at which point someone in the audience asks for a picture, and Mother Diva leans to his side and says, "Ready for a picture? what I told you" to Hector Xtravaganza, then laughs while sticking out his tongue and says, "'Pera, let me take off my glasses." "'Pera," short for the Spanish word "espera" (wait), denotes another form of linguistic code-switching in the event and also marks Mother Diva as Latino. As he takes off his glasses and prepares to pose for the picture, someone in the audience yells, "Cheese!," to which he responds, "Never cheese, baby, it's please," before putting his left hand

on his hip, cocking his head to the side, and retorting to the audience: "Already I have mass participation, qué rico."

In the midst of his verbal interaction with the audience, Mother Diva steps to the side of the stage and retrieves a beige manila folder that reads "Mother Diva" on the front, written in black sharpie. After opening the folder, Mother Diva begins to read the rules of competition, beginning with the stipulation, similar to the one in poetry slams, that poets should adhere to a three-minute time limit and that there are to be no repeat poems. Yet instead of just sharing the rules with the crowd, Mother Diva banters back and forth with the audience in a way that firmly positions the space and the event as queer with their own set of cultural practices. For example, he stipulates that there are to be no repeat poems, saying the line three times: "no repeat poems, no repeat poems, no repeat poems," pausing and turning his head to the side before saying the phrase each time for comedic effect. Amidst the audience's laughter, he then steps back from the microphone and proclaims, "Whew! I am feeling shady, honey." He proceeds to define "shade" for "all you heterosexuals" in attendance as "snotty, snobby, not correct, ill-mannered, arrogant, obnoxious," which is met with claps and loud laughter by the majority-queer audience. This moment, interrupted by a voice from the crowd saying, "lack of decorum," results in Mother Diva responding by repeating "lack of decorum" and then stating, "Always leave it to my child Robert Xavier, he always gives me the proper 'White' words to say."[27] Mother Diva says "White" as if it were a linguistic hiccup, his delivery marking "whiteness" as foreign and outside the community within the Cafe during the Glam Slam. In this moment, Mother Diva also references the kinship networks present in House culture when he calls Robert Xavier his "child." Within Houses, there are Mothers and Fathers, with other members figuring as children who often use the name of the House as their last name.

While in his definition of "shade" we see Mother Diva emphasizing his articulation of what he terms "White" vernacular, later in the event we see Mother Diva engaging in another type of articulation. Standing center stage, Diana Ross's "Love Hangover" playing in the background in a moment between categories, Mother Diva begins to dance, initially moving back and forth in a seeming box step, later followed by a full body spin. During this spin, he throws his head back and ro-

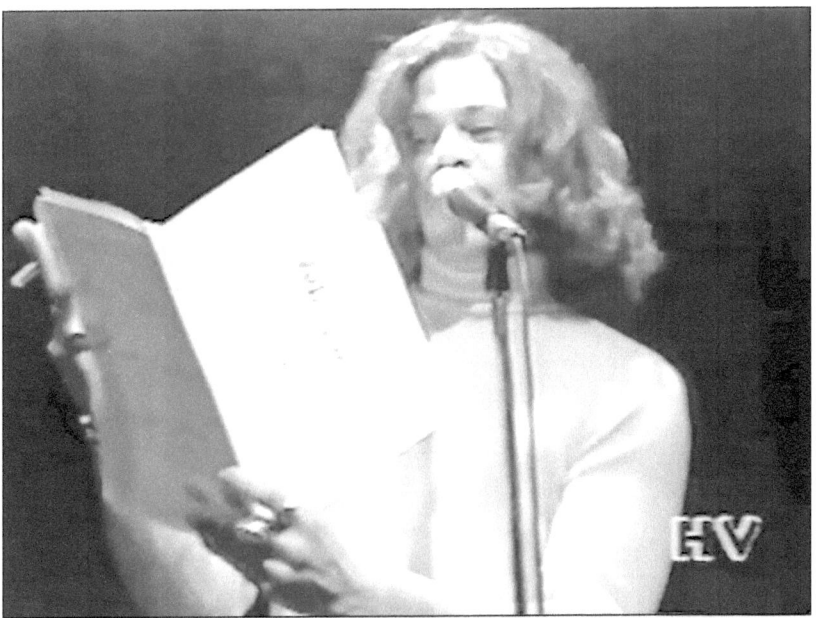

Figure 3.1. Andres "Mother Diva" Xavier hosting the Glam Slam at the Nuyorican Poets Cafe, 1999. Screenshot taken by the author from video footage included in the *HomoVisiones* Records, 1980–2002, Collection 2006-009. Center for Puerto Rican Studies Library and Archives, Hunter College, City University of New York.

tates it in a circular motion, his arms extending outwards forming a ninety-degree angle with the rest of his body as he continues to turn until the music hits a downbeat, at which point he stops and jumps directly upwards before grabbing the microphone and swaying back and forth. Illustrated here is the way the body also operates as text in this context, where articulation in the realm of dance worlds and choreography means bodily extension, muscle joint movement, and isolation (wrist, ankle, shoulder joint, hands); these two forms of articulation are fused via the spoken word and the Cafe's reworking through the ball vernacular. Throughout these interactions, Mother Diva's affect is one of pure joy, belying the precarity of queer of color lives. It is, after all, the 1990s—a time in New York City both of increased gentrification and of the signal shift of AIDS from epidemic to pandemic, from being associated with White gay men to Black and Brown people, intravenous drug users, and sex workers, many of whom hustled on the

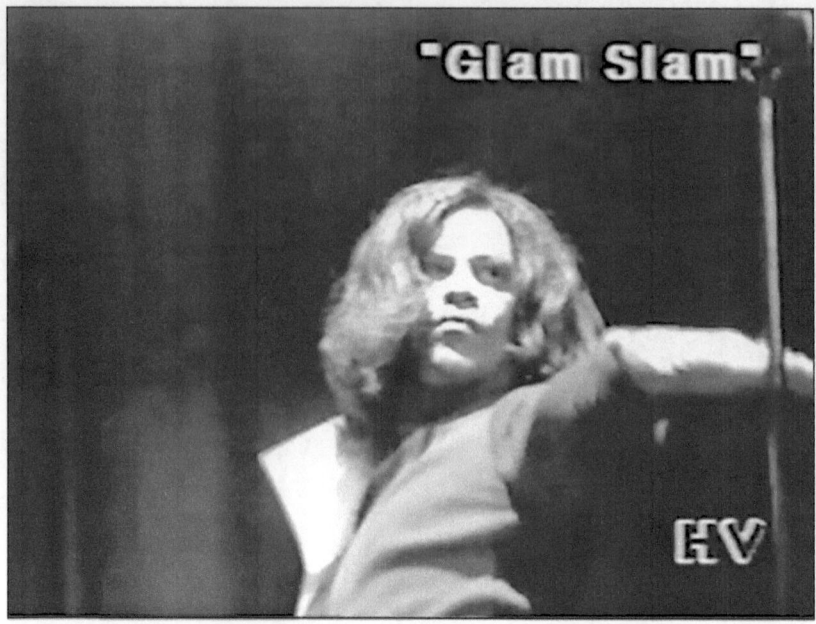

Figure 3.2. Andres "Mother Diva" Xavier voguing at the Glam Slam, 1999. Screenshot taken by the author from video footage included in the *HomoVisiones* Records, 1980–2002, Collection 2006–009. Center for Puerto Rican Studies Library and Archives, Hunter College, City University of New York.

Christopher Street Piers. In turn, the space in this moment is one of palpable celebration.

I linger on the verbal and corporeal exchanges between Mother Diva and the crowd as a way to index the relationship between body, text, poetry slam, and drag ball that informs this chapter, specifically the ways the Glam Slam demonstrates the fluidity from an ethnically fixed Nuyorican identity toward a raced queer nuyorican aesthetic. Membership in the House of Xavier, alongside participation in the event, is not limited to people who self-identify as queer or trans, or who are Puerto Rican or people of color more broadly. The children, or members of the House, were chosen by Xavier and Mother Diva based on their ability to positively represent the House, with preference given to those involved in the literary scene who they felt were "fabulous." "Fabulous" refers to someone displaying "an incredible, astonishing, or exaggerated nature," while also serving as "the ultimate compliment in the gay community."[28]

In poetry slams, a genre that tends to assume an auto-referential "I," poets are judged based on how effectively they perform their "authentic" identities for the audience. In these competitions, "*how* slam poets perform their identities is just as important as *what* they say about their identities."[29] In other words, it is what they say about themselves alongside how they say it. Theorist and slam poet Somers-Willett frames authenticity as a result of constructed, culturally sanctioned performances over time, where the judges then evaluate poets based on a rubric of preexisting examples. As I interrogate throughout the rest of this text, in the context of Regie Cabico's work in chapter 2 and Ellison Glenn as Black Cracker in chapter 4, authenticity within vernacular cultural productions such as poetry slams also refers to an adherence to preestablished sociocultural codes and conventions related to race, class, and ethnicity. Specifically, according to Somers-Willett, while configured

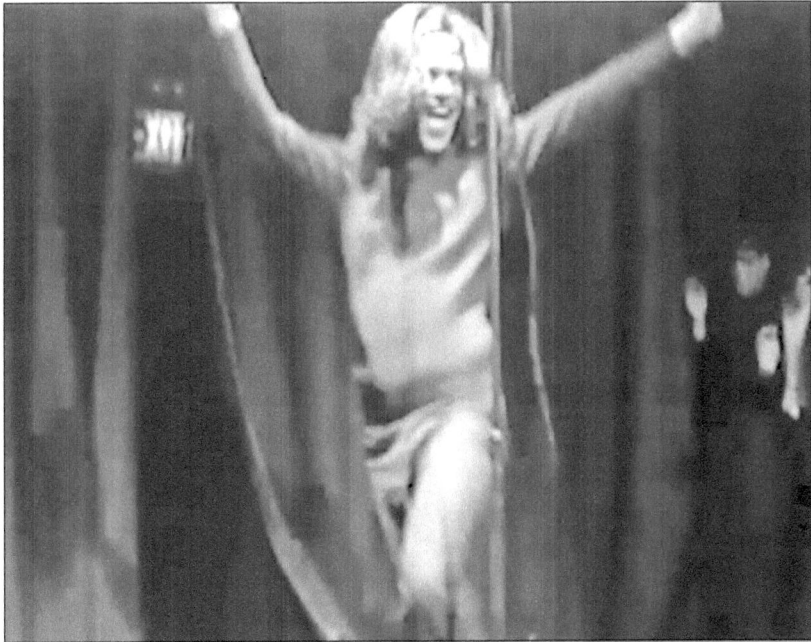

Figure 3.3. Andres "Mother Diva" Xavier's queer joy, Glam Slam, 1999. Screenshot taken by the author from video footage included in the *HomoVisiones* Records, 1980–2002, Collection 2006–009. Center for Puerto Rican Studies Library and Archives, Hunter College, City University of New York.

as a space open to dialogue, poetry slams value the articulation and expression of marginalized/oppressed groups, rewarding those who challenge dominant structures and paradigms, operating as a form of resistance and of making visible that which in majoritarian society is always rendered invisible or abject. Poets craft identities through works that contest or challenge their socially marginalized positions and shed light on what oppresses them through their usage of voice, gesture, dress, and physical appearance, not just through language and words. In terms of performance devices, poets utilize parody to make fun of or subvert the dominant narrative in their identity construction. For example, Filipino American Cabico utilizes parody as a tool for appropriating stereotypes—beliefs that particular behaviors and characteristics are innate, rather than learned, and socially constructed—in order to debunk them. Specifically, Cabico's parody demonstrates the constructed nature of ethnic, racial, and gendered identities through performance. In turn, Somers-Willett interrogates the role of stereotypes in slam poems, specifically how poems engaging with stereotypes are also often created in order to achieve higher scores.

There is a similarity between the way authenticity is performed in poetry slams and the way realness is judged in drag balls. As Judith Butler argues, gender is established through repetitious performance producing a copy of a copy, yet the copy has no original. Instead she proposes an inversion, suggesting that gender and identities alike occur as a result of performance and repetition. The claim of any identity operates as a political attempt at coherence. Yet that identity has been fabricated out of repeated productions, none of which are identical, thus resulting in the instability of signifying "categories." Thus, any identity develops as an imitation without an authenticating origin. For competitors in drag balls, participation in these competitions surrounds this idea of realness, of producing this "naturalized effect" aimed at some impersonation and idealization. For audiences, there is the understanding that this is obviously an artificial performance, but one that nevertheless achieves realness at a grand scale, resulting in winning and, especially, earning tens across the board. However, these contests expose the norms of realness, demonstrating the structural intermeshing of gender, race, and class. Through these balls, according to Butler, we see the constitution of subjects, but as part of a project of their mastery, the repeated

performance; it is about producing realness and exposing realness as fake. Thus, by constructing a new gender identity as a performance in a contest and labeling it as such, they show that this performance is what people do in the everyday, outside the realm of competition. The quotidian is about legibility, about how believable people are in the gender role that they choose. In turn, in balls the goal is toward exaggeration, excess, and amplification, highlighting the masquerade of naturalized behavioral and gender norms instituted by majoritarian society.

The Glam Slam demonstrates the dissonance between authenticity and realness. Within this framework, "realness" in ball culture is what Butler terms "fake." It is never a realness found in the quotidian or readily available in the everyday, but rather available only when staged on the runway of a ball. Thus, realness underpins the connection between a constructed performance of self in ball culture and the performance of the assumed auto-referential identities in poetry slam. In turn, in spoken word and poetry slam communities, as theorized by Somers-Willett, there is a call for poets to "keep it real," or to perform an "authentic racial identity" in poetry slams. The emphasis on authenticity that founds authority to speak and a realness that is fake informs and structures the relationship between text, the body, and performance that occurs in both poetry slams and drag balls. In particular, the Glam Slam as a poetry drag ball helps us to see the textuality of corporeality and the function of movement as scripted in poetry slams. As performed poetry competitions, the poets' movement via the verbal delivery of their texts operates as scripted movement. Therefore, the Glam Slam highlights the fact that the participants are avant-garde performers of quite similar art forms seeking to make visible marginalized communities in spaces codified as sites of political and artistic entertainment. Yet when thinking about gay, trans, Black, and Latina/o/x folks in economically depressed yet increasingly gentrified neighborhoods like Loisaida, the South Bronx, and El Barrio, we can see that these performances function as sites of corporeal enjoyment and release, a gathering of community in relationship to the systems and structures that accelerate queer of color death. Similar to the House of Latex Ball thrown by the Gay Men's Health Crisis, and in recognition of the precarity of queer of color lives, the House of Xavier donated a portion of the proceeds garnered during all of their Glam Slams to charities focusing on queer of color

youth, homelessness, and AIDS. As one example, the House of Xavier donated a percentage of the monies charged for admission to the 1998 Glam Slam to the New York Peer AIDS Education Coalition. In addition, the competitions in the balls signal what Cruz-Malavé describes as the "long and creative cultural interaction (and competition) between Puerto Rican/Latinos and blacks in neighborhoods such as Harlem, El Barrio, the South Bronx, and of course the Christopher Street Piers."[30] Beginning in the late 1970s, a time of great economic depression and regressive politics in New York City and the United States overall, ball culture and its Houses provided a "home" for the increasing number of gay runaway kids, like Xavier, who would find protection, status, and love outside their often homophobic biological families.

In the documentary *Paris Is Burning*, Dorian Corey defines "Houses" as families for those who do not have families, similar to the communes established by hippies in the 1960s. Corey frames the ball Houses as sites for alternative kinship networks that stand in for the "families" that the participants have been born into or have been raised by. Corey troubles the configuration of family as consisting of a man, a woman, and their child or children and presents families as "a group of human beings in a mutual bond."[31] The Houses critique, via mimicry and inexact replication, the nuclear biological familial model of father, mother, and children, foregrounding and celebrating critical differences. The roles of "Father" and "Mother" are not determined by sex, gender, or even age, but rather are based on the fulfillment of particular communally established roles. Houses reimagine and recodify "home" as the site of belonging and kinship, especially for queer youth of color often cast out of their homes due to their sexualities and gender expressions. "Mother" and "Father" are not biological or authoritarian categories within ball culture. Rather, these titles operate as honorifics given to the leadership of the Houses who provide historical knowledge of drag/trans/gay culture, training in voguing and walking, and housing as part of day-to-day sustenance for their "children." The balls operate as spaces for the building of kinship networks that sustain members dealing with issues of "dislocation, poverty, and homelessness."[32] The "Mothers" and "Fathers" of these Houses resignify the heterosexual family by helping to build community and, in doing so, gesture toward a "more enabling future," where the homespace functions as the site of belonging and car-

ing rather than abjection and dislocation.³³ Screening *Paris Is Burning* proves useful in terms of making visible on-screen the realities of queer of color homeless youth. The lead singer of the house club sensation Deee-Lite, Lady Miss Kier, contextualizes the economic conditions of the downtown dance world in the 1990s:

> The dance community is not living in a fantasy world. AIDS, homelessness, poverty. The poverty level in 1972 was eleven thousand dollars a year. In 1992, the poor live on four thousand dollars a year. . . . The dance community is not living in a fantasy world, because we deal with these problems every day.³⁴

Willi Ninja bluntly specifies, regarding the "children" of ball and voguing culture/competitions, "As *Paris Is Burning* pointed out, the majority of these kids are poor."³⁵ Glam Slam founder Emanuel Xavier's experience is exemplary of the macrostructural conditions Kier speaks to, as well as the reality Ninja puts forth.

Emanuel Xavier's move from hustling as a queer homeless teen, sleeping on Anji Xtravaganza's floor, to Father of the House of Xavier and creator of the Glam Slam begins with a chance encounter with a gay cousin outside a West Village gay nightclub called Monster. Xavier's cousin takes him in, and Xavier begins to frequent the Nuyorican Poets Cafe while working at the now-defunct gay bookstore A Different Light, also in the West Village. While working at A Different Light, Xavier introduces spoken word poetry via his "Realness and Rhythms" monthly reading series. In discussing the event, Xavier explains how he came up with the name: "'realness' because it's a word that came from the ball scene and 'rhythms' which is something that kind of came from spoken word poetry so I think it was a precursor to the House of Xavier."³⁶ While foreshadowing the connection and conversations between poetry slam and drag ball that Xavier later implements through the Glam Slam, the event also highlights Xavier's commitment to ensuring the visibility of marginalized voices and disenfranchised communities through performance by focusing on queer writers and poets of color.

I would like to return to the 2002 Glam Slam, where, after standing in line, I pay my ten dollars and walk into the Nuyorican Poets Cafe. As I had also found when I had attended to support my friend

Travis Montez Johnson, gone are many of the regulars I am accustomed to seeing at the Cafe's Friday Night Poetry Slam. Instead, the space affectively and literally has been transformed. I am surrounded by queer people of color, many of whom are Puerto Rican and Dominican, looking fabulous while disco and house music blares from the speakers. The stage, again, is no longer small and off to the side of the space; instead, it is front and center, with a set of chairs on each side and a runway down the middle of the floor. I am wearing black pants, a sheer long-sleeved black top, makeup, and sunglasses, and my still long, curly hair is out and down my back. I remember walking to the stage, competing in various categories, and subsequently winning. As my final poem, I perform a piece entitled "Born Again." I begin by facing the audience at the Cafe, center stage, and speaking directly into the microphone with my arms bent at a ninety-degree angle, palms open and facing upward as I say, "I am born again / like Lazarus I rise from the dead," and end with "I / Am / Born / Again."[37] The lines of the poem follow a familiar trope for people who were raised born-again Christian, that of resisting the homophobia directed at queer subjects by members of the church who used the Bible, the Book of Leviticus specifically, as ammunition in relegating non-heterosexuals to eternal damnation. It is my "coming out" poem, signaling my rebirth as a non-closeted lesbian, and one that I share frequently during this time as it enables me to verbally articulate my queerness in ways not evident in terms of my gender presentation. More importantly, through this poetic reclamation of self, I challenge the castigation and suffocating heteropatriarchy that surrounded me growing up in Bay Shore, New York, for all of those years. It is my performative call for community. I remember the excitement, the sense of belonging and feelings of acceptance I experienced when the legendary Willi Ninja presented me with my two trophies—one for the category I won, and the second, larger one crowning me the overall Glam Slam Champion of that year.[38]

The following year, in 2003, Mother Diva begins hosting while standing center stage, wearing long white dress slacks, a white long-sleeved dress shirt, white dress shoes, and a head wrap denoting his period of initiation into the Afro-diasporic cosmology known as Santería. He alerts the audience, many of whom are familiar with the

significance of his attire, that during this evening, there will be gestures and actions that he will not be able to participate/engage in. For example, no one is to hug or touch him as he cannot engage in a tactile relationship with anyone in attendance. Yet in spite of his request not to be touched and his expression that he will not enact certain movements, Mother Diva maintains the same sharp wit and gestures as in previous Glam Slams.

As the 2002 Glam Slam Champion, I am called to the stage in order to usher in the final category for the evening by performing a poem. I am wearing dark blue jeans, a black army navy shirt with epaulettes, a watch with a wide black band on one wrist, and a large black leather cuff on the other. I cut my hair that summer, so I am now wearing my hair buzzed on the sides and short on top. No longer femme presenting or identifying as bisexual, I inhabit the space as a queer Latina butch lesbian. Following Mother Diva's introduction, I run down the runway to the stage, adjust the height of the microphone, and move the music stand in front of me to the side of the stage.

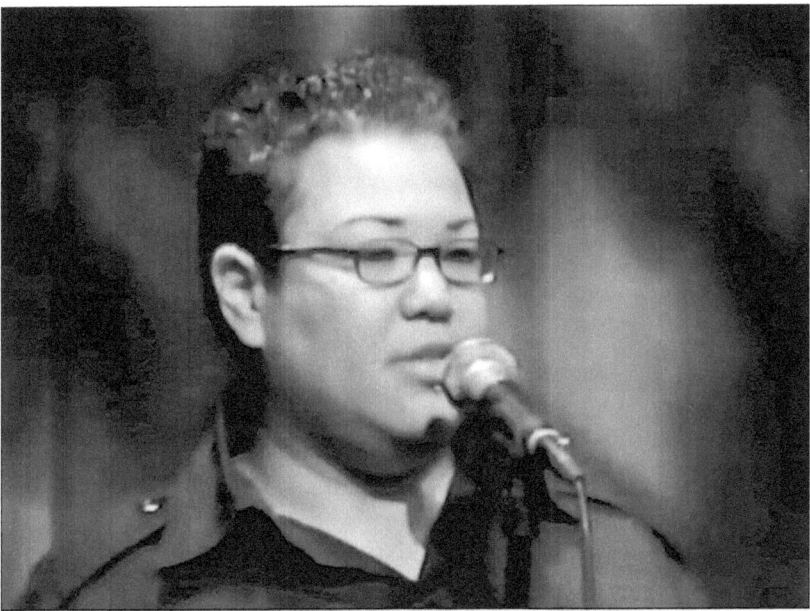

Figure 3.4. The author performing at the Glam Slam, 2003. Screenshot taken by the author from unedited footage of the Glam Slam.

As I do this, I say to Mother Diva, "I don't even know what my introduction was, since I was outside!" We both laugh, and I look at the crowd and ask, "Are y'all having a good time?" After being met with enthusiastic applause, I tell the crowd, "Y'all have to keep up that energy." I continue by contextualizing the poem for the audience, stating, "This piece is actually based on a series of interviews that I did with lesbian go-go dancers. This piece is actually about Maine, so anybody who knows who she is, here we go." A person with a higher-pitched voice in the crowd yells out, "Bring it, mama!" This moment highlights the call-and-response of poetry slams and drag balls. For me, as someone who is consistently misgendered as male, this moment reaffirms my assigned sex at birth and how I inhabit womanhood outside societal gender norms. Rather than receive the term "mama," Spanish for mother, as a derogatory gesture seeking to emasculate me and deem my gender presentation a failure, within this queer space and community this hailing of me as a woman affirms my successful presentation of butch identity. I, in turn, respond with a smile, a shake of the head, put my left hand to my throat and exclaim, "catch my breath." I exhale and begin:

> I wonder what you see
> when you look at me
> through society's
> judgmental eye—
> your stripping lapdancer
> come alive?
> That womyn,
> loving womyn
> you can't believe exists
> NOT for your pleasure.

In this moment, through my poem I articulate Maine's rejection of her positioning as a fetishized sex object due to her work as a dancer in bars and clubs. During her interview she shared with me the ways her corporeal boundaries were consistently transgressed by customers who felt that because she was dancing in minimal clothing, they could in turn just touch and grab her without waiting to receive her consent. In

addition, her gender presentation and costuming challenged rigid definitions of what a lesbian "looked like" and the misogyny that positions burlesque and exotic dancing as solely for the enjoyment of cis heterosexual men. I relay Maine's reality as a performer:

> The truth
> lies in the carriage,
> NOT in the rear,
> so listen closely
> as I break it down for you
> and make you feel
> like you're the
> ONLY person
> in the room
> and that
> this dance
> is just for you.
> I'll take you
> to places
> you can only
> dream of.
>
> I'll tell you
> who I am
> without
> ever
> uttering
> a single word.
> But don't mistake
> my silence
> for ignorance,
> my message
> transcends
> spoken word
> and can only
> be relayed
> through my body.

Although I am performing a poetic version of Maine's interview, her story extends beyond my verbal articulation and she performs her own version of embodied storytelling. Much like the other performers competing in the Glam Slam, in writing about Maine and attending to her corporeal movements through verse, I highlight the dialogic relationship between the body and/as text, as evidenced in the following lines:

> I am the new millennium Josie 2s 2s.
> Josephine Baker revisited—
> an underground club celebrity
> where recognition
> is the only paycheck.

During our interview, Maine shared with me her aspirations of becoming the next Josephine Baker, while also understanding how, due to her work in the downtown club scene in New York City, she functioned as an underground club celebrity. She was "underground" because she did not benefit from the monetary gains of mainstream, commercial success, yet she enjoyed a certain recognition within subaltern, nightlife communities. In addition, Maine self-identified as a woman who was deeply influenced by her southern (by way of Atlanta) roots. These roots included a familial commitment to civil rights activism, first by her mother and then by Maine herself. She viewed her work within queer communities as activist practice.

> I am that womyn,
> that my momma,
> a strong Southern Lady,
> wanted me to be.
>
> She marched with King
> from Selma to Montgomery,
> you know?
>
> Her struggle for liberation
> started down South,
> mine up North.

Ignorance
is a crop
too often planted
in our fields of knowledge
so I am left with the task
of uprooting labels and definitions
you try to place on me

(Butch/Femme dichotomy)
at a rate
that leaves Webster
at a loss for words.
But if you need
to call me anything,
call me a lady.

I am Mozart.
My instrument
is my body,
the notes are my steps—
my dancing
becomes the sound you'd hear
if light traveling
whispered in your ear . . .

But I'm afraid too many
are stuck in their
tits and ass fantasies—
their $1 dreams,
to see the me
that resides within.

I am a chameleon
that transforms herself
every
single
day.

I was your cowboy yesterday,
woke up
and wanted to be
your feminine diva today,
and think I'll be
yo' shawty
tomorrow.

See,
fantasies
are the realities,
that ONLY exist
in our minds . . .

and that's the only
part of your body
I wanna fuck with tonight.
You see
entertain,
does not
equal SEX;
a dollar and a dream,
is just an expression
and
"expectations
are planned
disappointments"

so if you came here
expecting
to get more
than a show—

PLAN

ON

BEING

DISAPPOINTED.³⁹

In my poem, I highlight issues of misogyny, sex work, social justice and civil rights activism, and the agency of self-identified women over their own bodies. In addition, throughout I attend to the relationship between dance—and movement specifically—as a form of articulation that operates as complementary to my verbal delivery. Following my delivery of the last line, Mother Diva responds with, "You see, dammit! Let me tell you something, Karen—you can mindfuck me any time you want. 'Cause if I could find a man that could hit me with lyrics the way you talk? Biiitttchhhhhh! I will pay your fucking bills, you hear me?" This moment at the end of the evening exemplifies what I find useful regarding this event as it relates to the nuyorican aesthetic: Mother Diva's praising of me, articulating queer love and kinship, framed through the usage of a sexual vernacular evidencing a fluency in a queer argot at the Nuyorican Poets Cafe, recodifies the space as queer. This reclamation highlights how the Glam Slam reframes identities—the santero, the macha—as vibrant and empowered cultural producers and performers through a glamorous poetic discourse expressing minoritarian subjectivities that serve as a defining characteristic of the nuyorican aesthetic. It is a practice first rooted in the physical space of the Cafe and in the culture that produced it.

4

Black Cracker's "Chasing Rainbows"

Hip-Hop Minstrelsy, Queer Futurity, and Trans Multiplicity

Art is not about nor will ever be about popularity. It is a quiet meditation on time and scale and skin that at times roars and erupts but mostly steeps until it evaporates. I just try my best to stay true to the voices in my head.
—Black Cracker

I first met Ellison Glenn, the artist who performs as Black Cracker, in 2000. Then, he was an art school dropout working at a paint store for less than minimum wage. Aside from the paint store, his income sources included spoken word prize monies and gigs as a musician. In order to reach him, I usually called his place and left a message with his roommate or on their answering machine. Often, I stopped by one of his usual haunts, Bar 13 or the Bowery Poetry Club in downtown New York City, in the hopes of running into him. This was before the advent of Facebook and smartphones. And then, as now, Glenn was always on the move. In fact, other than hosting the Wednesday Night Slam Open at the Nuyorican Poets Cafe, Glenn did not really follow a set schedule.[1] Such itinerance is commonplace for young artists of limited economic means in world metropolises like New York. Glenn's career, while part of the Nuyorican's queer genealogy, has had a more globalized trajectory—from the American South to Brooklyn and Manhattan, and now Berlin. When I recently contacted him as I sought out one of his early poems, he was returning to Europe from Australia. Glenn's signal contribution to the nuyorican aesthetic lies in this multiplicity and mobility in terms of class, gender, artistic genres, and performance strategies.

Glenn's work as an artist, as a performer who worked and performed extensively at the Cafe both before and after his adoption of the performance persona Black Cracker, challenges the heterosexist, masculinist,

and ethnically specific history of the space. In my interview with Glenn, he relayed to me that he adopted the moniker Black Cracker around 2007 after seeing an Atlanta Black Crackers baseball hat in a department store. Glenn knew it was the appropriate name for him "because of the sound and the political irony."[2] This performance identity demonstrates another contour of what I theorize throughout this analysis as the nuyorican aesthetic. Likewise, the moniker Black Cracker gestures toward Glenn's particular history as a Black southerner, his queer critique of a hip-hop heteromasculine imperative, and a trans utopic vision in the making. Specifically, Ellison Glenn as Black Cracker sounds and ironizes a twenty-first-century nuyorican aesthetic.

The nuyorican aesthetic evidenced in the work of Glenn, defined by simultaneity, recombination, positionality, gesturality, and orality, emerges as an artistic practice at the Nuyorican Poets Cafe. Glenn, through his work as Black Cracker, utilizes simultaneity to create cultural productions that both draw and move away from Nuyorican history and genealogy. In turn, he recombines racialized and queer trans aesthetic techniques including minstrelsy and Afrofuturity in order to underscore their differences, bringing together hip-hop tropes in dissonant ways, highlighting the dialectical relationship between communities and art practices that have been favored (Nuyoricans, urban New Yorkers, heterosexuals, and cis-men) and those that have not (transgendered peoples, butches, and non-Nuyoricans). Glenn writes as a Black US citizen-subject constantly in motion, critically embodying his trans identity, verbally articulating his temporal and geographic moves.

The metaphors articulated in the epigraph reveal how Glenn's artistic practice reflects his constant physical motion in a manner akin to tea steeping or water evaporating, ultimately shaping his flow as an artist. William Jelani Cobb defines flow as "an individual time signature, the rapper's own idiosyncratic approach to the use of time."[3] In this configuration, flow includes two "basic characteristics: the division of syllables and the velocity at which they are spoken."[4] Although this definition proves useful for unpacking Glenn's temporal and lyrical aesthetics as a rapper, it is Cobb's engagement with the "metaphysical implications" of flow, his proposal that the "aim of flow is to be fluid, protean in one's approach to sound," that I find most useful.[5] As Cobb further articulates,

"water and blood flow, liquids take the shape of their vessels."[6] Glenn's own lyrical flow as a poet and his moves between geographies, temporalities, genres, performance strategies, and technologies function as part of his art-making practice as Black Cracker. In particular, Glenn's invocation of "steeping" as a way to frame the durationality involved in creating art situates his artistic process within a queer paradigm. Steeping, the soaking of a solid in hot liquid to extract its essence and flavors, is how tea is made. Tea, sometimes denoted as "T," is a keyword of contemporary Black queer trans vernacular in speech, memes, and artistic expression. I use "keyword" here drawing on the work of Raymond Williams and his investigation of over a hundred words that are familiar but that vary in meaning depending on time period, geography, and cultural understanding, among other factors. I am particularly interested in Williams's suggestion that the usage of keywords points to how "certain uses bound together certain ways of seeing culture and society."[7] The sharing of "T," a riff on tea, operates as an example of polysemy where a word shares multiple concurrent meanings. "T" in this instance references a queer mode of being and expression that necessitates a cultural and social understanding of queer argot. Evaporation or the dispersal of water into the air signals a change in form, not content, a natural and secular transubstantiation. Whether it is a hot liquid or vapor, water remains—at a molecular level—water, in spite of its change in physical state. Glenn's ethics and aesthetics—that is, the way he flows—indexes his critical artistic consistency, rooted in a trans(itory) queer Black Atlantic. This constant geographic and temporal motion, always already rendered in raced and gendered terms, is evidenced across his biography and oeuvre.[8]

Glenn has been performing as Black Cracker since 2007. While maintaining this controversial moniker, Glenn has always destabilized its meaning via a near-constant shifting of personas, locales, audiences, and genres. Glenn's work moves across spoken word to punk (with his former group the Victory Riot) to his present work as an indie beatboxer/rapper/electro pop music producer. His embodied artistic practice and articulated political stances form a dialogic aesthetic between genres, audiences, and communities. Glenn as Black Cracker deliberately and brilliantly combines disparate and troubling elements in order to examine their facility for opening up new ways of being for

racialized subjects. In "Feeling Brown: Ethnicity and Affect in Ricardo Bracho's *The Sweetest Hangover (and Other STDs),*" José Esteban Muñoz proposes critical Brown affect as a utopic futurity through his close reading of Cherríe Moraga's poem "Dreaming of Other Planets." Moraga writes,

>my vision is small
>fixed
>To what can be heard
>Between the ears
>
>the spot
>between the eyes
>a well-spring
>opening
>to el mundo grande
>
>relámpago strikes
>between the legs
>I open against
>my will dreaming
>
>of other planets I am
>dreaming
>of other ways
>of seeing
>this life.[9]

Muñoz's analysis of Moraga's poem frames his reading of the "utopian impulse" present in Bracho's play. The "utopian impulse," as specifically articulated in the final stanza/lines, operates as what Moraga describes as "dreaming / of other ways / of seeing / this life."[10] According to Muñoz, Moraga's proposing "other planets" and "other ways of seeing / this life" "represents the type of utopian planning, scheming, imaging, and performing we must engage in if we are to enact other realities, other ways of being and doing within this world."[11] Glenn through Black Cracker devises cultural productions that push us to imagine different

worlds and other possibilities, as Moraga, Bracho, and Muñoz do, toward expansive queer of color futurescapes.

Queering Racial (Mis)Representations

"Cracker" as a racialized epithet for whiteness, White people, and especially working-class southern Whites functions as coterminous with "redneck" and "White trash." Specifically, "cracker" is defined as a "slang word used to refer to those of European ancestry."[12] This could be because the term derives from the sound of a whip being cracked by slaveowners, or because crackers are generally white in color.[13] Similar to Bracho as analyzed by Muñoz, Glenn subversively turns to charged language to combat and lampoon, critique and taunt the tropes of US race discourses. The appellation "Black Cracker" brings together two antagonistic concepts in the United States, and in particular the southern US imaginary. This recombination and the dialectical fission of its dissonance and shocking historicity propel Glenn's nuyorican aesthetic, from the Nuyorican Poets Cafe's stage to music venues in Europe and beyond. In devising a staged identity that operates as both "constructed and contradictory," that places in one Black trans body histories polarized by US racial binaries and histories, Glenn's practice, then, keenly relates to Muñoz's theory of disidentification, "a hermeneutic, a process of production, and a mode of performance."[14]

While disidentification defines the way minoritarian subjects refuse to turn toward or away from majoritarian or mainstream society and culture, as a performance methodology it enables Glenn to navigate a "phobic majoritarian public sphere that continuously elides or punishes the existence of subjects who do not conform to the phantasm of normative citizenship."[15] As such, as Black Cracker, Glenn inhabits polarized racializations, satirically disidentifying with the South's toxic, racist binaries and imagery. In choosing to perform, write, and make music as Black Cracker, Glenn lampoons essentialized whiteness and blackness, simultaneously forcing audiences to examine their own racialization and the anxieties of racial placement summoned in the name Black Cracker. Black Cracker functions as voice and vehicle for the queer/trans multimedia artist Ellison Glenn. Within this naming as critical juxtaposition, Glenn disavows that one cannot be both Black and a Cracker.

A mix of violence and comedy, as well as an imaginative restructuring of the historically toxic, defines Glenn's early work as Black Cracker. Such defiant invoking of minstrelsy is also at work in Spike Lee's film *Bamboozled* and MacArthur Fellow Branden Jacobs-Jenkins's play *Neighbors*.[16] In each of these Black cultural products and projects—all initially developed, staged, and/or filmed/performed/realized in New York City in the late 1990s/early 2000s—minstrelsy is not invoked as the unillustrious past but rather as the insidious pleasure and crass profitability of contemporary masked Black pain and gendered complicity. Glenn through his performances makes visible minstrelsy, defined by Jeffrey O. G. Ogbar as "characterized by buffoonish styles of singing, dancing and vernacular, ... [depicting] Black people as infantile and pathological while underscoring the importance of race to the meaning of democracy in America."[17]

I read Glenn's performances through the framework of Ogbar and Eric Lott. Lott argues that minstrelsy developed out of racial desire, allowing White culture to "try on" blackness. According to Lott, minstrelsy introduced the antebellum White northern male working class to Black culture, forcing their identification by equating them. In turn, Lott defines love and theft as minstrelsy's mixed erotic economy of celebration and exploitation, which allowed Blackface performers to commodify often inauthentic Black cultural practices, disseminating them to a White northern working-class audience.[18] Glenn's earliest pose as Black Cracker was as a minstrelized hip-hop emcee, a buffoon whose overwrought masculine racialization underlined long-held racist stereotypes and sexist posturing in commercial hip-hop that have made many a Black male a millionaire.[19] Specifically, Glenn used Black Cracker as a satirical portrait of hip-hop masculinity and its boastful masculinist stage and street personas. Through over-gesticulation and heightened mugging, Glenn's Black Cracker critically evoked the minstrel figure and minstrelsy. Trained via videos and marketing to see hip-hop artists and emcees generally as "authentic" countercultural performers of urban Black strife and success, both mainstream and "conscious" urban multiracial audiences figure the Black male hip-hop artist as oppositional to, and critical of, minstrelsy and the racist past.

As an example, Ogbar historicizes the relationship between hip-hop, authenticity, and minstrelsy, positing that "the centrality of African American art to hip-hop helps contextualize the aesthetic symbols and

creative expression found in the early hip-hop community and how they were inextricably tied to the era of the 1970s, which saw the minstrel as anathema."[20] "Authenticity," as I discuss when analyzing the work of Regie Cabico in chapter 2, references a particular legibility based on constructed ethnic and racial stereotypes that signal a racial, ethnic, and sociocultural position and politics in performance genres defined by an assumed auto-referentiality such as rap, spoken word, and slam poetry. But while the minstrel figure in this paradigm serves as the antithesis of hip-hop, this does not preclude artists from performing in ways that gesture toward minstrelsy in order to satiate White consumers' desire for the performance of Black pathos and Otherness, reinforcing White notions of superiority. Often performing what Mark Anthony Neal defines as "sonic blackface," wherein musical artists such as the rapper Lil Jon revel in articulating lyrics describing violence and hypersexuality through an animated demeanor while wearing platinum grills, these performers index how abject Otherness proves profitable.[21] Through their music, these artists bolster a framework where "the oversexed, violent, and misogynist tales that are passed off as ghetto realness" operate as a marker for credibility and racialized authenticity "that conflates poverty, crime, misogyny, and all things 'ghetto' with blackness."[22] In taking on minstrelsy, Glenn as Black Cracker aims to resist and debunk this configuration by appropriating the aesthetics of minstrelsy and demonstrating their constructedness.

Glenn employed minstrelsy as a performance device earlier in his career in staged collaborations with Bunny Rabbit (the Samoan/Mexican performance artist Melisa Rincon). On stage, Bunny Rabbit would rap while Glenn as Black Cracker provided the beats. Throughout their songs, Black Cracker adopted the stance and movement aesthetic of contemporary rappers—kicking one leg in the air before drawing one arm forward and then back to grab his crotch, all of this movement accompanied by a staccato bouncing up and down of his body. Through his physical movements and lyrics, Black Cracker placed himself in the position of hype man for Bunny Rabbit while simultaneously operating as the producer backstage. A hype man is "a kind of MC or toaster" who involves the audience or crowd "through wild fashion and side commentary on a song's main lyrics, with exclamation and interjections and attempts to increase the audience's excitement with call and response

chants."²³ I read this hype man performance of Glenn as Black Cracker as a form of queer hip-hop minstrelsy.

In framing Glenn's Black Cracker as an example of minstrelsy, queer hip-hop minstrelsy specifically, I analyze the liberatory potential of his cultural productions. In particular, I attend to how Glenn is not "trying on" blackness as proposed by Lott, but rather deploying a recognizable hip-hop version of blackness that he in turn queers through his engagement with his assigned gender at birth, his performance of masculinist gender tropes, and his sexuality. Ultimately, Glenn critiques the masculinist, corporatist agenda of much commercial hip-hop by presenting its centralized figure, the boastful Black masculine ideal, as racial buffoon and clown. While Glenn does not perform in Blackface, he makes of the hip-hop hype man a minstrel to subvert audience expectations and heteronormative gender stylings regularly articulated within hip-hop's aesthetics across songs, videos, films, and fashion. Glenn takes on the hip-hop iconography exemplified by Sean Combs and Jay-Z as analyzed by Nicole Fleetwood. In examining the role of fashion and its relationship to the performance of Black masculinity within hip-hop, Fleetwood emphasizes how images of Black men in hip-hop focus on how their "self-presentation relies on a self-conscious fashioning of the body that signals racial alterity, confidence, and self-possession."²⁴ Fleetwood then focuses on the presence of these markers on two billboards. The first, eighteen stories high, features Sean Combs advertising his cologne "I Am King," where Combs is shown wearing a white tuxedo with a black bowtie, left hand in the pocket of his slacks, staring directly at the viewer. For Fleetwood, Combs embodies "American success and establishment" while simultaneously representing a "racially inflected other."²⁵ In the geographic vicinity of Combs's billboard in midtown Manhattan is another, featuring musician, entrepreneur, and fashion designer Jay-Z. Fleetwood describes Jay-Z's image as "moody and mysterious": Jay-Z stands against a dimly lit background with his head tilted down, eyes covered by sunglasses. Sporting a nondescript button-down, Jay-Z represents material success, performance acumen—he is one of the most critically acclaimed and successful rappers of all time—and street credibility, signifying a vaunted positioning that Fleetwood describes as "his ability to stay connected with the mythic and material 'streets' of hip-hop."²⁶ Fleetwood posits that the Black male body in hip-hop embodies

"the interplay between a highly stylized and reproducible racial alterity, nationalism, and hypermasculinity."[27] Racial alterity within the framework of urban fashion and Black masculinity refers to how the Black male body signifies a type of coolness through difference, both racialized and masculine, which references a reproducible and commodified "outlawlessness."[28] Similar to Fleetwood's feminist and materialist critique of Combs and Jay-Z, Glenn's performance agenda magnifies via minstrelsy the auto-commodification and acritical absorption of a capitalist ethos by hip-hop's male successes. Glenn through Black Cracker, in his early performances with Bunny Rabbit, employs the exaggerated gestures, the facial expression—the wide grin, the pandering to the audience while walking around hunched over, extolling them to "come on, come on"—signaling a return to minstrelsy but with a wink to the audience. Glenn takes on the minstrel personage and recodifies it through his own queer version of hip-hop. Glenn's queering of hip-hop and his utilization of minstrelsy's aesthetics highlight what I, and his international audiences, have always found compelling about his work. In particular, I am continually drawn to how he reimagines, recodifies, and reappropriates the politically charged and the abject in order to reposition these as useful and potentially liberating for minoritarian subjects, similar to how artists of Puerto Rican descent reclaimed "Nuyorican" in the 1970s. Such recombination exemplifies and mobilizes the nuyorican aesthetic from the 1990s to now. Glenn creates multivalenced cultural productions based in lyrical dexterity, namely, the flow he developed as a spoken word artist in poetry slams.

I remember that when I first met Glenn, he had not debuted Black Cracker nor transitioned just yet. We were both participating in a poetry slam at the now-defunct Bottomline Club in the West Village. I was impressed at how Glenn deftly used his lyrical skills to subvert the tendency toward male dominance in poetry slams. That night, Glenn—wearing a denim jacket with the sleeves cut off, a t-shirt underneath, and blue jeans with his mid-length locked hair tied back—his appearance androgynous with a punk aesthetic, steps to the microphone and begins reciting the following poem:

> I nail my palms
> with my pen

to my desk
and confess all my committed sins
I forgive myself and move forward

like the book of Psalms
I read like parables
stories of the weight of the world
endured in both triumph and defeat
I lay my soul at your feet
and lay my heart on the line
hoping that blind eyes will see

I am not a prophet,
only the prophecy
of misery to come
unless you lend your understanding to me
I give my words to you
can you hear me?[29]

Glenn delivers these lines in a measured cadence, at mid-range volume as he stands directly in front of the microphone placed in the middle of the stage. His voice at this time is somewhat high-pitched with a husky quality, similar to that of singer Macy Gray. He possesses a quiet, subdued presence and does not use the commonly associated singsong cadence prevalent at slam competitions such as this one. During his performance, he keeps his arms slightly bent at the elbows, palms facing upwards as his hands maintain a slightly cupped shape. Glenn slowly raises and lowers his forearms, his hands facing downward as they jut out, punctuating his articulation of the line "can you hear me?" Alongside his gestures, Glenn deftly uses metaphor, mysticism, and repetition in addition to his slow verbal delivery and emphasized articulation in performing his writing. This poem, Glenn's final performance in the three-round poetry slam, earns the highest scores and ensures that Glenn wins the competition. Jack Halberstam attributes the lack of success of women in poetry slams to the fact that these competitions can very easily become a "macho contest of speed and fury."[30] The speed and fury described by

Halberstam alongside the tenor and cadence of the male voice create a performance that, similar to rap, fails to include many women.[31] Glenn prior to transitioning was an exception. He managed to engage with issues of race, gender, sexuality, and class while demonstrating a textual and verbal acumen that few poets were able to match. As a competitive poet, Glenn won both local and national slam competitions and was one of the most sought-after spoken word artists for both queer and non-queer events.

Introducing Black Cracker

During Black Cracker and Bunny Rabbit's rendition of their song "I Ain't Your Girlfriend No More" in the Bowery Poetry Club, Black Cracker steps to the stage wearing a blue basketball jersey with a white t-shirt underneath, baggy jeans, and a white baseball cap tilted to the side in an exaggerated fashion. Underneath Glenn's baseball cap, he wears his hair shaved on the sides while tufts of his afro come out of the front and the back of the cap, since the hat is more perched on the top of his head than pulled down over his hair. His gender presentation again reads as androgynous, yet less punk and more masculine, and he already identifies as Black Cracker. Next to him stands Bunny Rabbit in red jeans with a red tutu over them and a white tank top, made up similar to a Barbie doll, albeit one with shaved sides and bleached blonde hair to match. In this performance, Glenn's masculinity throughout serves as a stylized critique and larger-than-life representation of what we now might term toxic cis Black masculinity. Positioned next to Glenn as Black Cracker, Bunny Rabbit performs a racially White persona although ethnically self-identifying as Samoan and Mexican. Their performance both points to easy identification and defies it at the same time.

Throughout this rendition of their song, Bunny Rabbit rotates her hips from side to side while standing center stage as her tutu swishes back and forth. Juxtaposing her repetition of the constant refrain "I ain't your girlfriend no more," Black Cracker walks around her, semi-hunched over, cupping the microphone at the top rather than holding it at the base—a common gesture in rap and hip-hop performances—while grinning widely and clapping intermittently, extolling the

audience to "come on, come on."³² During this version of the song, Black Cracker appears to be relegated to the background. However, the backgrounding operates as the visual articulation of his position as a hype man and producer. Before the show, he created the beats on his computer, synthesizer, and mixer, while Bunny Rabbit took the microphone. The sexualized rendition of this song, moreover, demonstrates how the performance intervenes in the heteronormative public sphere by situating them as queer artists publicly performing their romantic desire. Glenn at this time still self-identified as female, and this musical number enabled him and Bunny Rabbit to create a queer counterpublic sphere for themselves and their audiences. José Esteban Muñoz argues that queer of color counterpublics serve not only to validate but also to produce minoritarian spheres that challenge whiteness and heteronormativity.³³

This performance and his subsequent cultural productions demonstrate how in stepping to the stage in a performance venue, Ellison Glenn as Black Cracker registers an intersectional identity marked by the co-presence of his sexuality, race, class, and gender in dialogic relationship to his collaborator on stage, as well as their transatlantic audiences. Prior to his transition, the lyric "I'm not your girlfriend no more" referenced the breakup of a lesbian relationship. However, following his transition, the song takes on new meanings and politics. As a transman, he is a boyfriend rather than a girlfriend, and his performance of the same song now marks the relationship between his assigned sex at birth and his gender identity. As I stated earlier, Black Cracker as Glenn's stage and song persona predates Glenn's transition. Through this critical queer and trans aesthetic, Glenn as Black Cracker makes the seemingly "exhausted and limited" performance genre of minstrelsy useful once again.³⁴ He compels us to deal with our anxiety regarding the production and subsequent performance of racial identity by forcing us to confront it both visually and aurally. Throughout the performance of this song, the audience remains seated, with smatterings of arms raised but no corporeal engagement or dancing throughout. The spectators at the Bowery Poetry Club ultimately respond by cheering and clapping as the final lines are sung.

Aurally, Glenn explicitly challenges his audiences through both poetry and music. For example, in the track "Salt and Pepper" from his

album with the Victory Riot, *Transparent Sand Reflecting the Edge of Crabs*, he forges a sonic critique of the homophobic and classist policies of the George W. Bush administration. The track begins with a series of staccato synthesizer drumbeats and the opening line:

> The roach motel located behind Heaven's gate
> waits for mice and men in hen suits
> clucking chickens

Soon after this, Glenn musically challenges the different historical realities of racialized people in the United States:

> I bet you my heartbeat
> That you speak of this life like it was a Loveboat
> but this is a slave ship

This is followed by a pointed critique of the George W. Bush administration:

> And love is love
> no matter who has the balls
> or the Bushes in their White House that turns
> and turns into a discotheque
> when the children go to bed

culminating in the final stanza:

> If abortion applied to communities in fetal position
> because they had no options but to starve to death
> the breathless souls ruling this country
> would dismiss them
> like kids in detention
> with no intention of ever lending a hand,
> or a slice of Spam or ham or concern.
> Instead they would burn them like toast
> and the urn
> full of a nation's ashes

> would sit on the table when roast was served
> and the guests would think it was pepper[35]

Lyrically, Glenn defines love as universal regardless of who possesses the "bushes" or the "balls," and describes poverty as a condition inflicted on minoritarian communities by corrupt politicians. He uses the term "bushes" to refer to the Bush administration and as the colloquial slang term for female genitalia. In articulating this clear linguistic pun, he critiques the disparaging ways that the Bush administration and its economic policies dealt with both queer and poor communities of color. According to Glenn, these communities ultimately suffer at the hands of politicians who dismiss them and their poverty, using their remains ("a nation's ashes") as salt and pepper. This salt and pepper, as both Black and White, stands in for the troubled relationship between Blacks and Whites in the United States that, according to Glenn, will be served for mass consumption.

Glenn extends his discourse on class, sexuality, and race on another track, "Whitening Cream," from the same Victory Riot album. This piece, yet another precursor to Glenn's adoption of Black Cracker, is firmly situated within the racial imaginary of the United States' history of Black enslavement. Similar to "Salt and Pepper," this track also begins with a staccato synthesizer drumbeat, intermittently interrupted by a high-pitched beeping and a gong sound that infuses the track with an eerie quality. From the onset Glenn articulates a critique of US capitalist hyper-consumption, imperialism, and colonialism:

> Sticks and stones are keeping
> our children blind
> and binding them
> from head to toe
> in J.Crew corporate attire.
> The only thing that we aspire
> is to make money
> and climb the ladder
> to the top of the World Trade Center.

Shortly thereafter, Glenn describes the US's racist past:

> Civility forgot how to be civilized
> grounded in the bakery
> of apple pies
> jolly slave ranchers
> on plantations.
> My imagination
> wonders if idiots
> in the corner back
> by the walls
> of their father's creation
> ever hesitated
> to pursue the Manifest Destiny
> that stirred the pot,
> melting the start
> of the Bible Belt
> and the backs of trees.

continuing with the stanza:

> We have the dumb
> leading the dumber
> while the bums,
> are getting bummier
> while the slums
> are being populated
> by yuppies
> and hillbillies,
> who don't understand,
> for them,
> it's cheaper rent.
> While for others
> it's their last standard of life,
> that's slipping
> through their hands

> like sand
> through wine glasses.

Glenn concludes by speaking directly to his listeners:

> I persuade this life to live in me
> So that I can one day
> Carry this universe like a Metrocard
> to a newfound world.[36]

On this track, Glenn criticizes gentrification in the lines "while the slums / are being populated / by yuppies and hillbillies," and puns on pop culture (the candy Jolly Ranchers) while citing the plantations of the antebellum South in "civility forgot how to be civilized / grounded in the bakery of apples pies / jolly slave ranchers on plantations." Glenn uses apples to typify Americana, enabling his critical engagement with US racial history. His last stanza, where he references a "newfound world" to be accessed by his carrying of the "universe like a Metrocard," mirrors the desire expressed by Muñoz's reading of Moraga, the quest for a utopic queer of color futurescape, and signals a move toward Glenn's engagement with trans Afrofuturity in his later cultural productions.

Glenn extends the critical race sonic discourse in *Transparent Sand Reflecting the Ego of Crabs* into social media by posting a tube of skin lightening cream as the default pic on his Myspace page, at the time the most popular app for transnational connection between friends and strangers, and artists and their potential audiences. The tube offers the user an opportunity to "look lovelier" by "looking lighter," and includes the picture of a Black woman wearing a large white sunhat with what appears to be a red-and-white striped scarf covering her neck. Only her face and smile appear on the tube. Underneath her image reads, "Dear Heart, the lighter you look, the lovelier you look: A complete skin lightening treatment with hydroquinone and Vitamin C."[37]

I remember when Glenn changed his profile picture to this image. Occurring prior to his adoption of Black Cracker, Glenn's usage of this image as his online "self-portrait" instantiated his use of parody as critique in live performance. Akin to his later use of minstrel gestural antics to lampoon masculinist hip-hop aesthetics, the posting of this whitening

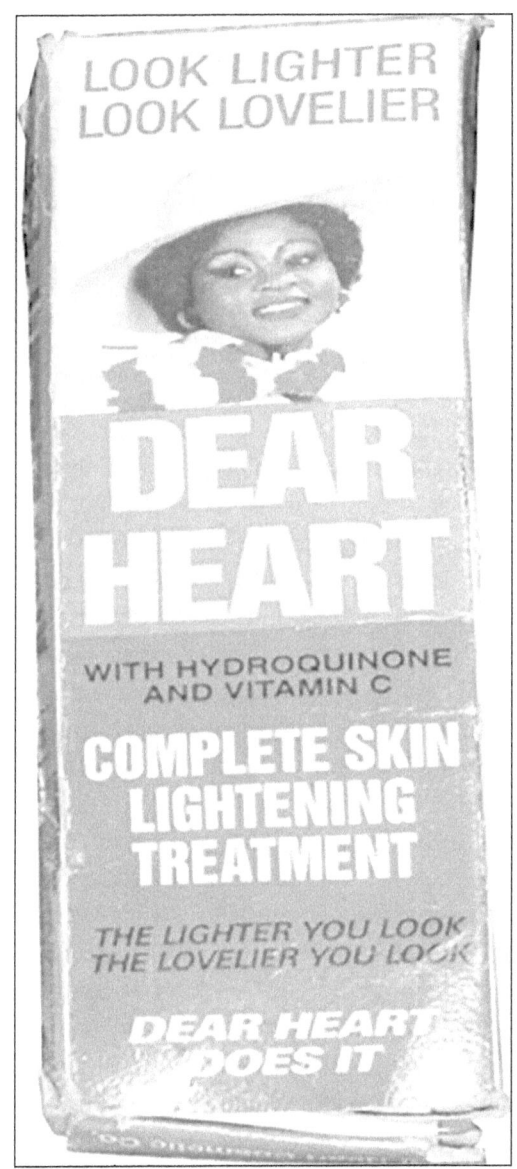

Figure 4.1. Vintage ad for skin lightening cream, used by Ellison Glenn as a Myspace profile picture. Screenshot taken by the author from Dodai Stewart, "Oldies but (Not So) Goodies," *Jezebel.com*, May 5, 2008, https://jezebel.com.

cream tube and ad functions as a wry commentary on the profitability of Black pain. Skin lightening offers people of darker skin the "opportunity" to lighten their skin and attempt to painfully, if inexactly, approximate whiteness. The image and text sell whiteness as possibility and beauty to Black consumers. This prepackaged racial mimicry is contingent on colorism and the historically racist ideology of our slavocracy. I return here to another collaboration between Black Cracker and Bunny Rabbit, who, in addition to their shows in the United States, also performed abroad in underground spaces and clubs. During a performance in Rotterdam in the Netherlands, documented on YouTube, Black Cracker presents himself on stage wearing a blue sweatshirt with the hood pulled down over his head, the front of his Mohawk hanging over the side of his face while he jumps around, circling Bunny Rabbit, gesticulating and yelling, "wild out, wild out." Bunny Rabbit wears a black baby doll dress with black-and-white striped sleeves, a large blue bow across her chest, and a red tutu skirt. A small video screen, next to a cross, rests on a circular table on the stage to their right. While Bunny Rabbit raps and gyrates on stage, Black Cracker appears once again to be channeling Flavor Flav from the rap group Public Enemy, the quintessential hype man.

Black Cracker complicates his hype man performance by grabbing Bunny Rabbit around the waist while hunching over and peeking out from the side of her body with a wide grin on his face. This image serves as reminiscent of minstrelsy, with the smiling, (seemingly) oblivious performer in Blackface. Glenn as Black Cracker reappropriates this trope only to debunk it a few seconds later when he stands up. This moment in the performance, where Bunny Rabbit recites the lyrics "stepped on my foot, stepped on my foot" in her dress, is contrasted by the following moment wherein Black Cracker stands and reassumes his power position in relation to Bunny Rabbit. Black Cracker, now behind Bunny Rabbit, simulates copulation by taking on the physically dominant position. He then moves to the forefront—placing himself as the center of attention—and begins jumping up and down, legs straight and together with one arm rising and falling as the other one holds on to the microphone. His movements are phallic, as is his power. He no longer gesticulates, hunched over or focused with his attention on Bunny Rabbit, but rather commands the attention for himself with one motion as he implores the crowd to "come on, come on" once again.[38] Here we see

how Black Cracker lends Bunny Rabbit the stage only to return to claim it. However, the performance is not rendered as natural, authentic, or real. Black Cracker, here, exposes both the gendered and performative tradition of the minstrel and the (hetero)sexual. This moment demonstrates minstrelsy's "talk of opportunity and investment, lending and ownership, subsistence and competition that is more preoccupied with cultural value than we might have expected. Its social unconscious, we might say, reveals a great deal of anxiety about the 'primitive accumulation' it ostensibly celebrates."[39] Glenn disrupts his backgrounding, his relegation to the back of the stage, and in moving to the forefront, owns his position as producer and musical co-star. In addition, as was also the case in their earlier performance at the Bowery Poetry Club, it is difficult to discern whether or not Black Cracker was assigned male or female at birth due to his androgynous gender presentation. Serving as a contrast to Glenn is Bunny Rabbit, who, in her short baby-doll dress, is marked as feminine via her exposed body and concomitant gender expression. Their work, as always, challenges the naturalization of gender roles and hetero sex via sardonic exaggeration. Black and White, gay and straight, masculine and feminine comingle, as does rap's look with electronica beats, prefiguring later work by more mainstream hip-hop/R&B artists such as Rihanna, Solange, and the queer female-fronted band The Internet.

Diana Taylor proposes that performance functions as a means to transmit "social knowledge, memory, and a sense of identity."[40] For Taylor, performance operates on at least two levels: one level is that of "object/process of analysis," where practices and events, theatrical or rehearsed, are ontologically affirmed, constituting what *is* performance. The second level is that of a "methodological lens," an epistemology that enables scholars to examine happenings *as* performance. Performance in the first sense, as an object or process of analysis, depends on the context or society in which it occurs. Thus, while Black Cracker's gestural vocabulary and on-stage antics are consistent across his transcontinental performances, the audiences—their antics, histories, and racialization—are quite distinct in response.[41] New York audiences are unsettled by Black Cracker's minstrelsy and troubled by his break from popular modes that affirm rather than lampoon masculinity. At the Bowery Poetry Club performance, his pointed racial buffoonery quieted the crowd but did earn

respectful applause by its end. In contradistinction, his Rotterdam audience sang along with him, started a mosh pit, and seemed enlivened by the staged racial and sexual excess. Minstrelsy, as a performance genre that reasserted the dominance of Whites and the seeming ridiculousness of non-Whites aspiring to the equality, knowledge, and respectability of Whites, registers differently in places such as Rotterdam, with dissimilar race politics. There is an arguable lack of recognition with respect to the ironic politics of Black Cracker as an identity, and Glenn's queering of minstrelsy specifically, since Glenn as a Black artist born and predominantly raised in the United States does not perform in a recognizable version of Blackface. Glenn's productions are not invested in reproducing the racist iconography of Blackface performance, but rather in queering minstrelsy and deploying the accompanying gestures as critical corporeal critiques of the production, dissemination, and inevitable consumption of racial identity. Despite the Netherlands's tradition of Zwarte Piet/Black Pete, a racist version of Santa Claus in Blackface, minstrelsy as a performance genre remains "a ground of American racial negotiation and contradiction."[42] Thus, Glenn as Black Cracker through his performance of a hip-hop minstrel manages to redefine the genre of minstrelsy, effectively and affectively queering it. "Black Cracker" as a performance identity grounds his nuyorican aesthetic, leading to a recombination of identity markers. Glenn reclaims peoples, artistic practices, and subjectivities deemed abject and reconfigures them as a political gesture of defiance. Ultimately, minstrelsy, for Glenn as Black Cracker, operates as a useful aesthetic strategy that opens up a larger discussion on the formation of racial identity in the United States.

Black Cracker and Queer Trans Afrofuturity

From his performances with Bunny Rabbit both in downtown New York City and abroad, Glenn as Black Cracker has since moved this performative persona away from underlining masculinist racial clowning of the hip-hop present and the minstrel past, and toward inaugurating a trans Afrofuturity that operates as both queer and diasporic. I draw from the work of Brent Hayes Edwards in framing Glenn's artistic movement as well as his geographic one. While he continues to perform as Black Cracker, Glenn is no longer based in the United States, having moved to

Berlin in 2012. Just as Paris in the 1920s served as a home for creative and political expressivity for Black US artists, Berlin has increasingly become a site for writing and performance by artists of color in the contemporary global art market. Glenn's current productions as Black Cracker begin to point toward what I define as trans Afrofuturity only after he moves away from the United States, Brooklyn specifically, and makes a home for himself in Germany. Edwards offers up a possible explication for why the work of artists of color shifts in different directions once they move abroad when he writes, "It is as though certain moves, certain arguments and epiphanies, can only be staged beyond the confines of the United States."[43] This is to say that although Glenn begins performing as Black Cracker while a US-based artist, his relocation away from the United States opens up specific conditions of possibility that allow him to imagine a different relationship to blackness and Black cultural productions. In addition, through his current work Glenn extends his usage of the nuyorican aesthetic into new geographic and artistic contexts. He begins his career as a spoken word artist, moves into punk and hip-hop, and now shifts toward a sonic hybridity encompassing electronica and R&B. Glenn as Black Cracker's constant artistic motion, evinced in the different sonic creations he puts forth, parallels his geographic movement from the United States to Europe while remaining politically grounded in a queer and trans of color critique.

In his current work, Glenn as Black Cracker performs what L. H. Stallings defines as a "transworld identity," or an "identity across possible worlds."[44] "Trans," in this chapter, operates on three levels. Initially, "trans" serves as an identitarian marker, signifying Glenn's position as a "man of transgender experience."[45] Second, "trans" signals the transit of Black people and politics worldwide, as evidenced by Edwards's understanding of diaspora and the interwar period. Finally, "trans" points us toward a Black Atlantic transnationalism with an increased emphasis on the immediate past as a historical archive in order to imagine and create a queer, trans Afrofuture. In turn, Black Cracker currently creates artistic productions that function as part of the larger tradition of Afrofuturism and electronica, producing beats for himself as well as other artists including Slick Rick, Grimes, and Trust.[46] The cultural and literary aesthetic of Afrofuturism, a term first coined by Max Dery in 1993 but later more fully explored by Alondra Nelson, combines elements of science

fiction, historical fiction, fantasy, Afrocentricity, scientific inquiry, and magical realism with non-Western cosmologies, and provides artists and scholars across genres and disciplines a methodology to revise, interrogate, and reexamine the historical events of the past.[47] Nelson highlights an inclusive Afrofuturism, contending that there are "other stories to tell about culture, technology, and things to come."[48] Through his videos, Glenn presents sonic counternarratives to the configuration of blackness as both "the anti-avatar of digital life" and oppositional to "technology driven chronicles of progress."[49]

While the science fiction writers Octavia Butler and Samuel Delaney, as well as the musician and philosopher Sun Ra, are generally positioned as the progenitors for today's artist Afrofuturists, Black musical groups such as Labelle and Parliament-Funkadelic should also be included in this emerging archive of resonance. Both bands through their lyrics, costumes, and staged theatrics critiqued racism, celebrated Black embodiment, toiled with history, and sang out to a utopic galaxy. They did so by invoking a Black otherworldliness for themselves, their audiences, and listeners. P-Funk's Mothership, the group's analysis of race and poverty in "Chocolate City" DC, and their use of a minstrel-like persona of a crow named "Sir Nose" are politics and aesthetics retraced by Glenn in performance mode as Black Cracker.[50] Labelle's questioning of the state's panoptic presence in Black lives, refusal to comply with stagnant gender roles and expectations, and use of egg/ovum metaphors for Black female origination, as well as a tendency to construct fable-like lyrical worlds of anthropomorphism, religious syncretism, and Black romanticism, all pre-figure Glenn's sexual-temporal-racial politics envisioned in "Chasing Rainbows."

Glenn's music video for "Chasing Rainbows," from his *PosTer Boy* album, functions as a future text, presenting the past and future, combining memory and utopia. What does it mean to "chase rainbows"? Similar to the classic ballad "Over the Rainbow," "Chasing Rainbows" expresses a (queer) quest for a better tomorrow. Yet, while "Over the Rainbow" articulates an eventual destination, "Chasing Rainbows" references a never-ending journey. After all, rainbows as phenomena caused by the reflection, refraction, and dispersion of light in water droplets have no visual or tactile beginning or end.[51] Rather, they seem to stand in for futures just over there, wherever "there" is. So, what *does* the fu-

ture sound like? Feel like? How do hip-hop and Afrofuturism enable Black Cracker's move between alternate lifeworlds, and can European electronica and the Black Atlantic serve as sites for utopic Black trans visions and worlds?

In "Chasing Rainbows," Glenn utilizes a green screen in order to digitally move between both geographic spaces and times, from a dark gray dystopia to a more colorful world, perhaps even a hopeful space, which seems to signal alternate "realities" and possible futures that emerge from chasing rainbows. The album that includes the track "Chasing Rainbows," *PosTer Boy* with a capitalized *T*, serves as the follow-up album to *PreTty Boy*, with the first *T* in "Pretty" also capitalized. The words "Pretty" and "Poster" before the word "Boy" invite a reading of how Glenn as Black Cracker marks his gender transition in relationship to "T," or testosterone. While the play with capitalization has roots in the work of Prince, Ntozake Shangé, and the Nuyorican Poets Cafe's poetic aesthetics, Glenn's titles and emphatic yet wry use of the capital *T* position his albums in an emerging trans and queer Afrofuturity. Here Stallings's work on transworld identities proves particularly useful in situating trans subjectivity away from the medicalized body by instead focusing on the relationship between transness and movement.

In the image introducing the video for "Chasing Rainbows," a White woman sits in a bedroom, her eyes and mouth missing, scratched out, while on the wall behind her bed hangs a poster of a shirtless Black male sitting in a chair, arms raised behind his head.[52] The visible pectoral scars, alongside his attire, especially when positioned next to a picture featured on the German website *Sudblock*, identify the person as Black Cracker. While the woman has no eyes or mouth and therefore cannot see or speak, neither can a headless Black Cracker. I read this image through the work of Miles White, who argues that in hardcore styles of hip-hop, facial expressions alongside the shirtless male torso telegraph hypermasculinity and this idea of psychic hardness, while simultaneously privileging the objectified and spectacularized body. Yet Glenn as Black Cracker complicates this reading by including his shirtless torso with no complementary facial expression.

What, then, is at stake in including a spectator who cannot see or speak in front of an object—the poster bearing the image of Black Cracker—that also cannot see or speak? Glenn's response to this

Figure 4.2. Initial scene of Black Cracker's music video "Chasing Rainbows," 2014. Screenshot taken by the author from YouTube, youtube.com/watch?v=2CfNNODUp2I.

question and to the classification of artists as LGBT or as part of the queer hip-hop scene represents the ways his work critically engages with the politics of identity. In a 2014 interview he states, "I believe it's discriminatory and will believe so until we define other things as heterosexual or White or male or skinny or all the numerous ways in which many are determined and dead set on making humans Other."[53] Glenn's post-humanist formulation here refuses the structural and categorical imperatives of White supremacy and heteropatriarchy that position him as Other without agency, history, or futurity. Glenn presents himself as forthright and declarative in the interview. However, his lyricism and positioned performance as *PosTer Boy* icon and dancing performer in the video for his song "Chasing Rainbows" are far more enigmatic. The headless Black transman and the disfigured/de-faced White (cis) woman are emblematic, then, of a move away from Muñozian disidentification and toward an expansive trans Afrofuturism.

The second image on the visual timeline presents an ominous blue-gray sky and dark mountains in the distance, while a small green patch of grass frames dead-end roads at the bottom of the screen that seem to be going somewhere/nowhere at the same time. The third image, a

fiery cloud of smoke, denotes an explosion, while a set of lipsticks serve as the end of this sequence. The lipstick at the end stands in for the construction of feminized/sexualized beauty, and also operates as a tool used in generating a facial mask. These pictures function as the backdrop to an emerging Black Cracker in the lower righthand corner. He begins rapping while wearing rolled up gray shorts, a white-and-black plaid wool shirt, baseball cap, and black combat boots. These images contradict one another: the ominous explosion followed by the arguably banal red lipstick, the horizon of the mountains seeming to represent a potential future over "there" contrasted by the apocalyptic end brought on by catastrophe.

In the following scene, we encounter the first of many scantily clad women throughout the video. The woman, with her White/light skin, is ethnically ambiguous, wearing a white lace bustier with matching underwear and garter belt. The woman sports long, straight black hair and initially sits in a chair, leaning back while opening and closing her legs. She then moves and begins to crawl seductively on a window ledge while Glenn as Black Cracker stands to the side of her and continues to rap. The camera's focus shifts to her while relegating him to the periphery, similar to his earlier performances alongside Bunny Rabbit. After this moment, the same woman, now wearing very high-cut denim shorts and a white tank top with a red heart covering the front, gyrates in the same white heels she wore in the previous sequence. At this point in the video, the woman has been duplicated and there are two versions of her dancing side by side behind Black Cracker. In both scenes we see the woman positioned at such a distance that her face and expression appear out of focus. This woman, surrounded by signs of decay—the peeling floor, the missing wall, the branches on what appears to be an old basketball court, evidenced by the fading lines for what seems to be the three-point shot—operates as both out of place and in place within the temporal realities that Black Cracker puts forth.

The contrast between what the White/ethnically ambiguous woman is doing, how she is dressed, and what is occurring in the video at that moment continues as a Black woman wearing a lavender dress appears in the corner of the screen. Shortly thereafter, we see the Black woman in a sleeveless Lycra magenta dress, arching her back while resting on her forearms, before she sits up and begins opening and closing her legs

while rubbing them seductively. This woman's face and expressions are visible, and she looks directly at the camera, meeting the viewer's gaze. There are multiple dancing versions of her on screen, similar to the other woman dancing in the video. Throughout, she alternates between being in front of and then behind Black Cracker while the screen flashes and changes colors. I find the representation and inclusion of women helpful in the context of this video and the dichotomies with respect to color that Black Cracker presents lyrically. While the appearance of these woman in the video can arguably be read as Black Cracker continuing to participate in the objectification and mistreatment of women due to a fear of female sexuality, as argued by Tricia Rose, I argue for a more complicated reading of this video.[54]

The video, visually, lyrically, and sonically, presents a constructed world of different possibilities. While the dancing women, arguably White and Black, are in constant motion, owning their sexuality, Black Cracker never makes them the object of his gaze, nor does he denigrate them lyrically. The White (cis) woman with her eyes scratched out in the initial sequence of the video is rendered static and remains fixed in one position, in a photograph. She becomes an object within an object with no agency, and no possibility to visually interact with the viewer. Yet her position in some ways mirrors ours, as listeners and viewers of the video. Recall that she appears in a room in which Black Cracker appears as mere poster boy, a two-dimensional and eroticized headless torso. Whereas in his earlier work he operated within modes of recoding and subverting binaries of Black/White and man/woman, in "Chasing Rainbows" he makes enigmatic the relations between women/men, cis/trans people, Black/White, and femininity/masculinity precisely by flattening them out. This is done, I believe, so that Black Cracker's later dancing and multiple selves in a stark landscape can figuratively bust out of the received narratives of race, embodiment, and subjectivity.

This engagement between the seemingly absurd and the carnivalesque continues in the subsequent two scenes of the video. In the first we see Black Cracker standing in front of overgrown foliage covering the former tracks of a derelict rollercoaster, while an oversized colorful butterfly hovers mid-flight between a series of flashing lights. The bright hope and transformational processes signified by the butterfly and the lights are juxtaposed in the following image by the unkempt greenery cover-

ing another amusement park signifier—the bumper car ring. But in this instance, the rusty metal frames where the rooftop would be, alongside the brown leaves and nonfunctional bumper cars, seem to highlight a ghostly lack of use and life. The earlier image portrayed a singular Black Cracker; in contrast, here we see three versions of Black Cracker, as if to articulate his refusal to be relegated to invisibility or a monological identity. In emerging headfirst from below, Black Cracker resists his erasure while forcefully embodying and presenting multiple versions of himself. These iterations of self continue in the next sequence, wherein three more versions of Black Cracker dance and rap in what seems to be a collapsing shed. In his earlier musical productions and performances, Glenn as Black Cracker would move between being a part of the background and lending the stage to Bunny Rabbit, only to later reclaim it; here, however, he not only reclaims the stage, but inserts multiple versions of himself. As in the work of Miguel Piñero, Regie Cabico, and the participants in the Glam Slam, Black Cracker's work as an example of the nuyorican aesthetic extends and disrupts the performative legacies of the Nuyorican Poets Cafe. In taking on a musical career, releasing singles and videos, as well as doing poster art publicity, Glenn also enters the genealogy of contemporary postmodern Black musical artistry. The video for "Chasing Rainbows" as a positioned performance of trans politics and aesthetics of futurity cites Black videographic history even as it sites it in an elsewhere of both postindustrial decay and utopic futuristic possibility.

In his essay on D'Angelo's music video "Untitled (How Does It Feel)," film scholar Keith Harris expands on the work of musical artist D'Angelo and his music video for the track.[55] While D'Angelo's video was experienced as a breakout video and somewhat ruptured the history thus far established of the Black R&B video, with regard to its visualization of Black masculinity and corporeality, it is also part of a contemporary lineage of Black videography and critical visual discursivity. For example, Michael Jackson, the King of Pop, was a Black musical artist who became prominent within the musical video field. Jackson's music video for the song "Billie Jean," from his record-breaking *Thriller* album, proves significant as it marks the first time a Black musical artist is featured in their own video airing on MTV. While Herbie Hancock's "Rock It" played on regular rotation on MTV, his video featured robots, not

the artist or other Black people, so as to ensure airing on the then-White and rock-identified MTV. However, an earlier video by Jackson inaugurates Black videographic multiplicity. The video for "Don't Stop 'til You Get Enough," exemplary of Jackson's iconicity and a positioned performance of singularity and multiplicity, premiered in 1979. The video, utterly lacking in any other signs of human life, highlights Jackson's tuxedoed dancing form moving across computer-generated backdrops of simulated cities, precious gems, abstracted concert stages, and a world populated with geometric sculptures. His musical genius and dancing prowess thus assume complete rarefication. His Black iconicity is located in being sui generis, evidenced in the resulting isolation and self-regard. Jackson's singularity becomes highlighted, sutured into notions of opulence, capitalist success, and a cyborgian field to dance and reign over, even as his image splits into multiples.

Chaka Khan's video for "I'm Every Woman" also uses multiple dancing images, but for the purpose of accentuating a feminist politics of Black female collectivity. This is most emphatically and visually clear, and declared, when five differently dressed versions of Khan fill the screen. The lead singer dissolves, disappears, and reappears, signaling an emphasis on the everyday Black woman, not the solo artist or Black diva of song. Her power, voice, and image as an "every woman" are constituted as choral. Her genius, unlike Jackson's, does not operate as individuated or individualized but is visually rendered as Black feminist multiplicity. Black Cracker's foray into Black music video artistry and historiography disrupts and extends Jackson's and Khan's work by enunciating a positioned performance of trans individuated multiplicity.

I return here to Glenn's reclamation and replication of self in the amusement park scene of the video. In particular, I attend to Ashon Crawley's examination of breath and how he considers "specific performances of breathing in black, breathing Blackpentecostal performance" as an entrance into thinking "more fully about how breathing is not just a sign of life but is an irreducibly irruptive critique of the normative world."[56] Crawley positions the physical act of breathing as a gesture of resistance defying the precarity of Black lives, where breathing signifies aliveness and challenges Black death, specifically within a spiritual framework. Crawley posits that "to breathe, within this western

theological-philosophical epistemology, is to offer a critical performative intervention into the western juridical apparatus of violent control, repression, and yes, premature death."[57] Thinking with and through Crawley's unpacking of the physical act of drawing in and releasing breath enables me to interrogate the possibilities in conceptions of flow in the work of Black Cracker. Flow, as I explicated earlier, relates to the pacing and velocity at which the lyrics and individual syllables are performed. Yet as a signifier demonstrating a fluency in hip-hop aesthetic practices, flow also references the pacing of breath, where the pace operates as a sonic disruption. This sonic disruption, when positioned alongside the visual imagery of the multiple Black Cracker dancing figures that come to populate the postindustrial scene of the inactive amusement park, opens up other secular worlds of possibility as practiced, represented, and reached for in the United States. Whereas Crawley focuses on Black Pentecostal prayer acts, I focus on Black Cracker's music video as a secular creation that also signals what Crawley theorizes as "otherwise possibilities," wherein "otherwise, as word—otherwise possibilities as phrase—announces the fact of infinite alternatives to what *is*."[58] These otherwise possibilities are revised and made trans and intercontinental in "Chasing Rainbows," both in terms of the lyrics, with flow being a hip-hop version of breath, and the secular redemption that I posit in my analysis of the amusement park where the video is partially set. Amusement parks in the United States function in television and film as representative of Americana, connoting the vacationing White nuclear family while serving as spaces for thrill rides, patriotism, and adolescent rites of passage (grad night, employment, youthful experimentation). In some ways Black Cracker's use of one in decay signals the end of that White supremacist heterocentric ideology and the advancement of a raced trans utopia on the decayed grounds of White fantasia. Textually, in the segment following the amusement park in disrepair, Glenn articulates this demise by including this message written on the wall of a rundown shed: "The old fortune teller lies dead on the floor, nobody needs fortunes told anymore."[59] Alongside the image of a spraypainted clown, this legend functions as a signifier for the collapse of memory and history, the present crumbling, the future unimaginable. The amusement park in disrepair, its promise and futurity decayed by economic recession and urban postindustrialization, all signal Glenn's

understanding of racial materiality as the matrix for the future's emerging, dancing and rapping, trans and queer selves.

In the final scene of "Chasing Rainbows" we see Black Cracker walking on an endless road (figure 4.3). This visual endnote relates to José Esteban Muñoz's theorization of utopia as an "anticipatory illumination of a queer world, a sign of an actually existing queer reality, a kernel of political possibility within a stultifying heterosexual present."[60] Here, I call attention to the following lyrics:

> In the midnight
> ebony/ivory
> I believe
> you and me
> live in prisms
> reflecting an infinity
> we coloring outside the lines
> white Light
> clouds/cumulus on the undefined.

the chorus continues:

> The night is black
> your skin is White
> my skin is Brown
> the seas is Grey
> your heart is blue
> your eyes are red
> the smoke is green
> we chasing rainbows.[61]

While lyrically layering colors in the way that rainbows do optically, Glenn, a dark-skinned Black man, once again puts Western polarities (ebony/ivory, Brown/White, me/you, heart/eyes) through a prismatic process of refraction that serves as his trans Afrofuturistic optic and sonic. Both the song and the video move toward a future collectivity by their end. Black Cracker extends the potential of "Chasing Rainbows" to

Figure 4.3. Final scene of "Chasing Rainbows," Black Cracker's endless road, 2014. Screenshot taken by the author from YouTube, youtube.com/watch?v=2CfNNODUp2I.

everyone when he describes it as "we chasing rainbows," not *I* am chasing rainbows. The chase is collective and in process. Black Cracker offers this future as a possibility for everyone, if we collectively move beyond fixed identitarian markers of space, place, or time. Like the work of Sun Ra, Parliament-Funkadelic, and Labelle before him in their futurized visions of Black subjectivity, Glenn's music, lyrics, and video imagery express a utopian impulse born from dystopic realities.

Glenn's musical productions as Black Cracker articulate a sonics of ceaseless motion and travel through repetition. The musical repetition creates a circularity, a temporal loop that signals a lack of arrival. Ultimately, Glenn as Black Cracker presents transness as unsettling to configurations of Afrofuturism as a politics of fixed and finite arrival. The future operates as an outside, an elsewhere, a dynamic function of geopolitics as theorized by Stallings. This movement away from and toward identitarian markers informs all of Black Cracker's cultural productions. Beginning with his early days as a poet at the Nuyorican Poets Cafe to his later work, Black Cracker as a performance identity enables Ellison Glenn to appropriate racist iconographies and reconfigure them as oppositional and joyful political gestures. The significance of his work

extends beyond the communities of spoken word, queer hip-hop videos, and multimedia productions. Glenn forces us to reexamine the ways race, class, gender, and sexuality as identity markers are produced and subsequently performed, not just in the United States, but everywhere that the music, lyrics, and images travel.

Conclusion

The Open Room

Yeah, the aesthetic . . . so I think we gotta plan a new book, a new anthology, with a new aesthetic, not the old one. Already we did theater, there's a book on theater. We did the primary Nuyorican. There's a book, 1975, on theater and poetry. And we wrote the essays and covered the book. Lois wrote the essay for the *Action* book. And we can certainly go right back and open up the arms of that book. We got the original bases. You guys can stand on that, those voices from the Nuyorican and the aesthetic of the voice that comes up there. What does it mean? And you can write it.
—Miguel Algarín, in conversation with the author, December 2018

I first step onto the stage at the Nuyorican Poets Cafe during the Open Room after attending the Friday Night Poetry Slam with friends in 1997. The Open Room starts between 12:45 and 1:00 a.m., after a majority of the crowd has left, serving as the noncompetitive conclusion for the evening's earlier poetry slam. The Open Room also operates as the beginning for many poets, me included. That evening, after I walked the brief distance from my front-row seat to the stage, Jeff Feller, then host of the Open Room, asked me whether it was my first time performing at the Cafe, to which I responded that it was. He then introduced me to a Nuyorican tradition. Whenever a poet appears on stage for the first time in the Open Room, the crowd, along with the host, serenades the poet with a communal singing of "virgin, virgin!" Over twenty years later I can't remember what poem I read or what I wore, but I do remember I was still femme-presenting and not yet out as a lesbian. I remember that

Figure c.1. Nuyorican Poets Cafe button. The author received this after performing in the Open Room for the first time. Photo by author.

the few people still present clapped at the end of my performance. I also remember Feller gifting me a button (figure c.1).

The button marks me as a "nuyorican poet" and signals the start of my journey with the Nuyorican Poets Cafe. Thus, the Open Room is the undercurrent for this text, functioning as an initiation into a society of poets, a noncompetitive sphere antithetical to the hyper-commodified slam world, and an aesthetic form. This form is also a forum for poetic exchange, grounding the practices of the Nuyorican while articulating an ethics of openness, a poetic undercommons. The undercommons refers to a conceptual space comprised of "black people, indigenous peoples, queers and poor people" who come together in resistance to their positioning outside the commons.[1] Instead of asking for recognition from those organizing structures that exclude and position them as

problematic subjects, they continually imagine and create new spaces for themselves as modes of communal survival.[2] The Open Room at the Cafe brought and continues to bring together those poets invested in spoken word poetry as a way to imagine other ways of being. This openness is not static and includes a constant negotiation with the space, its lineages, history, and aesthetic protocols that ultimately interanimate recombination, positionality, orality, and gesture.

In closing, I want to touch upon the relationship between the Cafe and the remaining members of the Nuyorican movement of the 1970s represented by Miguel Algarín and Lois Elaine Griffith, a Nuyorican founding poet, artist, educator, and lay archivist. Griffith shares an extensive history with the Nuyorican. She began performing and working there shortly after its founding as one of the initial hosts of the Open Room alongside Miguel "Lobo" Loperena. No longer a constant fixture in the space, Griffith remains in community with Algarín and other poets, performers, and artists who frequented the Cafe from the 1970s until the mid-2000s. While Algarín is hailed as Nuyorican Poets Cafe co-founder and progenitor of the Nuyorican movement internationally, Griffith's labor has been less recognized or lauded yet nonetheless merits significant recognition.

In the Beginning . . .

In 1973 Miguel Algarín, a former professor of Shakespeare at Rutgers University, brings together people as diverse as Nuyorican poetry icon Pedro Pietri and poet and playwright Miguel "Mikey" Piñero.[3] Pietri describes the literary and performance scene happening in Algarín's living room as magical and important. Lacking a venue and an audience, these young poets excitedly recite poetry to and for one another.[4] Once an Irish pub called the Sunshine Cafe became available across the street at 505 East 6th Street circa October 1974, Algarín rents it and the first "public" Nuyorican Poets Cafe is born.[5] The open door policies of the poetic gatherings first held by Algarín in his apartment are also implemented in this new public and commercial space. As former director of the Cafe, Griffith remembers the Open Room as "a stage where anybody could get up and share their art without prejudice. You didn't have to be a famous person; all you had to do was sign the book at the edge of the bar, wait your turn, and say what you had to say."[6] This lack of pretense

enables the Nuyorican Poets Cafe to function as a space for diverse performance mediums, races, ethnicities, and sexualities. Gaining entry and participating, then as now, requires no literary or social pedigree. The ethnic signifier "Nuyorican" in the Cafe's name does not preclude non-Nuyoricans from reading, performing, or taking on leadership roles within this space and this movement for urban cultural expression and communal uplift. As an example, the Cafe is originally run by Algarín and his live-in boyfriend, Richie August, while Griffith works the bar. August and Griffith are non-Latina/o/xs who both perform and work at the Cafe and who, alongside literary luminary Ntozake Shangé, are listed on the Cafe's website as Nuyorican founding poets. So, while "Nuyorican" signals a definitive ethnic-cultural background—Puerto Ricans in New York—the Nuyorican Poets Cafe always remains inclusive of those New York writers making politicized poems and performances regardless of their race, ethnicity, gender, or sexuality. In our 2006 discussion of those early days, Griffith tells me that although the Cafe has "its Puerto Rican roots," it remains open to everyone, resulting in people from the Lower East Side attending and participating in the events. Additionally, Griffith contrasts the exclusionary practices of "a lot of Latino and Black groups" during that time by emphasizing how non-Puerto Ricans are never excluded or discouraged from performing at the Cafe.[7]

Footage and materials documenting this history of openness foretell the performances that continue in the Cafe currently, from music to theater and poetry slam. Although audiovisual records are scarce, Marlis Momber's 1978 documentary *Viva Loisaida*, focusing on the Lower East Side, is useful as a historical record from the founding years of the Cafe and encompassing neighborhood. However, Momber is not the only person documenting performances at the Cafe during the early 1970s, as I discovered in 2018 as a Visiting Fellow at the Hemispheric Institute of Performance and Politics (the Hemi) at New York University. During my time at the Hemi I reconnect with Griffith, who has recently established the Nuyorican Poets Cafe's Founder's Archive Project (NPCFAP). I've known Griffith for almost twenty years, first meeting her when I began hosting the Friday Night Poetry Slam in 2003. Due to my connection with the Cafe and based on our previous collaborations, Griffith invites me to join her efforts to trace, gather, and catalog the history of the Cafe via a digital and physical archive. Reaching out to artists, performers,

and community members who contributed to and participated in the Cafe since its inception, Griffith looks to ensure that this important work will be preserved and accessible to all. As a member of the NPC-FAP I connect Griffith to the collections specialist and project manager for the Hemispheric Institute's Digital Video Library (HIDVL), Jehan L. Roberson, in order to begin acquiring video recordings from the 1970s onward to historically preserve a collection to be housed within the Hemi's digital library. From audio of 1970s-era street interviews conducted by Griffith and Pedro Pietri in the Lower East Side to a recent interview with Miguel Algarín conducted by Roberson, Griffith, and me, to raw footage of poetry slams in the 1990s, this collection will share Nuyorican past and present with a global audience. This archive operates from protocols established by the Open Room and within the genealogy of the nuyorican aesthetic.

Also included in the collection are open-reel magnetic tapes filmed by Stuart Reid, who was active at the Cafe in the 1970s, with black-and-white performance footage from 1974 that has never been seen before. In fact, the first few scenes (figures C.2 and C.3) on Reid's reel are of a young Louey Guzmán, now known as Luis Guzmán, a character actor and star of the stage and screen. Through his poetic performance Guzmán calls for revolutionary change and dedicates his poem to Changó, a Yoruba deity, falling in line with the cultural pride and affirmation through poetry most often associated with the Cafe during that time.

The camera pans out during Guzmán's performance as Reid captures the faces of audience members, many of whom are standing as they listen intently. One of the people in the audience is a young Black man with glasses and facial hair who is standing off to the side and playing an upright bass. Alongside him is a trio of drummers—Stephanie Chapman, Eddie Conde, and Richie Cruz—playing the congas, and who provide the musical soundtrack for many Cafe performances in the 1970s. Chapman, documented in action (figure C.4), comes into focus because of how she disrupts the patrilineage of conga playing and the heterosexism often used to define Nuyorican poetry and performance aesthetics. A member of ABC Loisaida, or A Band Called Loisaida, Chapman is a young lesbian active in the Loisaida art scene.[8] The dearth of information on Chapman, her artistic practices, and her subsequent influence on the Cafe and Loisaida in general speaks to the scant attention paid

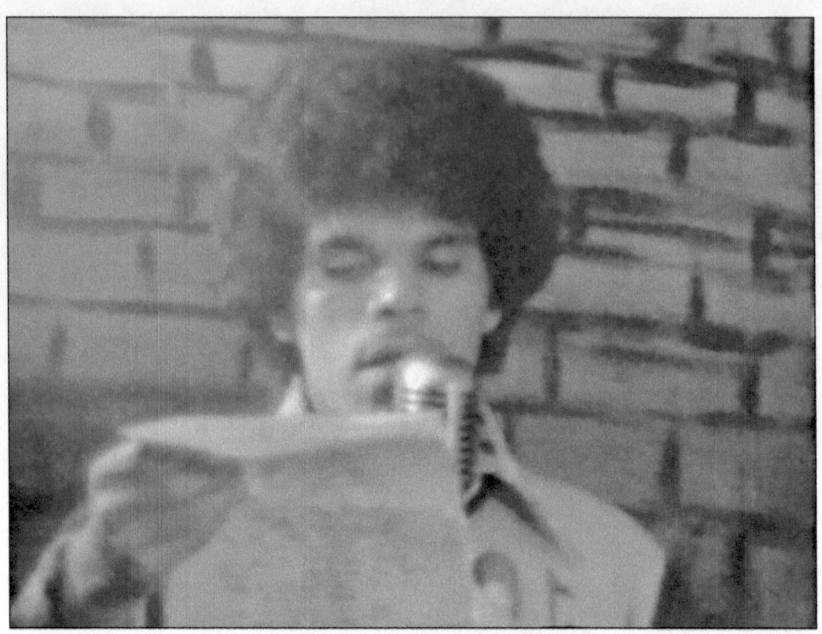

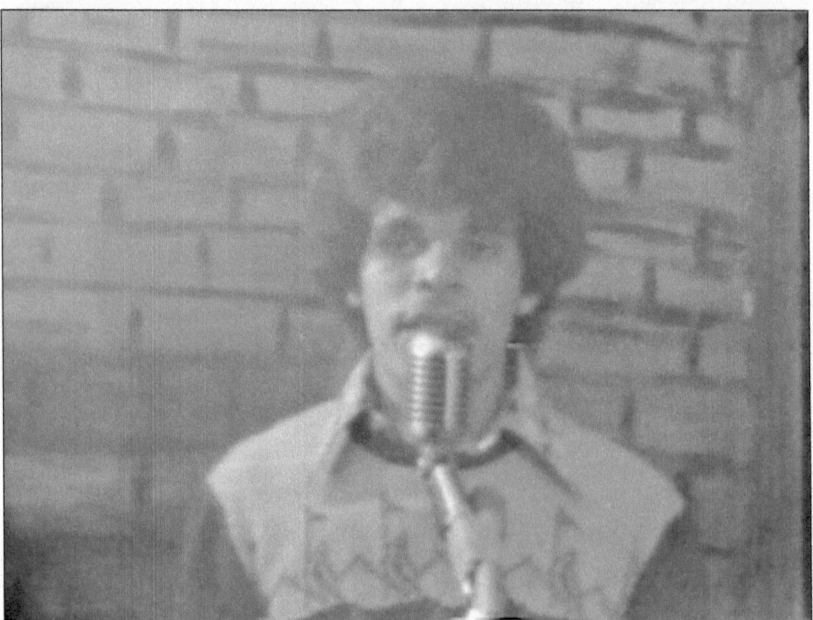

Figures C.2.–C.3. Actor Luis Guzmán performing at the Nuyorican Poets Cafe, 1974. Screenshots taken by the author from the Hemispheric Institute Digital Video Library.

to women and queer poets/performers in the Cafe's history. This lack of inclusion highlights the intervention of Patricia Herrera's book and also underscores the importance of queer practitioners within the same space as documented in *The Queer Nuyorican*. That Chapman, as a Nuyorican lesbian active in the Cafe, is never mentioned in previous texts documenting and analyzing the space remains a significant omission, as Chapman signals the rarely discussed early queer presence. Through this book and my participation in the NPCFAP, I aim to fill that historical gap and provide a more robust understanding of the Cafe and its resultant aesthetic practices.

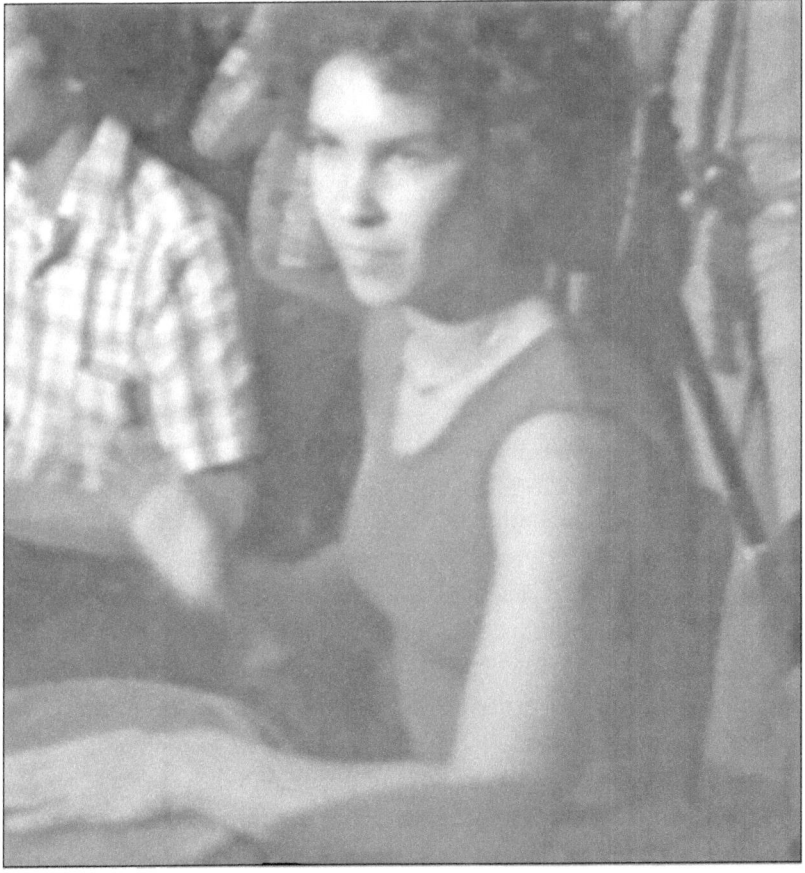

Figure C.4. Stephanie Chapman drumming at the Cafe, 1974. Screenshot taken by the author from the Hemispheric Institute Digital Video Library.

Moreover, this project takes on a necessary urgency as the number of people involved in the Nuyorican movement who were present and active at the Cafe since the beginning decreases due to illness and death. From Chapman to Loperena, and many others lost to the AIDS crisis of the 1980s and 1990s, the continued precarity of queer lives and histories at the Nuyorican compounds the exigency of this archival work with the continuing changes to the neighborhood. As of this writing, on December 6, 2019, two days after hosting an event centered on the negative and dangerous effects of gentrification in the Lower East Side, the Cafe is notified that it must close due to a conflict "between the Department of Buildings and the luxury condo development under construction next door."[9] Response to the Cafe's temporary closing is swift as borough president Gale Brewer, city councilwoman Carlina Rivera, and staff members of the Department of Buildings take quick action and enable the Cafe to remain open for small-scale events as the issues are resolved. The significance of this closing cannot be underestimated. Limiting attendance at Cafe events to seventy-four people or less results in the cancellation of the Friday Night Poetry Slam and other larger weekly events until the alley destroyed by the real estate developers is replaced. It seems ironic that the event that commercialized the Cafe, the Friday Night Poetry Slam, is the one most affected by the construction happening in the neighborhood. Yet, as I discussed in the introduction and have elucidated throughout this book, poetry slam as a performance genre at the Cafe has the potential to serve as performed historiography. Through slam poems, poets can relay the Cafe's original ethos of openness through the articulation of marginalized identities in verse as the fight against gentrification and hyper-capitalism in Loisaida continues.

In visiting and interviewing Algarín with Griffith and Roberson in December 2018, I am reminded of one of my more memorable experiences as host of the Friday Night Poetry Slam. It was Friday, March 5, 2004, two days after Pedro Pietri's death from cancer. The Cafe is collectively in mourning, as Pietri's death marks the loss of yet another prominent artistic voice whose writing documented the early struggles of Nuyoricans in New York. The date, March 5, is also the first time in the history of poetry slam at the Cafe that Algarín is scheduled as the featured poet. The opportunity to perform as the featured or spotlight poet is a great honor in slam culture. Traditionally, the qualifications

for featuring include success at National Poetry Slam competitions, significant literary production, and demonstrated performance excellence. People were, and are, chosen as spotlight poets based on their ability to hold an audience's attention for the twenty minutes prior to the beginning of the evening's competition. Algarín's lack of inclusion up until that point speaks to the emphasis placed on the theatrics of slam versus the content of the writing performed. As an older member of the spoken word community whose writing and reading predate poetry slam, Algarín's verse style and lack of a hip-hop inflection in his writing set him apart from slam poets and the expected poetic flow.

Still, Algarín defies expectations that Friday night as soon as he steps on stage. Following his introduction, Algarín welcomes the audience to what he defines as "his" house and begins by performing this version of Loperena's infamous Nuyorican chant:

> *La La La*
> *Le Le Le-e-e-e*
> *Le Le Le*
> *Le-e-e-e-a!*
>
> *Tru cu tum*
> *Cu tum cu tum*
> *{clave ///}*
> *Tru cu tum*
> *Cu tum cu tum*
> *{clave ///}*
>
> *La La La*
> *Le Le Le-e-e-e*
> *Le Le Le*
> *Le-e-e-e-a!*[10]

Algarín's rendering of Loperena's incantation, one that signals the shift from music to poetry in the original Open Room when Loperena co-hosted with Griffith, bridges the Open Room past of the Cafe with the poetry slam of the present. In addition, Algarín's reading of his own

work, initially written as a response to the politics of authenticity levied at Nuyoricans in New York, introduces him and the historical narrative of the Cafe to a fresh new audience.

I follow Algarín's lead and, a year later, perform my own poetic historiography. It is my last year hosting the poetry slam at the Cafe and I feel compelled to write "Ghosts in the Walls / Ode to the Nuyorican" as a way to interrogate the influence of poetry slam at the Cafe, to chastise performers who write and perform poetic verse adherent to stereotypes and tropes, and also to criticize the commercialization of poetry through slam. More than anything, I pay tribute to the Nuyorican/nuyorican poets and performers who came before me, highlighting their absent presence while gesturing toward the emergence of what I would come to know as the nuyorican aesthetic, a poetic forged through performance acumen and this insurgent tradition.

I can still remember performing this poem at the end of the Friday Night Poetry Slam, right before the crowd left and the Open Room began. That evening I told the audience I would be sharing some of my own work. Standing still with my arms at my sides, directly in front of the microphone placed center stage, I began slowly speaking.

> There are ghosts in the walls,
> their scorecards invisible
> their applause muted,
> they have no CDs or chapbooks for sale,
> no watches to give you,
> no trophies for you to carry home
> and no book deals for you to sign!
>
> There are ghosts in the walls
> who don't care
> how much you scream,
> yell,
> or stomp your feet.
>
> That don't care whether or not
> you memorized it,
> or are reading it from the page.

Memorizing it,
doesn't
make it
poetry . . .
it just makes it
memorized.

There are ghosts in the walls
ready to fight fake poets
and wanna be slammers.
Ready to fight
so-called
"wordsmiths,"
who pimp their work
to the highest bidder,
'cause it's about the dollar
not the dream
and money is what makes the world
go 'round
and poetry stopped being poetry
and became a product,
so they put on their best labels
and line up
hoping that someone,
will pick them up
before their shelf life expires,
when real poets
don't have expiration dates
and *their* currency is timeless.

There are ghosts in the walls
who don't wanna hear
your bullshit apologies,
your meaningless:

"I'm sorry. I hope I don't offend anyone—
It's just poetry."

There are ghosts in the walls who know

YOU
ARE NOT
A POET!

A poet,
would *never* apologize.
A poet
would *never* bow their head
and shy from speaking the truth.

If you say it,
make sure you mean it
'cause there are ghosts in the walls
who see through your veiled attempts
at saying something meaningful.

They guard poetry
like their lives depended on it,
make brick walls
their home,
and broken chairs
seem like fluffy couches.

There are ghosts in the walls
who make you forget,
that it's a Friday night in NYC
and you've waited on line
for an hour and a half,
paid $7
and are now sitting
on a dingy wood floor
with people stepping on your feet,
all because you heard that
this
is where poetry lives.

There are ghosts in the walls
who let you know that
odds are
you
will hear poetry tonight—
if you're willing to listen,
if you're willing to disregard
the judges
and look beyond
the theatrics to the words,
if you trust and believe
that the best poet
doesn't
always win,
you will hear poetry.

If you see beyond the arms flapping
and the singing,
if you see beyond the lit candles
spread out in the audience,
if you see beyond
the polished act,
you
will hear poetry.
If you sit back
and let the ghosts guide you,
you
will hear poetry
and it will become your own.

There are ghosts in the walls
who protect their own
and let them know that
fake poets don't prosper,
and that walls
aren't just walls
just like this

isn't *just* a Cafe;
it's *not*
just another place
where people read poetry . . .
It's *not*
just old brick and mortar
and dilapidated tables,
rickety chairs,
and dim lighting . . .

There are ghosts in the walls
whose lifespan
extends *beyond* the visible,
angels who watch and guide us
because
this
is their home,
and they want to make sure
that it's being taken care of . . .
This isn't *just* another place
where people get on the mic
and spit.
Fake poets beware,

This
Is
THE NUYORICAN![11]

This poem is my homage to the history of the Cafe, the ethos of openness that originated in the Open Room, and the ongoing contributions of foundational figures such as Algarín and Griffith. Algarín's investment in activism through poetic verse, specifically the writing, production, and performance of poetry, continues to this day. During our visit with him in December 2018, we discussed the possibility of establishing a writing workshop for adults. We spoke about the early days at the Cafe as I showed Algarín footage of performances by Piñero, Sandra María

Esteves, and himself, all while Griffith urged me to record our dialogue as I continued to pepper him with questions. My conversation with him and Griffith that day helps me understand how this conclusion is also an opening for further discussions on aesthetics and queerness as central to the Cafe. Specifically, as part of our exchange, Algarín told me that he felt that something needed to be written about aesthetics at the Cafe, and I replied that my book aims to do just that. Specifically, I told him how the book attends to queerness and aesthetics, and how what he and Griffith refer to as being sexually "fluid"—in terms of identity, practice, and adventure—shows up in the work of Cabico, the Glam Slam competitors, Ellison Glenn as Black Cracker, and co-founder Miguel Piñero. Algarín nodded, as did Griffith, who texted me the following message later that evening:

Dear Karen,

Thank you for your being present today with Miguel. You're saying that the development of the Nuyorican Poets Cafe which represents the life work of Miguel & myself should be viewed as a diaspora—as an aesthetic grown from our community of marginalized folk. Our aesthetic has nurtured many who have gone on to spread their voices in this world. I had not thought of our work in those terms, but your identifying it as having such influence seems accurate.
Thank you for this validation.
We must go further and create language to define specifics of our aesthetic.

<div align="right">Always in peace & love,
Lois[12]</div>

With this book I heed Algarín and Griffith's call. The specifics of the nuyorican aesthetic Griffith desires are delineated in the queer and trans poetics of Regie Cabico, the Glam Slam participants, and Ellison Glenn as Black Cracker. Their works enact their own countercultural critiques in the lineage of the Open Room and incendiary cultural politics articulated at the Cafe, in the earlier waves of the Nuyorican movement by

Griffith, Piñero, Pietri, Algarín, and many others. It is a critique that begins with poetic verse but, through the nuyorican aesthetic, is mobilized beyond the physical location of the Cafe, traveling between different spaces, times, and performance genres, extending nuyorican potentialities and futurities to all who enter.

ACKNOWLEDGMENTS

I write these acknowledgments in the midst of the COVID-19 pandemic, the fascist administration of 45, continued anti-immigration legislation, homophobic and transphobic governmental policies, and at the height of Black Lives Matter protests around the globe. This historic moment informs my approach for recognizing and expressing my gratitude to the people in my various communities. I fear that in spite of my best efforts, these acknowledgments will be woefully incomplete.

First and foremost, I would like to thank Eric Zinner, Stephanie Batiste, Robin Bernstein, and Brian Herrera for believing in and advocating for this book. Also, Dolma Ombadykow and Furqan Sayeed for all of their help.

In looking back, I realize now that this project began that Friday night in 1997 when I walked through the front door of the Nuyorican Poets Cafe. I found an artistic home and built lifelong friendships. Thank you to Miguel Algarín and to all of the early Nuyorican artists for their writing, their vision, and their dream that inspired this book. A special shout-out to Lois Elaine Griffith for all of her tireless labor and commitment to ensuring that Nuyorican history is properly documented. Without her, I would never have been able to access any of the early Nuyorican footage, or benefitted from the anecdotes that further grounded and underscored the claims I make throughout this text regarding queerness at the Cafe.

As host of the Friday Night Poetry Slam, I was preceded by two amazing hosts, curators, thinkers, and especially friends. I am most appreciative to the late, great Keith Roach for first inviting me to perform at the Nuyorican, and to Felice Belle for asking me to step in as host many moons ago at that now-closed sushi place on East 4th Street.

At the Cafe I was fortunate to meet some incredible artists whose writing and performances continue to provide me with tools necessary for queer survival. I am grateful to Regie Cabico, Emanuel Xavier,

Andres Chulisi Rodriguez, and Ellison Glenn for creating the performances that I examine throughout this text—I hope that I have done their cultural productions justice. I would also like to acknowledge the support afforded me by the current executive director of the Nuyorican, Daniel Gallant, who provided me with materials, access, and information that I needed for my research.

My time hosting at the Cafe coincided with the beginning of my doctoral studies in the Department of Performance Studies at New York University, and I would like to thank Fred Moten, Karen Shimakawa, and Barbara Browning for their mentorship and guidance. Along with these scholars and practitioners, I am indebted to my dissertation committee members Tavia Nyong'o, Gayatri Gopinath, and Renato Rosaldo for providing me with useful critical feedback. Two other members of my committee played an invaluable role and deserve special recognition: José Esteban Muñoz, and my committee chair Diana Taylor. I thank José for his sarcasm, his mentorship, for modeling the expansive possibilities of queer Brownness, and for *always* believing in and supporting me. To Diana Taylor, my mentor and friend, for sticking by me even when it didn't seem like I was ever going to finish. So much of my pedagogy, mentorship, and work with students is informed by her. I cannot thank her enough.

Thank you to Jason G. King, artist/scholar extraordinaire, for first telling me about performance studies, for countless phone conversations, and for taking a baby dyke just coming out under his wing. I owe my love of all things disco to him.

To my friends from graduate school to now. Thank you for your friendship and laughter, and for always picking me up whenever I felt like it was easier to just quit. To Sandra Ruiz (with whom I will always have *that* presentation and other moments of side-splitting laughter), Mar Fuentes—de ésta mesa no me tumban, Frank L. Roberts, Pablo Assumpção Barros Costa, Leticia Alvarado, Roy Pérez, Albert Sergio Laguna, Ariana Ochoa Camacho, Marisol Lebrón, Alexandra T. Vazquez, Christine Bacareza Balance (who I am lucky to have as both my dear friend/sister and colleague), Ricardo Montez, and Joshua Chambers-Letson. To my fellow 2013 cohort, Jessica Pabón-Colón and Kaitlin McNally Murphy—we did it! To Joshua Guzmán and Leon Hilton, whom I met at the beginning of

their academic journeys—I am so incredibly proud of the people, scholars, and intellectuals they have become.

Conferences are a necessity of this profession and I have been blessed to be able to foster community with some of the brightest thinkers and even better friends, including Christina León, Iván Ramos, Eliza Rodriguez y Gibson, Laura Gutiérrez, and Uri McMillan (my boo! #argot #whilst). Also, Scott Paulson-Bryant, my brother, there is no one I would rather share a meal, a walk, or spend countless hours people-watching in NYC with than him. And thank you to Deb Vargas, a dear friend and someone who continues to model for me queer, Brown butch mentorship and community.

A book requires time to write unencumbered by teaching and service obligations. Upon completion of my doctorate, I earned a Chancellor's Postdoctoral Research Fellowship at UIUC in the Department of Latina/Latino Studies. A special note of gratitude to Ricky Rodríguez, Laura Castañeda, and Alicia P. Rodriguez for their support and friendship. My research also benefitted from a Career Enhancement Fellowship funded by the Woodrow Wilson National Fellowship Foundation, and a semester spent as a Visiting Fellow at the Hemispheric Institute of Performance and Politics at New York University. Thank you to the Hemisexuals at 20 Cooper, especially to my friend of over twenty years, Lisandra María Ramos.

I am privileged to work at my alma mater, where I benefit from the community and support of two academic units, the Department of Performing and Media Arts and the Latina/o Studies Program. I thank Nick Salvato, Sara Warner, J. Ellen Gainor, and Amy Villarejo in PMA, who read book chapter drafts at the beginning of this process—their comments and feedback proved invaluable. A note of appreciation to my colleagues in LSP—Vilma Santiago-Irizarry, Ella Diaz, Debra Castillo, Sergio Garcia-Rios, Sofia Villenas, and María Cristina García—for continually motivating and inspiring me. I would also like to extend my heartfelt gratitude to the staff in both units, who always make my life easier, especially Marti Dense in Latina/o Studies. A special thank you to my cherished colleagues and friends from across various Cornell departments and programs, both past—Dehanza Rogers, Margo Crawford, Dagmawi Woubshet, and C. Riley Snorton—and present.

Fortuitously, my first year back in Ithaca coincided with an incredible cohort at the Society for the Humanities that included two dear friends, Ann Cvetkovich and Dana Luciano. Thank you for your friendship and encouragement and for sharing the important people in your lives who greatly enrich mine: Gretchen Phillips, Zachary Luciano, and the DC crew of Jennifer James, Nancy Raquel Mirabal, Ricardo L. Ortíz, Sangeeta Ray, and Fred Bohrer.

Along with the colleagues who read draft versions of this text, PMA also generously sponsored a workshop that brought Ramón Rivera-Servera and Arnaldo Cruz-Malavé to Ithaca. Thank you to Arnaldo for his comments, suggestions, and insight. His critical interventions and guidance continue to inform my scholarship in indescribable ways. And to Ramón, for mentoring me during the Woodrow Wilson retreat, for always being just a phone call or text away, for keeping me focused, and for hanging whenever we are in the same place, I am forever grateful.

I am most appreciative of everyone who invited me to share my work at numerous colleges/universities. These experiences provided me with critical interlocutors who helped me think more broadly about this project. A special thank you to Israel Reyes and the people at Dartmouth for the opportunity to participate in the Futures in American Studies Institute during the summer of 2019.

I would also like to express my deep gratitude to my development editor and friend, Ricardo Abreu Bracho. Ricardo helped me stitch together words and ideas in order to craft the patchwork quilt that is this book. I thank him for his thoughtful suggestions, comments, and edits.

Coming back to Ithaca was not easy, but it was a move that was facilitated by the hiring of Samantha N. Sheppard. We arrived at the same time, two strangers who became trusted colleagues, and most importantly dear friends. I can never thank Samantha enough for her support, her laughter, and for sharing Allen, Bayard, and Baldwin with me. I will always be grateful to her for making Ithaca feel like home.

I would also like to recognize the people in my life whom I consider more than friends, my framily who challenge me to step outside the academic echo chamber. To Jude Alfaro my PRican twin for his twenty-six years (and counting) of friendship, Cristina Bañuelos, who has driven more moving trucks for me than I can count, Vanessa Quiñones, Millie Velez, Tom Mandulak, John Williams, Justin Suh, Dot Katsias, Natasha

Jones, Shakahra Summers, Annette Chevalier, Nicole Davis, Tei Okamoto, Alberto Brandariz Núñez, Dre Núñez, Marga Gomez, and Dez Guido-Graham—words prove insufficient . . . They are my confidantes, my ports in any storm, and their laughter, support, and unwavering loyalty give me *life*.

I thank my family, especially my mother for always believing in me even when she doesn't always agree or understand. I would literally not be here without her.

And finally, to Jehan L. Roberson, who came into my life just as I was finishing this book. I thank her for her unconditional love, for brightening up my world, for being my favorite person, and for being the only person I could ever imagine being quarantined with. Her love and care sustained me throughout this process, while her keen editorial skills helped me to improve this book beyond measure. Please know that any grammatical errors are solely mine.

NOTES

INTRODUCTION

1. Poetry slams are three-round poetry competitions consisting of five poets, judged by five sets of randomly selected judges on a scale of one to ten, including decimal points. The highest and lowest scores are dropped and the other scores are tabulated, resulting in thirty as the highest possible score.
2. Sommer, *Bilingual Aesthetics*, 34.
3. I understood then, as I do now, that the Cafe has been framed as predominantly ethno-Puerto Rican while having always included performers and writers of all races and ethnicities. This, however, does not diminish the significance of Algarín, Piñero, and others utilizing Spanglish in their writing and throughout their performances as a political gesture.
4. Ahmed, *Queer Phenomenology*, 1, 23, 9.
5. Ibid. In *Queer Phenomenology*, Sara Ahmed posits that spaces do not exist outside the body, and that the social also has a skin that might be affected by "the comings and goings of different bodies," impacting the ways "things are arranged."
6. Noel, *In Visible Movement*, xx–xxi.
7. Mickelson, *City Poems*, 163.
8. Herrera, *Nuyorican Feminist Performance*, 8.
9. Ibid.
10. Ibid., 5.
11. Hernández, *Puerto Rican Voices*, 40.
12. Ed Morales, *Living in Spanglish*, 95.
13. I interrogate the countercultural politics and history of the space further in chapter 1.
14. Aparicio, "From Ethnicity to Multiculturalism," 26.
15. Diaz, *Flying under the Radar*, 1.
16. Beltrán, "There Was Never No Tomorrow."
17. Ibid.
18. There are no Nuyorican studies departments, for example.
19. Chase, *"Operation Bootstrap" in Puerto Rico*, 4–5.
20. Hernández, *Puerto Rican Voices*, 108.
21. Aptowicz, *Words in Your Face*, 11.
22. Ibid.
23. Ibid.

24 I discuss slam, its history, and the politics of the genre further in my analysis of Regie Cabico's work in chapter 2, and in relationship to the Glam Slam in chapter 3.
25 Hernández. *Puerto Rican Voices*, 118.
26 Beltrán, "There Was Never No Tomorrow."
27 Ibid.
28 Sevcenko, "Making Loisaida," 295.
29 Ibid.
30 A bohío is a thatch roof hut, originally constructed by the peoples indigenous to the Antilles—the Taínos/Arawaks. CHARAS is an acronym including the first letters of the founding members' names: Chino, Humberto, Angelo, Roy, Anthony, and Salvador. Founded in 1965 and originally known as the Real Great Society, CHARAS was intended as an ethnic and progressive response to Lyndon B. Johnson's Great Society. As I discuss further in chapter 1, CHARAS spent over twenty years rebuilding an abandoned school building, formerly Public School 64, converting it to include classrooms and theaters, as well as dance and studio spaces that provided cultural and educational programs for members of the community. Anderson, "Story of Chino and CHARAS."
31 Torres, "Poetry of Bimbo Rivas." For further information on the politics of Loisaida and Rivas's activism in the neighborhood, see Rivas, "Loisaida."
32 Soja, *Postmodern Geographies*, 120.
33 López, "Nuyorican Spaces," 204.
34 Perez-Bashier, "Kickin' It with Keith Roach." In an interview with Gladys "Poppy" Perez-Bashier for her blog, Roach comments on the musical influences present in his poetry that inform his approach to art making and artistic curation. For example, he remarked that for him, poetry was about sound, stating that his "aim all along was to create possibilities that the poets themselves could groove with and create the sounds that they were looking for to express the feelings, sentiments[,] and knowledge that they wanted to own."
35 Joseph, "(Yet) Another Letter," 13.
36 Okoth-Obbo, "Where Neo-Soul Began." For further reading on the specifics of musical arrangement and instruction in neo-soul, see Miles White's definition of neo-soul in the Oxford Music Online site.
37 An example of such a reading series is the one at the Brooklyn Moon Cafe in Brooklyn. For further contextualization, see Anglesey, "Brooklyn Moon Cafe Poets."
38 Rodríguez, *Sexual Futures*, 2.
39 Here I am referring to the useful research completed by Urayoán Noel in his book *In Visible Movement: Nuyorican Poetry from the Sixties to Slam*.
40 For a book focused on women and their histories, contributions, and aesthetics, see Patricia Herrera's *Nuyorican Feminist Performance: From the Café to Hip Hop Theater*.
41 De Certeau, *Practice of Everyday Life*, 97–98.

42 Rivera-Servera, *Performing Queer Latinidad*, 6.
43 Rosaldo, "Doing Oral History," 91.
44 Rose, *Black Noise*, 90.
45 Johnson, *Appropriating Blackness*, 10.
46 In chapter 4 I discuss an interview I conducted with Glenn and his reasons for adopting the moniker "Black Cracker."
47 Halberstam, *In a Queer Time and Place*, 168.
48 Algarín and Holman, *Aloud*, 24.
49 Here I also find inspiration from the title of Janet L. Abu-Lughod's "Welcome to the Neighborhood," in the anthology she co-edited, entitled *From Urban Village to East Village: The Battle for New York's Lower East Side*. In her writing, Abu-Lughod traces the history of migration, settlement, gentrification, and economic displacement in the Lower East Side neighborhood of New York City. I similarly examine and reframe the history of the Nuyorican Poets Cafe, in particular its relationship to its surrounding neighborhood, both in the introduction and throughout the book.

CHAPTER 1. WALKING POETRY IN LOISAIDA

1 Figueroa Martínez et al., "Walking through Deprived Neighborhoods," 175.
2 La Fountain-Stokes, *Queer Ricans*, 132.
3 Ibid., 133.
4 Ibid., 97.
5 Algarín, "Nuyorican Literature," 91.
6 Ibid., 92.
7 In analyzing the changing demography of Loisaida after the introduction of poetry slam, I find Arlene Dávila's framing of neoliberalism as "a rubric of economic and urban development policies that favor state regulation" useful. It is this deregulation in both El Barrio and Loisaida that fosters a marketing of culture as a mechanism to lay claim to space. Dávila, *Barrio Dreams*, 9.
8 Smith, *New Urban Frontier*, 18.
9 Ibid., xvi-xvii.
10 Ibid., 18. Also, while Smith does not frame it as such, an analysis of the culture industry is initially formed by Max Horkheimer and Theodor Adorno in "The Culture Industry: Enlightenment as Mass Deception" in their book *Dialectic of Enlightenment*.
11 As I discuss further in the introduction, 1996 is a hallmark year at the Cafe due to the documentation of the Friday Night Poetry Slam in Paul Devlin's film *SlamNation*.
12 For further analysis of this tension between the initial performances occurring at the Cafe in the late 1970s with those that later emerge in the 1990s, see the introductions by Algarín and Holman to their edited anthology *Aloud*.
13 Schulman, *Gentrification of the Mind*, 26.
14 Rossini, "Miguel Piñero," 239.

15 Camillo, introduction to *Short Eyes*, vii-viii.
16 This poem is later included in Piñero's *Straight from the Ghetto* (1973) and *La Bodega Sold Dreams* (1980).
17 Rossini, "Miguel Piñero," 239-40.
18 Aarons, "As His Short Eyes Triumphs."
19 As I document in chapter 3, gay poetry icon Emanuel Xavier receives similar support in the 1990s.
20 Momber, *Viva Loisaida*.
21 The film foregrounds the later attempts at redevelopment by Gregg Singer, who, due to continued community protests, has been unable to renovate PS 64 after purchasing it for $3.2 million in 1998. As of 2018, the building remains vacant except for his residence. Hobbs, "Gentrification's Empty Victory."
22 Sevcenko, "Making Loisaida," 293.
23 Dávila. *Barrio Dreams*, 70–71.
24 Ibid., 72.
25 Sevcenko, "Making Loisaida," 307.
26 Anderson, "Story of Chino and CHARAS."
27 Sevcenko, "Making Loisaida," 314.
28 WoW Café Theatre is also founded in the Lower East Side during this era, highlighting the connection between space, place, and resistant politics challenging gentrification in the area through politically charged creative productions that affirm minoritarian identities.
29 Griffith, interview.
30 "In Rem Law and Law and Legal Definition," USLegal.com, accessed December 1, 2017, http://definitions.uslegal.com/.
31 Alvin Eng, "'Some Place to Be Somebody,'" 141.
32 Griffith, interview.
33 Alvin Eng, "'Some Place to Be Somebody,'" 141.
34 Leah, "Before the Puerto Rican Poets."
35 Alvin Eng, "'Some Place to Be Somebody,'" 136.
36 Algarín tells me that he purchased 236 East 3rd Street in 1981 for about $1,000 (although I cannot confirm that amount). What I find fascinating about his purchase and move from the bar on East 6th, the defunct gay bar that has been Sunshine Cafe, Wonder Bar, and Eastern Bloc, is that the original wood bar was "cut up, put onto roller-skates and pushed down the three blocks to 236 East 3rd," as documented by Rachel Leah in her article "Before the Puerto Rican Poets."
37 Warner, *Publics and Counterpublics*, 56.
38 Noel, *In Visible Movement*, 137.
39 Sevcenko, "Making Loisaida," 306.
40 Maffi, "Appendix," 143.
41 Ibid.
42 Griffith, interview.
43 Ibid.

44　Algarín and Piñero, *Nuyorican Poetry*, 11–12.
45　De Certeau, *Practice of Everyday Life*, 97.
46　Ibid., 97–98.
47　Piñero, *Outlaw*, 19. The performance described here, seen in the documentary *Fried Shoes, Cooked Diamonds*, features performances by Allen Ginsberg, William S. Burroughs, LeRoi Jones (later known as Amiri Baraka), Algarín, and Piñero that evidence the connection between the Beats and the Nuyorican movement in the late 1970s. Footage can be seen on YouTube: www.youtube.com/watch?v=jEWvJojpPpw and at the Allen Ginsberg Project website, https://allenginsberg.org/.
48　Piñero, *Outlaw*. This performance, again, is the one included in the documentary *Fried Shoes, Cooked Diamonds*.
49　Ibid.
50　Spaniels, "Goodnite, Sweetheart, Goodnite."
51　Piñero, "Book of Genesis."
52　Miguel Piñero, "Lower East Side Poem," in *Outlaw*, 4, 5.
53　Summers, *Queer Encyclopedia of the Visual Arts*, 23. For critical writing on the sexual relationship and artistic collaboration between Wong and Piñero, see Pérez, "Glory That Was Wrong."
54　According to the Bible (Luke 1:26–38), the annunciation in Catholic religious terms refers to the announcement of the incarnation of the word made flesh by the angel Gabriel to the Virgin Mary.
55　Boucher, "Bronx Museum."
56　Algarín, "Miguel Algarín, Nuyorican Poet."
57　Piñero, "Lower East Side Poem," 5.
58　Algarín and Holman, *Aloud*, 5.
59　I situate my analysis within the years I served as the host for the Friday Night Poetry Slam at the Nuyorican Poets Cafe, 2003 to 2005.
60　Schulman, *Gentrification of the Mind*, 31.
61　Both Kobena Mercer and Marcos Sánchez-Tranquilino state that the zoot suit is originally worn by Latino (Chicano) males on the West Coast in the 1940s and trace the zoot suit as resistant fashion aesthetic. An earlier version of this mural appears on the cover of Piñero's *Outrageous One Act Plays*. Mercer, "Black Hair/Style Politics"; Sánchez-Tranquilino, "Mano a Mano."
62　Garcia, "Bio Page."
63　From approximately 2012 to the present, the Cafe begins offering advanced seating, meaning that people are able to enter the space and secure a seat without having to wait in line.

CHAPTER 2. THIS IS THE REMIX
1　Cabico, *Filipino Shuffle*.
2　Hoch, "Toward a Hip-Hop Aesthetic," 351–54.
3　Ibid.

4 *Bomb-itty of Errors*, written by Jordan Allen-Dutton, Jason Catalano, GQ, and Erik Weiner with music by J.A.Q (Jeffrey Qaiyum), originally developed and directed by Andy Goldberg, was first produced at 45 Bleecker Street Theatre in New York City on December 12, 1999.
5 Hoch, "Toward a Hip-Hop Aesthetic," 351–54.
6 Ibid.
7 Rivera, *New York Ricans*, 2–3.
8 Isaac, *American Tropics*, 24–25.
9 Ibid.
10 Go, *American Empire*, 1.
11 Ibid., 7.
12 Ibid., 4.
13 Somers-Willett, *Cultural Politics of Slam Poetry*, 154, n. 4.
14 Yet, as I discuss further in the introduction, what occurs with the increase in visibility and commercialization of poetry slam and poets post-1996 is the emergence of particular performative tropes that poets rely on in order to win slams because of the resulting career opportunities.
15 Rivera, *New York Ricans*, 100.
16 Poetry slam as a genre is created by Marc Kelly Smith, a White blue-collar worker in a neighborhood bar in Chicago in the mid-1980s, while hip-hop as a culture emerges in the late 1970s/early 1980s South Bronx neighborhood of New York City.
17 The overwhelming majority of people both on stage and in the audience at the Nuyorican Poets Cafe are, and have always been, people of color.
18 Bertoglio, *Downtown 81*.
19 Siegel, "One Final Visit."
20 Pyramid Club, "History."
21 Cabico, interview.
22 As I describe earlier in this book, poetry slams include a host, five poets, five sets of randomly selected judges, and a scorekeeper. As a former slam host at the Cafe, I found that one of the most challenging aspects of the evening was finding someone who would be willing to serve as a scorekeeper. The scorekeeper, as the person who tallies up the judge's five scores, used to receive a complimentary drink and not much else. During his time as host, Holman relied on the scorekeeping services of performer and poet Shut Up Shelley. In her author's bio in *Verses That Hurt: Pleasures and Pain from the Poemfone*, Shelley identifies as Holman's co-host for the Friday Night Poetry Slam, as former host of the Wednesday Night Poetry Slam Open, and as former Queen of the Mermaid Day Parade. Shelley is also featured as the coach of the 1996 Nuyorican Grand Slam Team in the documentary *SlamNation*, which I discuss in the introduction.
23 Cabico, interview.
24 Prior to hosting the Friday Night Poetry Slam, I hosted the Wednesday Night Poetry Slam Open for a month while the host at the time, poet/performer Ellison Glenn/Black Cracker, whose work I analyze in chapter 4, was on tour.

25 In addition to having their work published, as in the case of Paul Beatty, whom I mention in the introduction, there are other economically lucrative ventures available to Nuyorican Grand Slam Champions, as evidenced by the careers of 1996 winner Saul Williams, 1997 winner and Tony Award-winning performer Sarah Jones, and Tony Award-winning Mayda Del Valle, who won the championship in 2001.
26 For example, award-winning actor, singer, writer, composer, and poet Daniel Beaty competed for the 2003 title, only to lose to Julian Curry. Beaty chose not to compete in any of the runoff slams and instead returned to compete and win the Grand Slam Championship in 2004.
27 Poetry slam strategy dictates that poets should save their strongest poem, both in terms of delivery and possible crowd appeal, for the third and final round. For further reading on poetry slam strategy, see Mali, *Top Secret Slam Strategies*.
28 I have seen Cabico perform this poem live, and although there are other videos online of him performing "Check One," the TEDx version is the one that best captures the mechanics of his delivery during a slam.
29 Cabico, "I'll Check 'Other,'" 0:09:13.
30 Rose, *Black Noise*, 62.
31 Cabico, "I'll Check 'Other.'"
32 Chocolate City is the colloquial name for Washington, DC, referencing its once majority-Black population, as discussed by Natalie Hopkinson in her *New York Times* op-ed, "Farewell to Chocolate City."
33 In "Perfect Covers: Filipino Musical Mimicry and Transmedia Performance," Abigail De Kosnik discusses nursing as one of the primary forms of labor performed by Filipinas/os in the United States, and as a major remittance-generating source. De Kosnik, "Perfect Covers," 141–42.
34 Cabico, "I'll Check 'Other.'"
35 Ibid.
36 Poems in poetry slams are often delivered at a rapid-fire pace in order to adhere to the three-minute time limit imposed on competing poets. While there is generally a ten-second grace period depending on venue or competition, anything beyond that results in point deductions. The Cafe initially did not enforce a time limit until poets began preparing for National Poetry Slam competitions.
37 Cabico, "I'll Check 'Other.'"
38 "Negrito" is also the term used to refer to "Filipinos in the region whose physical features are similar to those of Africans," as discussed in Otálvaro-Hormillosa, "Resisting Appropriation," 332.
39 Cabico, "I'll Check 'Other.'"
40 Algarín and Holman, *Aloud*, 47–48.
41 Chuh, *Imagine Otherwise*, 34.
42 Ibid., 3.
43 Algarín and Griffith, *Action*, xii-xiii.
44 Sapphire, introduction to *Wild Like That*, 7.

45 Algarín and Griffith, *Action*, xvi.
46 Townsend, *Hollywood Shuffle*.
47 Ibid.
48 Hoch, "Toward a Hip-Hop Aesthetic," 352.
49 Rose, *Black Noise*, 90.
50 Ibid.
51 De Kosnik, "Perfect Covers," 141–42.
52 Ibid.
53 Ibid., 142.
54 Muñoz, *Disidentifications*, 130.
55 Cabico, *Filipino Shuffle*.
56 Duke, *Thorn Birds*.
57 Cabico, *Filipino Shuffle*.
58 Hoch, "Toward a Hip-Hop Aesthetic," 352.
59 *America's Most Wanted*, created by Steven Chao and Michael Lindner, aired 1988–2012, in broadcast syndication.
60 Cabico, *Filipino Shuffle*.
61 Manalansan, "*Biyuti* in Everyday Life," 155.
62 Ibid.
63 Ibid.
64 Ibid.
65 Ibid., 154.
66 Ibid.
67 Ibid.
68 Cabico, *Filipino Shuffle*.
69 Somers-Willett, *Cultural Politics of Slam Poetry*, 90.
70 In his essay "Fetishism," from *Miscellaneous Papers, 1888–1938*, Sigmund Freud articulates his theorizations on the sexual fetish. Freud proposes that a boy child refuses to acknowledge that his mother does not possess a penis. He does not believe it to be true, for if his mother had a penis and it was no longer there, then she has been castrated, signaling the possibility that he himself could also be castrated. Experiencing what Freud defines as castration anxiety, the boy then both accepts and rejects the reality that his mother does not possess a penis. In the boy's mind, the woman still has a penis, but this penis is different than it was before, it is not a phallus. This penis/not penis of the woman becomes a substitute and takes on the interest originally directed at the mother figure. Further, "this interest suffers an extraordinary increase as well, because the horror of castration has set up a memorial to itself in the creation of this substitute." In that disavowal, that refusal to acknowledge the mother as lacking a penis, that desire becomes displaced onto another object, resulting in the formation of a fetish object. Freud, "Fetishism," 198–204.
71 In order to understand how Cabico challenges and resists fetishization, I turn to the work of theorist David L. Eng and his psychoanalytic critique of *M. Butterfly*

in *Racial Castration: Managing Masculinity in Asian America*. *M. Butterfly*, the Broadway show based on Giacomo Puccini's opera, tells the story of a civil servant (Gallimard) attached to the French embassy in China who falls in love with a Chinese opera diva (Song). Eng attends to how Gallimard views Song's body: "instead of seeing at the site of the female body a penis that is not there to see, Gallimard refuses to see at the site of the Asian male body a penis that *is* there to see." Eng argues that Gallimard's castration of the Asian body is both sexual and racial; specifically, that the orientalist disavowal of the penis through the White gaze in *M. Butterfly* becomes the fetish. In the same way that Gallimard refuses to see Song's penis as actual in *M. Butterfly*, for Cabico in the bar section of *Filipino Shuffle*, so do his suitors fetishizing his skin and unaccented English.
72 Algarín and Griffith, *Action*, xvi.
73 Somers-Willett, *Cultural Politics of Slam Poetry*, 115.
74 In *Cruising Utopia: The Then and There of Queer Futurity*, José Esteban Muñoz analyzes the work of performance artist Kevin Aviance through an engagement with Karl Marx and his theory of the commodity fetish. Muñoz writes, "Marxism tells the story of the commodity fetish, the object that alienates us from the conditions of possibility that brought whatever commodity into being." Here, Simmons's brands signal the hyper-commodification of race under late capitalism that Muñoz critiques through his work on Kevin Aviance.
75 Cortiñas, "Are We Dancing to Our Own Beat?"
76 Cabico, "What Kind of Guys," 0:03:44.
77 Cabico, *Filipino Shuffle*.
78 Cortiñas, "Are We Dancing to Our Own Beat?"
79 Cabico, "What Kind of Guys." The text for this poem is different on HBO than in the poetry anthology *Aloud*. This is most likely due to editing, as Cabico needed to ensure that the poem was no longer than three minutes in order to be included in the half-hour episode.
80 This scene is Cabico's version of the moment in the movie (later the opening sequence of the television show) where we see the cast running/dancing/pirouetting through the streets of New York City singing the song "Fame."
81 Currently the Fiorello H. LaGuardia High School of Music & Art and Performing Arts as a result of the merger of the High School of Music & Art and the School of Performing Arts.
82 Dana Plato was a child actor, well known for her portrayal of Kimberly Drummond on the hit sitcom *Diff'rent Strokes* (1978–1986). In 1989, hoping to revive her career, she posed for *Playboy* and went on to star in a few low-budget films, as well as perform in some small theatrical productions. She died of a drug overdose in 1999. Oliver, "Dana Plato."
83 Cabico, *Filipino Shuffle*.
84 Nipa huts are indigenous dwellings in the Philippines.
85 Cabico, *Filipino Shuffle*.
86 Foster, *Monster's Ball*.

87 A longtime collaborator with Cabico, Cho was a fellow member of the performance collective Peeling. Originally founded as Peeling the Banana by director/performer Gary San Angel in 1995 at the Asian American Writers' Workshop, the group included productions that combined theater, music, poetry, and dance. Cho and Cabico help to later reform the group as Peeling in 2000. Interestingly, Cho later becomes a member of the House of Xavier, which I discuss in chapter 3. Asian/Pacific American Archives Survey Project, "Peeling."
88 Foster, *Monster's Ball*.
89 Ibid.
90 Flax, *Resonances of Slavery*, 46.
91 David L. Eng, *Racial Castration*, 151.
92 Aptowicz, *Words in Your Face*, 245.

CHAPTER 3. TENS ACROSS THE BOARD

1 Henry Miller's Theater was renamed the Stephen Sondheim Theater in 2010. Xavier was able to secure the space for the initial Glam Slam through nightlife promoter Louis "Loca," who used to organize a monthly Sunday party, Café Con Leche, from January 1993 to July 1999, in downtown New York City.
2 As I discuss in more detail in chapter 2, the Grand Slam includes the five best poets of the slam season at the Nuyorican Poets Cafe competing to be crowned the Nuyorican Grand Slam Champion.
3 Cruz-Malavé, *Queer Latino Testimonio*, 179.
4 Rose, "Nobody Wants a Part-Time Mother," 167.
5 Butler, *Bodies That Matter*, 128–29.
6 Massiah, "Authenticating Audience."
7 Ibid.
8 Bambara, *Deep Sightings*.
9 Johnson, *Appropriating Blackness*, 10.
10 Ibid.
11 Montez, "Over Me."
12 Flores, *From Bomba to Hip-Hop*, 117.
13 Ibid.
14 Wonder, "Overjoyed."
15 Montez, "Over Me."
16 As I discuss further in chapter 1, I use Michael Warner's definition of a counterpublic as operating in opposition to a larger public while recognizing its lesser status.
17 Corey, "Bronx's Gay Culture."
18 Anderson was also a founding member of the San Francisco-based lesbian-feminist spoken word touring collective Sister Spit. She later becomes widely known for directing *The Punk Singer* (2013), a documentary about riot grrrl musician Kathleen Hanna's feminist artistry and experience with late-stage Lyme disease. For further information, see Bendix, "Sini Anderson."

19 Moore, *Fabulous*, xi.
20 Bailey, *Butch Queens*, 4.
21 Bourdieu, "Social Space," 731.
22 Moore, *Fabulous*, 34.
23 Rose, "Nobody Wants a Part-Time Mother," 168.
24 Ibid., 170.
25 Alongside hosting the Glam Slam, the House of Xavier also hosted mini-balls more in line with traditional house balls that did not feature poetry as part of their competition. These events were held at clubs, such as Escuelita in midtown Manhattan, that catered to Black and Latino queers, predominantly gay men, drag queens, and trans club divas. The hosting of these events in clubs was met with resistance, according to Xavier, as there was an established tradition of balls being held in community spaces, such as the Imperial Elks Lodge in Harlem, that do not require a deposit or a percentage of the entrance fee. Balls served as fundraisers for organizations focused on the health, well-being, and survival of queer people—Gay Men's Health Crisis, for example.
26 I use masculine pronouns throughout to refer to Mother Diva as he does not identify as trans, or as a drag queen, but as a femme gay man.
27 De Jesús, *HomoVisiones*.
28 *Merriam-Webster Dictionary*, s.v. "Fabulous," accessed December 26, 2018, www.merriam-webster.com/. Also see *Urban Dictionary*, s.v. "Fabulous," accessed December 26, 2018, www.urbandictionary.com.
29 Somers-Willett, *Cultural Politics of Slam Poetry*, 70.
30 Cruz-Malavé, *Queer Latino Testimonio*, 179–80.
31 Livingston, *Paris Is Burning*.
32 Butler, *Bodies That Matter*, 137.
33 Ibid.
34 Kirby, "Hello," 158.
35 Rose, "Nobody Wants a Part-Time Mother," 169.
36 Izquierdo Ugaz, "Fuck It, I'm Gonna Do It."
37 Jaime, "Born Again."
38 As in balls, Glam Slam winners were given trophies—smaller ones for the winners of the individual categories, and a larger one for the overall Glam Slam winner.
39 Jaime, "Maine."

CHAPTER 4. BLACK CRACKER'S "CHASING RAINBOWS"

An excerpt of this chapter was previously published in "Special Issue: The Issue of Blackness," a guest-edited issue of *TSQ: Transgender Studies Quarterly*, as "'Chasing Rainbows': Black Cracker and Queer, Trans Afrofuturity." The issue editors are Treva C. Ellison, Kai M. Green, Matt Richardson, and C. Riley Snorton.

1 As I discuss in chapter 2, the Wednesday Night Slam Open at the Nuyorican Poets Cafe serves as the qualifying event (three-round poetry competition that is judged by randomly selected audience members in groups as judges) for the Friday Night

Poetry Slam of the Cafe. The winner of the Wednesday event is guaranteed a slot as one of the five competing poets in the Friday night event. I served as the host of the Friday Night Poetry Slam from 2003 to 2005 but filled in as the host of the Wednesday Night Slam Open for a month during the summer of 2001.

2 Glenn, interview.
3 Cobb, *To the Break of Dawn*, 87.
4 Ibid.
5 Ibid.
6 Ibid.
7 Williams, *Keywords*, 15.
8 Here, I am referencing the work of Paul Gilroy on the Black Atlantic in *The Black Atlantic*.
9 Moraga, *Last Generation*, 33.
10 Ibid.
11 Muñoz, "Feeling Brown," 74.
12 *Urban Dictionary*, s.v. "Cracker," by Correcta, accessed December 26, 2018, www.urbandictionary.com.
13 *Urban Dictionary*, s.v. "Cracker," by FigurinOutLife, accessed September 15, 2016, www.urbandictionary.com.
14 Muñoz, *Disidentifications*, 25.
15 Ibid., 4.
16 Jacobs-Jenkins also engages with minstrelsy in his play *A Mulata, Shange's Spell #7*. Minstrelsy is also thoroughly documented in Marlon Riggs's 1987 documentary *Ethnic Notions*.
17 Ogbar, *Hip-Hop Revolution*, 13.
18 Lott, *Love and Theft*, 6, 39.
19 Here, I am drawing on Nicole Fleetwood's writing on Black visibility, specifically the fourth chapter of her text *Troubling Vision*, entitled "'I Am King': Hip-Hop Culture, Fashion Advertising, and the Black Male Body." Fleetwood, *Troubling Vision*, 147–76.
20 Ogbar, *Hip-Hop Revolution*, 25.
21 Ibid., 31.
22 Ibid., 30.
23 Goldsmith and Fonseca, *Hip-hop around the World*, 330.
24 Fleetwood, *Troubling Vision*, 148.
25 Ibid., 168.
26 Ibid.
27 Ibid., 152.
28 Ibid.
29 C. Glenn, "I Nail My Palms."
30 Halberstam, *In a Queer Time and Place*, 168.
31 Ibid.
32 1macool, "I Ain't Your Girlfriend."

33 Muñoz. *Disidentifications*, 146.
34 Ibid., 109.
35 C. Glenn and the Victory Riot, "Salt and Pepper," track 3 on *Transparent Sand*.
36 C. Glenn and the Victory Riot, "Whitening Cream," track 8 on *Transparent Sand*.
37 Stewart, "Oldies but (Not So) Goodies."
38 Nonotv, *Bunny Rabbit & Black Cracker Live*.
39 Lott, *Love and Theft*, 19. Lott draws the notion of primitive accumulation from Karl Marx's *Capital*, vol. 1, chapter 26, "The Secret of Primitive Accumulation."
40 Taylor, *Archive and the Repertoire*, 2–3.
41 Similarly, philosopher Elizabeth Grosz defines performance as framed behavior, arguing that what is framed in one society is overlooked or a nonevent in another. Grosz, *Chaos, Territory, Art*.
42 Lott, *Love and Theft*, 30.
43 Edwards, *Practice of Diaspora*, 4–5.
44 Stallings, *Funk the Erotic*, 207.
45 "Black Cracker—On Rhythm."
46 Ozuna, "Music Preview."
47 Nelson, "Introduction."
48 Ibid., 9.
49 Ibid., 1.
50 "Chocolate City," as I discuss in chapter 2, refers to Washington, DC, and highlights its once majority-Black population.
51 See the entry "Rainbow" in *National Geographic*'s online resource library, last updated December 5, 2013, www.nationalgeographic.org/.
52 Blck Crckr, *CHASING RAINBOWS*, 0:04:39.
53 Romana, "Interview."
54 For critical writing on the role generally assigned to women in hip-hop videos, see Rose, "Never Trust a Big Butt and a Smile."
55 Harris, "'Untitled.'"
56 Crawley, *Blackpentecostal Breath*, 42.
57 Ibid., 34.
58 Ibid., 2.
59 Blck Crckr, *CHASING RAINBOWS*.
60 Muñoz. *Cruising Utopia*, 49.
61 Blck Crckr, *CHASING RAINBOWS*.

CONCLUSION

1 Halberstam, "Wild Beyond," 6.
2 Harney and Moten, *Undercommons*.
3 The title of this section references Miguel Piñero's poem "The Book of Genesis according to Saint Miguelito," where he poetically reimagines the creation story from the book of Genesis in the Bible, as I discuss in chapter 1. Pedro Pietri's performance of "Puerto Rican Obituary," as documented in the 1996 film ¡*Palante*

Siempre Palante! (dir. Iris Morales), poetically relays the Puerto Rican experience in New York and becomes a rallying cry in the struggle for self-determination proposed by the Young Lords Party from the end of the 1960s until the late 1970s.

4 Hernández, "Pedro Pietri," in *Puerto Rican Voices*, 117.
5 Interestingly, this bar is now home to gay bar Eastern Bloc but was formerly Sunshine Cafe and Wonder Bar.
6 Griffith, interview.
7 Ibid.
8 For further information on Chapman's involvement in ABC Loisaida and her connection with the neighborhood, see https://pupasantiago.weebly.com.
9 Nuyorican Poets Cafe, "Nuyorican Closes," Facebook post, December 6, 2019, www.facebook.com.
10 Miguel "Lobo" Loperena, the original host of the Open Room on East 6th Street, used to signal the start of the open mic with a guttural, non-syntactical series of sounds. The entire chant is included on pages 23–24 in *Aloud*, the anthology edited by Algarín and Holman.
11 Jaime, "Ghosts in the Walls / Ode to the Nuyorican."
12 Lois Elaine Griffith, text message to author, December 17, 2018.

BIBLIOGRAPHY

1macool. "I Ain't Your Girlfriend No More." YouTube, November 6, 2016. www.youtube.com/watch?v=Rr1ylbvF95o.

Aarons, Leroy. "As His Short Eyes Triumphs on the Screen, Miguel Piñero Still Faces an Armed Robbery Rap." *People*, November 14, 1977. https://people.com.

Abu-Lughod, Janet, ed. *From Urban Village to East Village: The Battle for New York's Lower East Side*. London: Blackwell, 1994.

Adorno, Theodor W., and Max Horkheimer. *Dialectic of Enlightenment*. Translated by John Cumming. London: Verso, 2016.

Ahmed, Sara. *Queer Phenomenology: Orientations, Objects, Others*. Durham: Duke University Press, 2006.

Algarín, Miguel. "Miguel Algarín, Nuyorican Poet." Podcast. Produced by Stacy Abramson and Sound Portraits Productions. *Storycorps*, June 1998. https://storycorps.org.

———. "Nuyorican Literature." *MELUS* 8, no. 2 (1981): 89–92.

Algarín, Miguel, and Lois Griffith, eds. *Action*. New York: Simon and Schuster, 1997.

Algarín, Miguel, and Bob Holman, eds. *Aloud: Voices from the Nuyorican Poets Cafe*. New York: Henry Holt, 1994.

Algarín, Miguel, and Miguel Piñero, eds. *Nuyorican Poetry: An Anthology of Puerto Rican Words and Feelings*. New York: Morrow, 1975.

Allen-Dutton, Jordan, Jason Catalano, Gregory J. Qaiyum, and Erik Weiner. *Bomb-itty of Errors*. New York: Samuel French, 2010.

Allione, Constanzo, dir. *Fried Shoes, Cooked Diamonds*. VHS. 1979; Mystic Fire Video, 1998.

Anderson, Lincoln. "The Story of Chino and CHARAS; Activist Hopeful for Old P.S. 64's Return." *Villager*, April 29, 2018. http://thevillager.com.

Anglesey, Zoë. "Brooklyn Moon Cafe Poets." *BOMB*, April 1, 1997. https://bombmagazine.org.

Aparicio, Frances. "From Ethnicity to Multiculturalism: The Historical Development of Puerto Rican Literature in the United States." In *Handbook of Hispanic Culture: Literature and Art*, edited by Francisco Lomelí, 19–39. Houston: Arte Público, 1993.

Aptowicz, Cristin O'Keefe. *Words in Your Face: A Guided Tour through Twenty Years of the New York City Poetry Slam*. New York: Soft Skull, 2008.

Asian/Pacific American Archives Survey Project. "Peeling." January 28, 2015. https://apa.nyu.edu.

Bailey, Marlon M. *Butch Queens Up in Pumps: Gender, Performance, and Ballroom Culture in Detroit*. Ann Arbor: University of Michigan Press, 2013.

Bambara, Toni Cade. *Deep Sightings and Rescue Missions: Fiction, Essays, and Conversations*. Edited by Toni Morrison. New York: Random House, 1999.

Beltrán, Raymond R. "There Was Never No Tomorrow: Nuyorican Pedro Pietri in His Own Words." *La Prensa-San Diego*, February 6, 2004. http://laprensa-sandiego.org.

Bendix, Trish. "Sini Anderson on 'The Punk Singer' and Sister Spit." *AfterEllen*, November 27, 2013. www.afterellen.com.

Bertoglio, Edo, dir. *Downtown 81*. Film. 1980–81; Music Box Films, 2001.

"Black Cracker—On Rhythm, God and a Background-Dancing Obama." *Indie: The Independent Style Magazine*, March 31, 2015. https://indie-mag.com.

Blck Crckr. *CHASING RAINBOWS-Black Cracker (2/5)*. YouTube, March 9, 2014. www.youtube.com/watch?v=2CfNNODUp2I.

Boucher, Brian. "Bronx Museum Mounts Martin Wong's First Museum Retrospective since His Death." *artnet news*, August 20, 2015. https://news.artnet.com.

Bourdieu, Pierre. "The Social Space and the Genesis of Groups." *Theory and Society* 14, no. 6 (November 1985): 723–44.

Butler, Judith. *Bodies That Matter: On the Discursive Limits of "Sex."* New York: Routledge, 1993.

Cabico, Regie, perf. *Filipino Shuffle*. DVD. Nuyorican Poets Cafe Roar Theatre Festival, 2003.

———. "I'll Check 'Other.'" TEDx talk, YouTube, May 22, 2018. www.youtube.com/watch?v=AHDMLvRYOb8.

———. Interview with the author. Summer 2010.

———. "What Kind of Guys Are Attracted to Me." urbanrenewalprogram, YouTube, August 28, 2010. www.youtube.com/watch?v=3FY6FYTOEh0.

Camillo, Marvin Felix. Introduction to *Short Eyes: A Play*, by Miguel Piñero, vii–xiii. New York: Hill and Wang, 1974.

Chao, Steven, and Michael Lindner, creators. *America's Most Wanted*. Aired 1988–2012. 20th Century Television.

Chase, Stuart. *"Operation Bootstrap" in Puerto Rico*. N.p.: National Planning Association, 1951.

Chuh, Kandice. *Imagine Otherwise: On Asian Americanist Critique*. Durham: Duke University Press, 2003.

Cobb, William Jelani. *To the Break of Dawn: A Freestyle on the Hip Hop Aesthetic*. New York: New York University Press, 2008.

Corey, Matthew. "Bronx's Gay Culture—en la televisión." *Norwood News* 12, no. 3 (February 11–24, 1999). www.bronxmall.com (site discontinued).

Cortiñas, Jorge Ignacio. "Are We Dancing to Our Own Beat?" *American Theatre* 21, no. 5 (May 2004): 24–67.

Crawley, Ashon. *Blackpentecostal Breath: The Aesthetics of Possibility*. New York: Fordham University Press, 2017.

Cruz-Malavé, Arnaldo. *Queer Latino Testimonio, Keith Haring and Juanito Xtravaganza: Hard Tails*. New York: Palgrave Macmillan, 2007.
Dávila, Arlene. *Barrio Dreams: Puerto Ricans, Latinos, and the Neoliberal City*. Berkeley: University of California Press, 2004.
de Certeau, Michel. *The Practice of Everyday Life*. 1984. Reprint, Berkeley: University of California Press, 2011.
de Jesús, Gamalier, creator. *HomoVisiones*. Featuring Emanuel Xavier, Andres Chulisi Rodriguez, Suheir Hammad, and Willi Ninja. Aired 1999–2002. HomoVisiones, Inc. BRONXNET.
De Kosnik, Abigail. "Perfect Covers: Filipino Musical Mimicry and Transmedia Performance." *Verge Studies in Global Asias* 3, no. 1 (Spring 2017): 137–61. DOI: 10.5749/vergstudglobasia.3.1.0137.
Devlin, Paul, dir. *SlamNation: The Sport of Spoken Word*. DVD. 1998; New York: Docurama, 2005.
Diaz, Ella Maria. *Flying under the Radar with the Royal Chicano Air Force: Mapping a Chicano/a Art History*. Austin: University of Texas Press, 2017.
Duke, Daryl, dir. *The Thorn Birds*. DVD. 1983; Burbank, CA: Warner Home Video, 2004.
Edwards, Brent Hayes. *The Practice of Diaspora: Literature, Translation, and the Rise of Black Internationalism*. Cambridge: Harvard University Press, 2003.
Eng, Alvin. "'Some Place to Be Somebody': La MaMa's Ellen Stewart." In *The Color of Theater*, edited by Roberta Uno and Lucy Mae San Pablo Burns, 135–44. London: Continuum, 2002.
Eng, David L. *Racial Castration: Managing Masculinity in Asian America*. Durham: Duke University Press, 2001.
Figueroa Martínez, Cristhian, Frances Hodgson, Caroline Mullen, and Paul Timms. "Walking through Deprived Neighborhoods: Meanings and Constructions behind the Attributes of the Built Environment." *Travel Behaviour and Society*, no. 16 (2019): 171–81. https://doi.org/10.1016/j.tbs.2019.05.006.
Flax, Jane. *Resonances of Slavery in Race/Gender Relations: Shadow at the Heart of American Politics*. New York: Palgrave Macmillan, 2010.
Fleetwood, Nicole. *Troubling Vision: Performance, Visuality, and Blackness*. Chicago: University of Chicago Press, 2011.
Flores, Juan. *From Bomba to Hip-Hop: Puerto Rican Culture and Latino Identity*. New York: Columbia University Press, 2000.
Foster, Marc, dir. *Monster's Ball*. DVD. 2001; Santa Monica, CA: Lionsgate Home Entertainment, 2007.
Freud, Sigmund. *Collected Papers: Miscellaneous Papers, 1888–1938*. London: Hogarth and Institute of Psychoanalysis, 1924–1950.
García, Antonio "Chico." "Bio Page." *Chicoartnyc*. Accessed October 20, 2019. http://chicoartnyc.com (site discontinued).
Gilroy, Paul. *The Black Atlantic: Modernity and Double-Consciousness*. Cambridge: Harvard University Press, 1993.

Glenn, C., and the Victory Riot. "I Nail My Palms (Believe in Me)." In *The Spoken Word Revolution: Slam, Hip Hop & the Poetry of a New Generation*, edited by Mark Eleveld, 51–53. Naperville, IL: Sourcebooks MediaFusion, 2005.

———. *Transparent Sand Reflecting the Ego of Crabs*. By C. Glenn. CD. Counter Revolution, 2003.

Glenn, Ellison. Interview with author. May 28, 2016.

Go, Julian. *American Empire and the Politics of Meaning*. Durham: Duke University Press, 2008.

Goldsmith, Melissa Ursula Dawn, and Anthony J. Fonseca, eds. *Hip Hop around the World: An Encyclopedia*. Santa Barbara, CA: ABC-CLIO, 2019.

Griffith, Lois Elaine. Interview with author. September 2006.

Grosz, Elizabeth. *Chaos, Territory, Art: Deleuze and the Framing of the Earth*. New York: Columbia University Press, 2008.

Halberstam, J. Jack. *In a Queer Time and Place: Transgender Bodies, Subcultural Lives*. New York: New York University Press, 2005.

———. "The Wild Beyond: With and for the Undercommons." In *The Undercommons: Fugitive Planning and Black Study*, edited by Stefano Harney and Fred Moten, 2–13. Brooklyn: Autonomedia, 2013.

Harney, Stefano, and Fred Moten, eds. *The Undercommons: Fugitive Planning and Black Study*. Brooklyn: Autonomedia, 2013.

Harris, Keith. "'Untitled': D'Angelo and the Visualization of the Black Male Body." *Wide Angle* 21, no. 4 (October 1999): 62–83.

Hernández, Carmen Dolores. *Puerto Rican Voices in English: Interviews with Writers*. Westport, CT: Praeger, 1997.

Herrera, Patricia. *Nuyorican Feminist Performance: From the Café to Hip Hop Theater*. Ann Arbor: University of Michigan Press, 2020.

Hobbs, Allegra. "Gentrification's Empty Victory." *New York Times*, June 1, 2018. https://nytimes.com.

Hoch, Danny. "Toward a Hip-Hop Aesthetic: A Manifesto for the Hip-Hop Arts Movement." In *Total Chaos: The Art and Aesthetics of Hip-Hop*, edited by Jeff Chang, 349–64. New York: Basic Civitas, 2006.

Hopkinson, Natalie. "Farewell to Chocolate City." *New York Times*, June 23, 2012. www.nytimes.com.

Isaac, Allen Punzalan. *American Tropics: Articulating Filipino America*. Minneapolis: University of Minnesota Press, 2006.

Izquierdo Ugaz, Ximena. "Fuck It, I'm Gonna Do It: An Interview with Emanuel Xavier." *Nat Brut*, fall 2017. www.natbrut.com.

Jacobs-Jenkins, Branden. *Neighbors: A Play*. London: Bloomsbury, 2012.

Jaime, Karen. "Born Again." Unpublished poem. 2000.

———. "'Chasing Rainbows': Black Cracker and Queer, Trans Afrofuturity." In "Special Issue: The Issue of Blackness," edited by Treva C. Ellison, Kai M. Green, Matt Richardson, and C. Riley Snorton. Special issue, *TSQ: Transgender Studies Quarterly* 4, no. 2 (May 2017): 208–18. https://doi.org/10.1215/23289252-3815009.

———. "Ghosts in the Walls / Ode to the Nuyorican." Unpublished poem. 2005.
———. "Maine." Unpublished poem. 2002.
Johnson, E. Patrick. *Appropriating Blackness: Performance and the Politics of Authenticity*. Durham: Duke University Press, 2003.
Joseph, Marc Bamuthi. "(Yet) Another Letter to a Young Poet." In *Total Chaos: The Art and Aesthetics of Hip-Hop*, edited by Jeff Chang, 11–17. New York: Basic Civitas, 2006.
Kirby, Lady Kier. "Hello." In *Microphone Fiends: Youth Music, Youth Culture*, edited by Andrew Ross and Tricia Rose, 158–59. London: Routledge, 1994.
La Fountain-Stokes, Lawrence. *Queer Ricans: Cultures and Sexualities in the Diaspora*. Minneapolis: University of Minnesota Press, 2009.
Leah, Rachel. "Before the Puerto Rican Poets, There Was the Polish Violinist." *Bedford + Bowery*, December 28, 2016. https://bedfordandbowery.com.
Lee, Spike, dir. *Bamboozled*. DVD. 2000; Burbank: New Line Cinema, 2001.
Livingston, Jennie, dir. *Paris Is Burning*. DVD. 1991; Toronto: Miramax Films, 2005.
López, Edrik. "Nuyorican Spaces: Mapping Identity in a Poetic Geography." *Centro Journal* 17, no. 1 (Spring 2005): 202–19.
Lott, Eric. *Love and Theft: Blackface Minstrelsy and the American Working Class*. Oxford: Oxford University Press, 2003.
Maffi, Mario. "Appendix: The Other Side of the Coin: Culture in Loisaida." In *From Urban Village to East Village: The Battle for New York's Lower East Side*, edited by Janet L. Abu-Lughod, 141–48. London: Blackwell, 1994.
Mali, Taylor. *Top Secret Slam Strategies*. Edited by Cristin O'Keefe Aptowicz. New York: Words Worth Ink and Wordsmith Press, 2001.
Manalansan, Martin F., IV. "*Biyuti* in Everyday Life: Performance, Citizenship, and Survival among Filipinos in the United States." In *Orientations: Mapping Studies in the Asian Diaspora*, edited by Kandice Chuh and Karen Shimakawa, 153–71. Durham: Duke University Press, 2001.
Massiah, Louis. "The Authenticating Audience." *Feminist Wire*, November 18, 2014. www.thefeministwire.com.
Mercer, Kobena. "Black Hair/Style Politics." *New Formations*, no. 3 (Winter 1987): 33–54.
Mickelson, Nate. *City Poems and American Urban Crisis: 1945 to the Present*. London: Bloomsbury Academic, 2018.
Momber, Marlis, dir. *Viva Loisaida*. Film. New York: Gruppe Dokumentation, 1978.
Montez, Travis. "Over Me." *Lodestar Quarterly*, no. 3 (Fall 2002). http://lodestarquarterly.com.
Moore, Madison. *Fabulous: The Rise of the Beautiful Eccentric*. New Haven: Yale University Press, 2018.
Moraga, Cherríe. *The Last Generation: Prose and Poetry*. Boston: South End, 1999.
Morales, Ed. "Grand Slam: The Last Word at the Nuyorican." *Village Voice*, October 14, 1997, 62–63.
———. *Living in Spanglish: The Search for Latino Identity in America*. New York: St. Martin's, 2002.

Morales, Iris, dir. ¡Palante Siempre Palante! PBS, 1996.
Muñoz, José Esteban. *Cruising Utopia: The Then and There of Queer Futurity*. New York: New York University Press, 2009.
———. *Disidentifications: Queers of Color and the Performance of Politics*. Minneapolis: University of Minnesota Press, 1999.
———. "Feeling Brown: Ethnicity and Affect in Ricardo Bracho's *The Sweetest Hangover (and Other STDS)*." *Theatre Journal* 52, no. 1 (March 2000): 67–79.
Nelson, Alondra. "Introduction: Future Texts." *Social Text* 20, no. 2 (Summer 2002): 1–15.
Noel, Urayoán. *In Visible Movement: Nuyorican Poetry from the Sixties to Slam*. Iowa City: University of Iowa Press, 2014.
nonotv. *Bunny Rabbit & Black Cracker Live at Europa - feb. 2007*. YouTube, February 17, 2007. www.youtube.com/watch?v=DcI9VMZE6dE&feature=related.
Ogbar, Jeffrey O. G. *Hip-Hop Revolution: The Culture and Politics of Rap*. Lawrence: University Press of Kansas, 2007.
Okoth-Obbo, Vanessa. "Where Neo-Soul Began: 20 Years of Erykah Badu's Baduizm." *Pitchfork*, February 10, 2017. https://pitchfork.com.
Oliver, Myrna. "Dana Plato; Overdose Kills Troubled Actress." *Los Angeles Times*, May 10, 1999. www.latimes.com.
Otálvaro-Hormillosa, Gigi. "Resisting Appropriation and Assimilation via *(a)eromestizaje* and Radical Performance Art Practice." In *Pinay Power: Peminist Critical Theory: Theorizing the Filipina/American Experience*, edited by Melinda L. de Jesús, 327–40. New York: Routledge, 2005.
Ozuna, Tony. "Music Preview: Grand Pianoramax Featuring Black Cracker." *Jazzofilo*, February 18, 2012. https://jazzofilo.blogspot.com.
Pérez, Roy. "The Glory That Was Wrong: El 'Chino Malo' Approximates Nuyorico." In "Lingering in Latinidad: Theory, Aesthetics and Performance in Latina/o Studies," edited by Joshua Javier Guzmán and Cristina A. León. Special issue, *Women & Performance: A Journal of Feminist Theory* 25, no. 3 (April 2016): 277–97. https://doi.org/10.1080/0740770X.2015.1124665.
Perez-Bashier, Gladys "Poppy." "Kickin' It with Keith Roach the Poet." *The Weight of Words* (blog), July 23, 2011. http://gladysperezbashier.blogspot.com.
Piñero, Miguel. "The Book of Genesis according to Saint Miguelito." In *Nuyorican Poetry: An Anthology of Puerto Rican Words and Feelings*, edited by Miguel Algarín and Miguel Piñero, 62–64. New York: Morrow, 1975.
———. *Outlaw: The Collected Works of Miguel Piñero*. Edited by Nicolás Kanellos and Jorge Iglesias. Houston: Arte Público, 2012.
———. *Outrageous One Act Plays*. N.p.: Players Press, 1986.
Pyramid Club. "History." Accessed October 26, 2019. https://thepyramidclub.com.
Riggs, Marlon, dir. *Ethnic Notions*. San Francisco: California Newsreel, 1986.
Rivas, Bittman John "Bimbo." "Loisaida: The Reality Stage." *WIN*, December 20, 1974.
Rivera, Raquel Z. *New York Ricans from the Hip-hop Zone*. New York: Palgrave Macmillan, 2003.

Rivera-Servera, Ramón. *Performing Queer Latinidad: Dance, Sexuality, Politics*. Ann Arbor: University of Michigan Press, 2012.

Rodríguez, Juana María. *Sexual Futures, Queer Gestures, and Other Latina Longings*. New York: New York University Press, 2014.

Romana, Thomas. "Interview: Black Cracker (and Free Download of The New Acid Washed Remix)." *Local Suicide*, March 14, 2014. www.localsuicide.com.

Rosaldo, Renato. "Doing Oral History." *Social Analysis: The International Journal of Social and Cultural Practice*, no. 4 (September 1980): 89–99.

Rose, Tricia. *Black Noise: Rap Music and Black Culture in Contemporary America*. Middletown, CT: Wesleyan University Press, 1994.

———. "Never Trust a Big Butt and a Smile." In *That's the Joint! The Hip-Hop Studies Reader*, edited by Murray Forman and Mark Anthony Neal, 291–306. New York: Routledge, 2004.

———. "Nobody Wants a Part-Time Mother: An Interview with Willi Ninja." In *Microphone Fiends: Youth Music, Youth Culture*, edited by Andrew Ross and Tricia Rose, 163–75. London: Routledge, 1994.

Rossini, Jon D. "Miguel Piñero." In *Dictionary of Literary Biography: Twentieth-Century American Dramatists*, 3rd series, edited by Christopher Wheatley. Farmington Hills, MI: Gale, 2001.

Sánchez-Tranquilino, Marcos. "Mano a Mano: An Essay on the Representation of the Zoot but Its Misrepresentation by Octavio Paz." Unpublished manuscript, 1986.

Santiago, Edwin M. "The Beginning of A Band Called Loisaida." Pupa Santiago official website. Accessed October 24, 2019. https://pupasantiago.weebly.com.

Sapphire. Introduction to *Wild Like That: Good Stuff Smelling Strong*, by Tish Benson, 7–8. New York: Fly by Night Press, 2003.

Schulman, Sarah. *The Gentrification of the Mind: Witness to a Lost Imagination*. Berkeley: University of California Press, 2013.

Sevcenko, Liz. "Making Loisaida: Placing Puertorriqueñidad in Lower Manhattan." In *Mambo Montage: The Latinization of New York*, edited by Augustín Laó-Montes and Arlene Dávila, 293–318. New York: Columbia University Press, 2001.

Siegel, Allison B. "One Final Visit to 118 East 1st Street (and Darinka) before Demolition." *Bowery Boogie*, February 28, 2017. www.boweryboogie.com.

Smith, Neil. *The New Urban Frontier: Gentrification and the Revanchist City*. New York: Routledge, 1996.

Soja, Edward. *Postmodern Geographies: The Reassertion of Space in Critical Race Theory*. London: Verso, 1989.

Somers-Willett, Susan B. A. *The Cultural Politics of Slam Poetry: Race, Identity, and the Performance of Popular Verse in America*. Ann Arbor: University of Michigan Press, 2009.

Sommer, Doris. *Bilingual Aesthetics: A New Sentimental Education*. Durham: Duke University Press, 2004.

The Spaniels. *Goodnite, Sweetheart, Goodnite*. Vinyl EP. Recorded September 23, 1953. Vee-Jay.

Stallings, L. H. *Funk the Erotic: Transaesthetics and Black Sexual Cultures.* Urbana: University of Illinois Press, 2015.

Stewart, Dodai. "Oldies but (Not So) Goodies." *Jezebel*, May 5, 2008. https://jezebel.com.

Summers, Claude J., ed. *The Queer Encyclopedia of the Visual Arts.* Jersey City: Cleis, 2004.

Taylor, Diana. *The Archive and the Repertoire: Performing Cultural Memory in the Americas.* Durham: Duke University Press, 2003.

Torres, George "Urban Jibaro." "The Poetry of Bimbo Rivas: 'Loisaida' (by Bimbo Rivas; Written in 1974)." *Sofrito for Your Soul*, May 25, 2015. www.sofritoforyoursoul.com.

Townsend, Robert, dir. *Hollywood Shuffle.* DVD. 1987; Beverly Hills, CA: MGM, 2001.

Trachtenberg, Jordan, and Amy Trachtenberg, eds. *Verses That Hurt: Pleasures and Pain from the Poemfone Poets.* New York: St. Martin's, 1997.

Warner, Michael. *Publics and Counterpublics.* New York: Zone Books, 2002.

White, Miles. *From Jim Crow to Jay-Z: Race, Rap, and the Performance of Masculinity.* Urbana: University of Illinois Press, 2011.

———. "Neo-Soul." Oxford Music Online. January 20, 2016. www.oxfordmusiconline.com.

Williams, Raymond. *Keywords: A Vocabulary of Culture and Society.* New ed. New York: Oxford University Press, 2014.

Wonder, Stevie. "Overjoyed." By Stevie Wonder. Track 4 on Side 2 of *In Square Circle.* CD. Recorded 1985. Motown Records.

INDEX

1996 Nuyorican Grand Slam Team, 12, 17, 179n11, 182n22, 183n25

abjection, reimagining of, 7–9, 29–30, 44–45; and drag balls, 100–103, 112–13; and Glenn, 129–31, 142
activism, 5–6, 57, 63, 90, 168, 178n31; for civil rights, 66–67, 121; community, 14, 32–33, 118, 180n21
Afrofuturism, 24, 124, 138, 142–46, 152–53
Ahmed, Sara, 4–5, 177n5
AIDS crisis, 31, 101, 107–8, 111–13, 162
Algarín, Miguel: and Cafe history, 34–36, 44–45, 157–59, 162–64, 168–70, 180n36; and Open Room, 25, 155, 190n10; and performance, 11–12, 18, 55, 69–70, 100, 179n12, 181n47; and Spanglish, 3–8, 29–30, 32, 177n3
Aloud, 11, 179n12, 185n79, 190n10
Anderson, Sini, 102–4, 178n30, 186n18
The Annunciation According to Mikey Piñero (Wong), 42, 181n54. *See also* Wong, Martin
appropriation, 54–55, 70–71, 74, 84, 102–3, 110, 153; to critique minstrelsy, 24, 58, 129–31, 140; and "negrito," 183n38; and "nuyorican," 5–7, 18; topographical, 33, 36–37
archive, 4, 20, 143–44, 157–62
Asian Americans, 8, 18, 53, 61. *See also* Filipina/o identity
Asian American Writer's Workshop, 186n87

Asian stereotypes, critiques of, 23, 61, 69, 76–77, 110, 184n71. *See also* tropes
authenticity, 92–94, 141, 163–64; and ethnicity, 3, 7–8, 43–44, 69, 79–80, 128–29; and performance of self, 18, 23, 61, 109–11
autoethnography, 4, 23–24

ball awarding systems, 18–19, 90–91
Baraka, Amiri (LeRoi Jones), 10, 55, 181n47
Beat poets, 10, 12, 28, 55, 181n47
Beatty, Paul, 11, 183n25
Belle, Felice, 4
Berlin, 123, 142–43
Berry, Halle, 82–85
biblical references, 38–40, 97–98, 114, 137, 181n54, 189n3
bilingualism, 3, 16, 29, 101
"biyuti," 75
Black Arts movement, 10, 55
Black Atlantic, 125, 143–45, 188n8
Black Beat poets, 10
Black Cracker (Ellison Glenn), 5, 24–25, 87, 90, 104, 123–32, 169, 179n46, 182n24; and "Chasing Rainbows," 142–54; and Victory Riot, 133–41
Blackface, 24, 128–30, 140, 142
"Black Woman with a Blonde Wig On," 31. *See also* Piñero, Miguel
bohío, 14, 178n30
Bomb-itty of Errors, 58, 61, 182n4
"The Book of Genesis according to Saint Miguelito," 39–40, 189n3. *See also* Piñero, Miguel

199

"Born Again," 114
Bourdieu, Pierre, 23, 103
Bowery Poetry Club, 10, 89, 123, 133–34, 141
Bracho, Ricardo, 126–27
breathing, 68, 98, 116, 135, 150–51
Bronx, NY, 29, 31, 62, 111–12, 182n16
Bunny Rabbit, 129–31, 133–34, 140–42, 147, 149
Burroughs, William, 55, 181n47
Bush, George W., 135–36
Butler, Judith, 23, 76, 92, 110–11

Cabico, Regie, 4–5, 20, 22–26, 37; at Cafe, 57–60, 63–64, 149; and "Check One," 65–69, 183n28; and *Def Poetry Jam*, 77–81; and queer camp, 61, 74–77, 82–85, 109–10, 129, 169; and sampling, 70–73, 86
call-and-response, 5, 67–68, 95, 116, 129–30
Camillo, Marvin Felix, 31
camp theatrics, 7, 18–21, 89–93, 103; and Cabico, 22, 57–58, 61, 70–74, 85–86
Cara, Irene, 80–81
Caribbean American communities, 18, 58–59, 61–62, 91
Carrere, Tia, 81–83
casting practices in Hollywood, 70–71
castration anxiety, 184n70–n71. *See also* masculinity
Catholicism, 23, 65–66, 72–75, 181n54
Chapman, Stephanie, 6, 159–62, 190n8
CHARAS, 14–15, 33, 178n30
"Chasing Rainbows," 24, 144–53. *See also* Black Cracker; Glenn, Ellison
"Check One," 65, 69, 86, 183n28. *See also* Cabico, Regie
Chicago, IL, 11, 55, 91, 182n16
Cho, Aileen, 84, 186n87
Chocolate City, 144, 183n32, 189n50
choreopoems, 69–70

Christopher Street Piers, 107–8, 112
citizenship, 43–44, 59, 127
civil rights activism, 66–67, 118, 121
Cobb, William Jelani, 124–25
code-switching, 3, 8, 101, 105
colonialism, 8–9, 22–24, 59–60, 68, 70–72, 82, 136
Combs, Sean, 84, 130–131
commercialization of poetry slam, 13, 17–18, 30, 34–37, 64, 162–64, 182n14
Cortiñas, Jorge Ignacio, 22, 78–79
counterpublics, 35, 100–101, 134, 186n16
"cracker," 24, 127. *See also* Black Cracker; whiteness
Crawley, Ashon, 150–51
criminalization of Black men, 66–67, 84
Cruz-Malavé, Arnaldo, 43, 91, 112, 174
culture industry, 30–31, 37, 54, 179n10

Dalmau, Julio, 27, 46, 53
Darinka: A Performance Studio, 62–63
Dávila, Arlene, 33, 179n7
de Certeau, Michel, 20–21, 36
Def Poetry Jam, 61, 77–78, 81. *See also* Cabico, Regie
De Kosnik, Abigail, 72, 183n33
Del Valle, Mayda, 55, 183n25
Devlin, Paul, 12, 17, 179n11, 182n22
A Different Light (bookstore), 113
disco, 94, 113–114
disidentification, 127, 146
DJ aesthetics, 58, 62, 74, 79, 86
documentary films, 12, 32, 112, 158, 181n47–n48, 182n22, 186n18, 188n16
"Don't Stop 'til You Get Enough," 150
Downtown 81, 62–64
drag, 18–20, 63, 91–92, 187n26
drag balls, 89–90, 101–3, 108–13, 116, 187n25
drag houses, 91–94, 99, 106, 112–113
"drama," 75
"Dreaming of Other Planets," 126–27. *See also* Moraga, Cherríe

drug trafficking, 14, 27, 33–34, 37, 47
drug use, 33–34, 40, 44–45, 47, 62, 64, 107–8, 185n82

Eastern Bloc, 180n36, 190n5
East Harlem, 10, 33
East Village, 1, 30–31, 34, 43–46, 63
Edwards, Brent Hayes, 142–143
El Barrio, 10, 33, 98, 111–12, 179n7
electronica, 141–145
embodiment, 5, 8, 13–16, 19, 177n5, 188n19; and Cabico, 57–58, 65–68, 77–79, 82, 86–90; and Glenn, 123–25, 129–31, 140–41, 144–45, 148–49; and Jaime, 114–21; and Mother Diva, 103–11; and Piñero, 30–31, 38–39, 44
emcee, 128–29. *See also* hype man
Esteves, Sandra María, 6, 47, 168–69
ethics, 18–19, 125, 156

fabulousness, 23, 102–103, 108, 114
Fame, 80–81, 185n80
family. *See* kinship
fashion, 34, 46–47, 101, 105, 181n61; hip-hop, 58, 129–31; houses, 91–92
feminist aesthetics, 6, 131, 150, 186n18
fetishism, 184n70
fetishization, resistance to, 22, 71, 77, 84, 116, 185n71, 185n74
Field, Patricia, 104
Filipina/o identity, 22–23, 57–60, 68–72, 75–76, 86; and feminized labor, 65–67, 81–83, 183n33
Filipino Shuffle, 22, 57–60, 69–71, 77–80, 83, 85–87, 184n71. *See also* Cabico, Regie
first draft poems, 12–13, 25
first-generation experience, 4, 93, 98–99
Fleetwood, Nicole, 130–31, 188n19
flow, 18–19, 66, 124–25, 131, 151, 163
for colored girls who have considered suicide . . . , 69–70. *See also* Shangé, Ntozake

Friday Night Poetry Slam, 2, 11, 64, 94, 113–14, 155, 164–66, 187n1; hosting, 4, 25–27, 45, 53–54, 102, 158, 162–63, 171, 181n59, 182n24; in *SlamNation*, 179n11, 182n22
Fried Shoes, Cooked Diamonds, 181nn47–48

García, Antonio "Chico," 47, 49
Garcia, Carlos "Chino," 15, 32
Gay Men's Health Crisis, 111–12, 187n25
genealogies, 4, 9, 18, 57, 90, 104, 123–24, 149, 159
gentrification, 13–16, 21, 77, 162, 179n49, 180n21, 180n28; balls as resistance to, 107–8, 111; Glenn's critiques of, 137–38; Piñero's critiques of, 30–37, 42, 46, 54–55
gesturality, 5, 15, 19, 39, 54, 90, 115–16; and Black Cracker, 124, 131–33, 138–42, 150–51, 157; and Cabico, 57, 61, 66–67, 76–80, 85–86
"Ghosts in the Walls," 164–68
Ginsberg, Allen, 55, 181n47
Glam Slam, 4–5, 20–26, 37, 89–100, 149, 169, 178n24, 186n1; and ball culture, 101–15, 187n25, 187n38
Glenn, Ellison (Black Cracker), 5, 20, 24–25, 37, 104, 109, 123–32, 169, 179n46, 182n24; and "Chasing Rainbows," 142–54; and Victory Riot, 133–141
global poetics, 11–12, 17–18, 35, 45–46, 68–69, 143
Go, Julian, 23, 59–60
Grand Slam Finale, 12, 64–65
Griffith, Lois Elaine, 34, 157–59, 162–63, 168–70
Guzmán, Louey (Luis), 159–60

Halberstam, Jack, 24, 132–33
Harlem, 10, 33, 89–91, 112, 187n25
HBO, 77–83, 185n79. *See also* *Def Poetry Jam*

Hemispheric Institute of Performance and Politics, 158–59
Henry Miller's Theater, 89, 186n1
Herrera, Patricia, 6–7, 161, 178n40
heteropatriarchy, 6, 20, 47, 93, 99, 114, 123–25, 146, 159
hip-hop, 22, 58, 73–74, 77–79, 86–87
Hip-Hop Theater Festival, 58
historiographies, 6, 11, 150, 162–64
Hoch, Danny, 7, 22, 58, 71, 74
Hollywood Shuffle, 22, 70–71, 77
Holman, Bob, 1, 5–7, 10–14, 17–18, 63–64, 91, 179n12, 182n22, 190n10
homelessness, 40, 43, 63, 112–13
homophobia, 22, 75, 98–100, 112, 114, 135
HomoVisiones, 101, 107–9
house music, 94, 113–14
House of Latex Ball, 112
House of Ninja, 91, 99, 102–4, 113–14
House of Xavier, 101–6, 111–13, 186n87, 187n25
House of Xtravaganza, 99, 102–5, 113
housing crisis, 13, 32–34, 46. *See also* gentrification
hype man, 129–30, 134, 140

"I Ain't Your Girlfriend No More," 133. *See also* Black Cracker; Bunny Rabbit
"I Nail My Palms," 131–132. *See also* Glenn, Ellison
intergenerational support, 3, 17–18, 32, 91–92, 112–13

Jackson, Michael, 149–50
Jacobs-Jenkins, Branden, 128, 188n16
Jaime, Karen (poems). *See* "Born Again"; "Ghosts in the Walls"; "Maine"
Jay-Z, 78, 130–31
jazz, 17, 34, 91
Johnson, E. Patrick, 23, 93
Johnson, Travis Montez, 94–100, 113–14
Jones, LeRoi (Amiri Baraka), 10, 181n47

kinship, 91–93, 100, 103, 106, 112, 121. *See also* intergenerational support

Labelle, 144, 153
La Fountain-Stokes, Lawrence, 29
Latina/o immigrants, 3, 21, 31, 42, 46, 53, 77, 93, 111–12
Leah, Rachel, 34, 180n36
legibility, 61, 94, 99, 111, 127–29
lesbian identity, 6, 18, 90, 101, 104, 116–17, 134, 159–61, 186n18; and author positionality, 4, 25, 114–15, 155–56
"Letter to Filipino Celebrity Number 2: Tia Carrere," 81–83
Livingston, Jennie, 23, 93, 103, 112–13
"Loisaida," 14–15. *See also* Rivas, Bittman John "Bimbo"
"Loisaida" (usage), 14–15, 33–34, 40, 45
Loisaida movement, 33–35
Long Island, NY, 41, 45, 93
looping, 57, 71, 74, 153
Loperena, Miguel "Lobo," 157, 162–63, 190n10
López, Edrik, 16, 40
Lott, Eric, 24, 128, 130, 189n39
"Lower East Side Poem," 21, 40–44. *See also* Piñero, Miguel

"Maine," 116–20
Manalansan, Martin F., IV, 23, 75–76
Manhattan, NY, 31–33, 45–46, 60–62, 98, 123, 130, 187n25
Marrero, Elizabeth "Macha," 29
masculinist Nuyorican mythos, 5–8, 47, 90, 123–24
masculinity, 84, 90–93, 99–101, 104, 133, 184n71, 187n26; and hip-hop, 24, 27, 46–47, 79–80, 128–31, 138–42, 145, 148–49
M. Butterfly, 80, 184n71
Mercer, Kobena, 181n61
methodology of book, 4–7, 21–23, 93, 141

Miguelito Piñero's Random Thoughts and Walking Poetry, 20, 27–28. *See also* Piñero, Miguel
mimicry, 24, 54, 72–75, 112, 140
mini-balls, 105, 187n25
minstrelsy, 24, 58, 77, 128–31, 134, 138–44, 188n16
Momber, Marlis, 32, 158
Monster's Ball, 22, 71, 83–85
Moore, Madison, 23, 102–3
Moraga, Cherríe, 126–27, 138
Mother Diva (Andres Chulisi Rodriguez), 105–9, 114–16, 121, 187n26
movement, corporeal. *See* embodiment
A Mulata, Shange's Spell #7, 188n16. *See also* Jacobs-Jenkins, Branden
multiplicity, 5, 25, 43, 93, 123, 148–51
Muñoz, José Esteban, 126–27, 134, 138, 146, 152, 172, 185n74
murals, 32, 46–49, 53, 181n61
Musto, Michael, 102–3
Myles, Eileen, 102, 104

nationalism, 13, 20–22, 93, 101, 131
National Poetry Slam competitions, 12, 60, 65, 162–63, 183n36
"negrito," 43, 68, 1183n38
Neighbors, 128. *See also* Jacobs-Jenkins, Branden
Nelson, Alondra, 25, 143–144
New York Peer AIDS Education Coalition, 112
New York University, 54, 61, 64, 80, 94, 158
Ninja, Willi, 91, 102–4, 113–14
Noel, Urayoán, 5, 35, 178n39
"Nuyo," 17
Nuyorican chant, 163, 190n10
"Nuyorican Esthetic," (Algarín), 30–31; evolution of, 29–30
Nuyorican Grand Slam Championship, 55, 60, 64–65, 78, 183nn25–26, 186n2
Nuyorican Grand Slam Team, 12, 17, 182n22

Nuyorican movement, 5–9, 42, 47, 157–162, 169–170, 181n47
Nuyorican Poets Cafe's Founder's Archive Project (NPCFAP), 158–61. *See also* archive

objectification, 22, 80–86, 145, 148
Open Room, 3, 25, 155–70, 190n10
Operation Bootstrap, 9
orientalization, 71, 79–80, 184n71
Outrageous One Act Plays, 181n61. *See also* Piñero, Miguel
"Over Me," 95–98. *See also* Johnson, Travis Montez

Paris Is Burning, 23, 93, 103, 112–13
Parliament-Funkadelic, 144, 153
parody, 22, 57, 61, 70, 84, 110, 138
Performance Space: New York (formerly Darinka: A Performance Studio), 62–63
Philippines, 22–23, 59–60, 68–72, 185n84
Pietri, Pedro, 1, 5–13, 18, 47–49, 157–59, 162, 170, 189n3
Piñero, Miguel, 157, 168–70; and Nuyorican Poets Cafe history, 1, 4–11, 20–25, 34–36, 63, 177n3; finding poetic voice, 27–32, 54–55, 86–87, 149, 189n3; and walking poetry, 36–41, 44–46, 181n48; and Wong's painting, 42–43, 181n53, 181n61
place, 3–4, 127, 142, 147; and Cafe as community, 30–32, 36–37, 45–46, 53–55, 77–78, 168; and Lower East Side, 12–14, 32–34, 41–44, 62–64, 179n49, 180n28. *See also* space
poetry as competition. *See* Glam Slam; Nuyorican Grand Slam Championship
Portrait of Mikey Piñero, 42. *See also* Wong, Martin
"positioned performance," 76, 80, 146, 149–51

PosTer Boy, 144–46. *See also* Glenn, Ellison
poverty, 8, 13, 31, 112–13, 129, 135–36, 144
PreTty Boy, 145. *See also* Glenn, Ellison
Prince, 81, 145
"Puerto Rican Obituary," 189n3. *See also* Pietri, Pedro
Puerto Rico, 2–3, 7–9, 30–31, 41–46, 59–60, 70, 98
punk, 18, 125, 131–33, 143, 186n18

queer ball culture, 18–19, 23, 89–92, 95, 100–105, 108, 111–13
queer of color counterpublics, 5, 35, 100–101, 134, 186n16
queer of color precarity, 107, 111, 150, 162
queer survival, 8–9, 76, 91, 103, 156–57, 187n25
queer/trans vernaculars, 19, 60, 76, 90–91, 107, 121, 125
queer world making, 102–3

racism, art as challenge to, 8, 35, 70, 99–100, 110, 128, 144, 164
racist tropes. *See* Asian stereotypes; tropes
rap, 10, 58, 99; and Cabico, 60–62, 78, 129; and Glenn, 133, 140, 147–49
R&B, 17, 141, 143, 149
"reading," 91. *See also* shade
Real Great Society, 178n30
realness, 23, 61–62, 101, 110–13, 129
"Realness and Rhythms," 113
reclamation projects, 12–13, 33–35, 82, 114, 121, 131, 149–50
remixes, 18, 22, 57, 60–61, 69–75, 83–86. *See also* hip-hop; sampling
repetition, 68, 71, 74, 85, 106, 110–11, 132–33, 153
Rivas, Bittman John "Bimbo," 14–15, 32, 40, 178n31
Rivera, Raquel Z., 58–59
Rivera-Servera, Ramón, 21
Roach, Keith, 3–4, 17, 178n34

Roberson, Jehan L., 159, 162
Rodríguez, Juana María, 19
Rosaldo, Renato, 21, 172
Rose, Tricia, 22, 66, 71, 74, 91–92, 103–4, 148
Royal Chicano Air Force (RCAF), 8–9

"Salt and Pepper," 134–36. *See also* Glenn, Ellison
sampling, 22–23, 57–61, 69–74, 86. *See also* hip-hop; remixes
Santería, 66, 114, 121
Schulman, Sarah, 31, 46
scorekeeping, 3, 12–13, 23, 64, 92, 110, 132, 164, 177n1, 182n22. *See also* Glam Slam
"Seekin' the Cause," 37–38. *See also* Piñero, Miguel
"selling out," 82–83
Sevcenko, Liz, 32–33
shade, 23, 90–91, 106
Shangé, Ntozake, 55, 69–70, 77, 145, 158
Short Eyes, 31, 42. *See also* Camillo, Martin Felix; Piñero, Miguel
Sia, Beau, 12, 77
skin lightening, 138–40
SlamNation, 12, 17, 179n11, 182n22
Smith, Marc Kelly, 11, 182n16
Smith, Neil, 30–31, 54, 179n10
Soja, Edward, 15–16
Somers-Willett, Susan B. A., 23, 61, 77, 79, 109–11
South Bronx, NY, 29, 62, 111–12, 182n16
space, 4–5, 8, 11–16, 43–47, 86, 115–16; as ethnically marked, 21–22, 34–37, 55, 76–77, 123–24, 153, 158, 179n7, 180n28; and queer kinship networks, 19–20, 29–30, 63, 89–92, 101–6, 109–12, 121, 177n5. *See also* place
Spanglish, 3–9, 14, 29, 40, 55, 177n3
Spanish-American War of 1898, 23, 59
Spanish Harlem. *See* El Barrio

speed of delivery, 24, 37, 54, 67, 132–33, 151, 183n36. *See also* flow
Stallings, L. H., 25, 143, 145, 153
stereotypes. *See* Asian stereotypes; tropes
Streisand, Barbra, 57, 71–72
subaltern communities, 35, 99, 118
Sun Ra, 144, 153
symbolic capital, 23, 44, 103

"T," 125, 145
Taylor, Diana, 25, 141
temporal dynamics, 4, 82; competition time limits, 106, 183n36; and Glenn, 123–25, 144–45, 147, 153; and Piñero, 21, 37, 44. *See also* flow
The Thorn Birds, 22, 74
Townsend, Robert, 70–71
Transparent Sand Reflecting the Edge of Crabs, 135, 138
transworld identity, 143–45
tropes, 17–18, 70–72, 110, 114, 164, 182n14; Black Cracker's critiques of, 124, 127–30, 140; Cabico's critiques of, 22–23, 57, 61–62, 77–86. *See also* Asian stereotypes
trophies, 91–92, 114, 164 187n38

undercommons, 25, 156
utopia, 144, 151–53
utopian impulse, 126–27, 153

Victory Riot, 125, 134–36. *See also* Glenn, Ellison
Vietnam War, 37–39

Viva Loisaida, 32, 158
voguing, 23, 89–92, 101–5, 108, 112–13

Warner, Michael, 35, 186n16
"The Way We Were," 71–73
Wednesday Night Poetry Slam Open, 64, 123, 182n22, 182n24, 187n1
"What Kinds of Guys Are Attracted to Me," 77–81, 86
White, Miles, 145, 178n36
whiteness, 16, 24–25, 44–47, 57, 106–7; lampooning, 127–29, 133–36, 140–42; and power, 84–86, 92, 146, 151, 184n71
"Whitening Cream," 136. *See also* Glenn, Ellison
Williams, Saul, 12, 17, 183n25
women, 82–85, 121, 147–48, 189n54; in Cafe history, 6–7, 47, 91, 104, 160–61, 178n40; exclusion of, 132–33
Wonder, Stevie, 97, 99–100
Wong, Martin, 42–43, 181n53
WoW Café Theatre, 180n28

Xavier, Emanuel, 89, 101–9, 113. *See also* House of Xavier
Xtravaganza, Hector, 102–5. *See also* House of Xtravaganza

Young Family, 32. *See also* intergenerational support
youths, at-risk. *See* intergenerational support

zoot suits, 46–47, 181n61

ABOUT THE AUTHOR

KAREN JAIME is Assistant Professor in the Department of Performing and Media Arts and the Latina/o Studies Program at Cornell University. She is affiliate faculty in the American Studies, Feminist, Gender, and Sexuality Studies, and Lesbian, Gay, Bisexual, and Transgender Studies Programs. She is also a spoken word artist and published poet who hosted the Friday Night Poetry Slam at the Nuyorican Poets Cafe from 2003 to 2005.

www.ingramcontent.com/pod-product-compliance
Lightning Source LLC
Chambersburg PA
CBHW020408080526
44584CB00014B/1231